LANDMARK COLLECTOR'S LIBRARY

Stationary Steam Engines of Great Britain

The National Photographic Collection

Volume 10

PART 1: MARINE ENGINES
PART 2: READERS' RESPONSES; WHERE ARE THEY NOW?;
CONSOLIDATED MAKERS' INDEX

George Watkins

STATIONARY STEAM ENGINES OF GREAT BRITAIN

THE NATIONAL PHOTOGRAPHIC COLLECTION

VOLUME 10

PART 1: MARINE ENGINES

PART 2: READERS' RESPONSES; WHERE ARE THEY NOW?;
CONSOLIDATED MAKERS' INDEX

George Watkins

Landmark Publishing

Published by

LANDMARK
Publishing Ltd ● ● ● ●

Ashbourne Hall, Cokayne Ave
Ashbourne, Derbyshire, DE6 1EJ England
Tel: (01335) 347349 Fax: (01335) 347303
e-mail: landmark@clara.net
web site: www.landmarkpublishing.co.uk

ISBN 1-84306-107-4

© George Watkins

Print: CPI Bath Press, Bath

Designed by: James Allsopp

Series editor: A P Woolrich

Series proof readers: Colin Bowden & J Woolrich

Production: C L M Porter

Front cover: SER 558

Back cover: SER 1470C

Page 3: SER 816

CONTENTS

PART 2

FOREWORD
by A. P. Woolrich

George Watkins (1904-1989) spent most of his working life as a heating engineer and boilerman in Bristol. Starting in the 1930s, in his spare time he made short trips throughout Britain photographing and recording stationary steam engines. In 1965, aged 61, he was appointed a research assistant at the Centre for the Study of the History of Technology at Bath University, under Dr R. A. Buchanan, and was enabled to devote all his time adding to and classifying his collection. He was still making field trips until the late 1970s, when ill-health made travelling difficult.

He was an occasional contributor to *Model Engineer* and other periodicals, and wrote important papers for the *Transactions of the Newcomen Society*. Following his appointment to Bath University he was in much demand as a lecturer and produced a series of books based on his research. These were:

The Stationary Steam Engine (1968)

The Textile Mill Engine, 2 Vol, (1970, 1971), 2ed, (1999)

Man and the Steam Engine, (1975), 2 imp (1978) (with R. A. Buchanan)

The Industrial Archaeology of the Stationary Steam Engine, (1976) (with R. A. Buchanan)

The Steam Engine in Industry 2 vol, (1978, 1979)

On his death in February 1989 his collection was gifted to the Royal Commission on the Historical Monuments of England. It may be freely consulted at English Heritage's National Record Centre at Swindon. As well as photographs the collection comprises numerous technical notes about all manner of steam engine related topics; an incomparable archive of trade catalogues, some dating from the late nineteenth century; a collection of letters from like-minded friends, of value today for the light they shed on the history of the growth of Industrial Archaeology; lecture notes and slides. His library was left to Bath University.

He would visit a site and take illustrated notes and photographs, usually around half a dozen. His notes usually contained measured sketches of the machines and also the layouts of the premises he visited. In all, he travelled over 120,000 miles and visited nearly 2,000 sites, but in approximately 10% only took written notes. He filed sets of contact prints of each visit in binders sorted by engine type and between 1965-1971 he made a selection of the best prints for Bath University staff to print to a larger format. These were drymounted on card and annotated with details from his field notebooks and today form what is known at the Steam Engine Record. It is this collection, with notes, which forms the basis of the present series of regional books.

The Steam Engine Record is filed in numerical order, but catalogues are available listing makers, engine types and locations. When the field trips were being made the historic county names still applied, but the modern catalogues in the Search Room at Swindon allow searching by new counties and metropolitan areas, such as Cleveland and Greater Manchester. In this series, however, the historical county names have been retained.

When he began his surveys, he travelled by bicycle and train, and many were to sites he could reach readily from Bristol, but he soon graduated to a series of autocycles, on which he would pack his photographic gear and his clothing. He planned his trips meticulously during the winter months, writing to mill owners to gain permission, and then during the following summer (when his boiler was shut down for maintenance), having saved up all his available leave time, would then spend two or three weeks on his travels, staying in bed-and-breakfast accommodation, or, as he became more widely known, with friends. During the autumn he would write up his notes, and begin planning the following year's trip.

He was initially interested in beam engines, but soon concentrated on the textile mill engines of mostly Lancashire and Yorkshire. In this he was greatly aided by local experts such as Frank Wightman and Arthur Roberts, who were working in these areas. Later his interest included colliery winding engines, waterworks and marine engines. During the War, when he found difficulty in both travelling far and in getting permission to enter industrial sites, he investigated water-powered sites, such as the Avon Valley brass mills, near Bristol, and the Worcestershire edge tool manufacturing sites. An area of steam technology which did not concern him was the railway locomotive, though he did record a small number of industrial locomotives and traction engines he found on his visits.

The regional distribution of the sites he visited includes most English counties and a number in Wales and Scotland. The numbers of sites he saw in the counties differ greatly, with Yorkshire, Lancashire, and the counties around Bristol predominating. This is because he had close links with other workers in those areas, and he relied on this network to learn where engines might be found. Areas where he had few contacts tended to be thinly covered.

In many counties he saw sites with a marine connection. These will be covered in Volume 10 of this series. In this context this means a steam engine which drove a vessel, whether at sea, river or canal; also preserved marine engines. Engines at waterside features such as dockside workshops are included in the regional sequence of books.

George Watkins often photographed under near impossible conditions. Engine-room lighting was frequently indifferent, and confined space often made hard the siting of the camera for obtaining adequate perspective views. For most of the work reproduced in this series he used a tripod-mounted wooden plate camera with extension bellows which he modified to accept different lenses. In his early years he was continually experimenting with different combinations of film speeds, lenses and exposure times. Although he did eventually own a 35mm roll film camera, he was never happy with using it, and was frequently heard to grumble about the quality of modern film stock.

He used cut film, held in a dark slide, and had the films developed by a local chemist in the centres he visited so he could go back and take another if a print failed. He overcame bad lighting by having very long exposures, so was able to appear in his own prints occasionally.

The long exposures also meant he was able to 'freeze' a slow-moving engine. He did this by shielding the lens by a hand-held card or the lens cap until the engine had reached, say, top dead centre and then removing the shield momentarily. This cumulative exposure resulted in an image of a still engine, and such was his deftness of touch and impeccable timing, that it is very hard to see any kind of shake or blemish on the photographs. He was adept at 'painting with light' - utilising hand-held electric lead-lights with which he could illuminate different parts of the engine successively.

He made copies from his negatives at home for distribution to his friends by using a simple contact-print frame and developer chemicals. There are many small sets of his prints in private hands.

The lenses he used were not bloomed to prevent 'flaring' of the image caused by extraneous light from windows or hanging light bulbs, and some of the photographs reproduced are marred by this. He made his selection of prints for the Steam Engine Record on the basis of their historical and technical importance, and not on their artistic quality.

His photographs are a unique record of the end of stationary steam power in this country, being made at a time when electrification, nationalisation and trade depression created wholesale changes in the physical structure of the industrial landscape. They are an invaluable resource to our understanding of the reality of industrial activity, and will interest, as well as the technical historian, the local historian and modelmaker. It is good to know they are being published, for this in turn will focus attention on the rest of his reference collection, which deserves to be more widely known and used.

ISSES (The International Stationary Steam Engine Society) is publishing a number of volumes devoted to George Watkins and his work. The first volume was published mid-2002. It includes a biography of George Watkins, reminiscences by his friends, and copies of a number of his earlier writings, including some unpublished ones from the 1930's, and an account of the Watkins collection at Swindon.

Details and prices may be obtained from:

Mr John Cooper,
73 Coniston Way, Blossom Hill,
Bewdley, Worcestershire,
DY12 2QA
Tel: 01299 402946

Email: John.Cooper@isses2.freeserve.co.uk
Web site: www.steamenginesociety.org

The sites are in alphabetical order of geographical location, and then site name and no attempt has been made to place them by precise grid references. As work on this series has progressed it has become plain that the locations are sometimes wrong, particularly county names. This is because George used the nearest post town, which was sometimes in the next county. This has caused problems when allocating the entries to the books of this regional series, so work has been done closely cross checking the remaining original SER cards and revising the headings as necessary.

Each entry heading has an illustration number for this volume, the location, revised as necessary and the Steam Engine Record (SER) number. This latter number is the key for accessing the copies of the field notebooks and the files of additional photographs in the National Monuments Record at Swindon.

INTRODUCTION
by A. P. Woolrich

George Watkins had a special interest in marine engines and ships, and photographed 100 of them. In this book they have been arranged in alphabetical county order, and not in the same order as the previous volumes of the series.

His collection at the National Monuments Record at Swindon has several substantial files of data, which he used for writing his definitive paper on the Large Marine Steam Engine, published by the Newcomen Society, and the short pieces he wrote for *Funnel,* the journal of the Steam Boat Association of Great Britain, and *Model Engineer,* as well as other periodicals. Another interest was the development of the American river paddle steamer. None of these appear in the Steam Engine Record, of course, but there are substantial files and engine-makers' catalogues in the collection.

The engines he photographed were all from coastal or canal craft and tended to be small, compared with the engines installed in ocean-going vessels. For a number of sites the engines were preserved in museums or in the open air when he saw them. Of particular interest are the two mud scrapers used for clearing docks, one at Bristol and the other at Bridgwater. Both engines were made in Bristol in the mid-nineteenth century and both have been preserved since, in the latter with the entire vessel. There are several series of prints showing trip boats in England and Scotland together with their engine and boiler details. He was able to examine engines on naval vessels at Portsmouth. In view of the usual dockyard security today, one wonders how he managed to get on board! There are also details of several large cranes and grain elevators in London and on the Mersey.

There are only a few private steam launches included. This is surprising, in view of his close relationship with the Steam Boat Association of Great Britain, for it is known he was very involved with a number of boat owners. The reason is probably because at that time he had largely abandoned his large-format photography and had changed to a SRL camera, with which he did not get on. Any photographs he took then do not appear in the Steam Engine Record, though it is highly probable that negatives of them can be found at Swindon.

Further reading:

Watkins, George, 'Large Marine Steam Engines' in *Transactions of the Newcomen Society*, Vol 47, (1974-75 and 1975-76), pp 133 - 148.

Articles in *Funnel*, published by the Steam Boat Association of Great Britain

Watkins, George, article on steam launch boilers, No 10, May, 1975

Watkins, George, continuation of above, No 13, May 1977

Watkins, George, 'Watkins's wisdom' - on noisy feed pumps, No 21, Dec, 1979

Watkins, George, 'Boilers, inspection and care', No 24, Sept 1980

In addition the Association has three unpublished papers by George in their archives, on single-acting multi-cylinder engines, valve gears, and oil burners.

Articles in *Model Engineer*

Watkins, George, article by-lined 'Student' on the PS *Victoria*, Vol 109, 1953, p 572.

Watkins, George, article by-lined 'Student' on the PS *Empress*, in, Vol 112, 1955, p 656

Watkins, George, 3-part serial about the design and operation of the Bristol Docks Mud Scraper, the BD6, (with line drawings by Frank Wightman), Vol 126, 1962, pp 635, 710 and Vol 128, 1963, p 120

Other periodicals

Watkins, George, 3-part series 'George Watkins's Scrapbook', [copies of advertisements from C19 periodicals], in *Steamboats and Modern Steam Launches*. January-February , March-April, May-June, 1963 [Pages not known, originals in the Watkins collection]

Watkins, George, 'HMS Warrior - for restoration', in *Shipbuilding and Marine Engineering International,* October 1979 [Pages not known, original in the Watkins Collection]

Watkins George, 'The starting platform in the steam age' in *Marine Engineers Review* (Pub. Inst. Marine Engineers), May 1979, pp 36-7

PART 1 MARINE ENGINES

BRISTOL

1) Bristol, S. S. 'River Queen', ex Tewkesbury SER 894

Type:	Triple expansion non-condensing
Photo taken:	1958
Maker & Date:	Sisson & Co, Gloucester, 1901, No 605?
Cylinders:	About 6in – 8in and 10¼in x 7in – Piston valves
Hp: About 80	*Rpm:* 350 *Psi:* 180
Service:	Passenger trip vessel

This was Sisson's usual design for river passenger trip vessels, and was almost standard for such vessels in the United Kingdom. Working on fresh water, they were usually run non-condensing, which avoided trouble from cylinder oil fouling the boilers as well as noise from the pumps. The engine had been removed from the hull and is here seen when in store at Totterdown, Bristol about 1954. [This date does not accord with the date George Watkins claimed he took the photograph. Ed]. It was sold when the yard owner was ill, and no trace remained of the buyer's name. All of the valves were piston type driven by Marshall's valve gear, and balance weights were fitted which gave very sweet running at high speeds. The thrust block was integral with the rear main bearing and the whole was high speed design at its best, providing good power with light weight.

2) Port of Bristol, P. S. 'Cardiff Queen', Messrs P. & A. Campbell
SER 816

Type:	Diagonal triple expansion
Photo taken:	1956
Maker & Date:	Fairfield Shipbuilding & Engineering Co., Govan, Glasgow, 1947
Cylinders:	25½in, 39in and 61in x 6ft 0in – 4 slide valves per cylinder
Hp: 330 nominal	*Rpm:* 45 *Psi:* 160
Service:	Passenger paddle vessel. 240ft x 30ft x 9ft.

These were probably the last paddle engines made by Fairfields, and were fitted with Bremme valve gear driving Andrews and Camerons balanced slide valves with a separate valve for the inlet and the exhaust at each end of the cylinder. The air, feed and circulating pumps were all independent and steam driven. The cams of the engine valve gear were rather noisy in working, and were encased in acoustic cladding about 1956. She was fitted with a double ended Scotch boiler and was sold about 1968.

3) Port of Bristol, P. S. 'Bristol Queen', Messrs P. & A. Campbell
SER 817

Type:	Diagonal triple expansion
Photo taken: 1956	
Maker & Date:	Rankin & Blackmore, Greenock, 1946, No 517
Cylinders:	27in, 42in and 66in x 5ft 6in – Piston & slide valves
Hp: 330	*Rpm* 45 *Psi:* 160
Service:	Passenger vessel. Paddle driven.
	Hull built by Charles Hill, Bristol 244ft x 31ft x 10½ft deep

These were a plain and very good set of engines with very short eccentric rods for the valve gear, which worked extremely well. In contrast to *Cardiff Queen* she had one piston valve for the high pressure, and one flat slide valve each for the low and intermediate cylinders. The auxiliary pumps again were separate from the main engine. She was the last paddle

Continued on page 20

3

SER 817 continued...

boat to be built in Bristol, and was a very good vessel. The service was discontinued after several poor seasons, due to bad weather, and she was laid up at Cardiff, where she was damaged by a vessel when a tow rope failed, taking the impact on the paddle, and this resulted in her sale for scrapping. She was a very good sea boat and well liked by passengers, but running costs need capacity-filled trips, which were rare after the 1950s.

4) Port of Bristol, P. S. 'Britannia', Messrs P. & A. Campbell SER 818

Type:	Diagonal compound
Photo taken:	1956
Maker & Date:	Hutson & Co, Glasgow, 1896, No 209
Cylinders:	37in and 67in x 5ft 6in – Piston and slide valves
Hp: 304 nominal	*Rpm:* 42 *Psi:* 140
Service:	Paddle driven passenger vessel. 230ft x 29ft x 9^1/$_2$ft deep

Britannia was one of the fastest and best loved of all Campbell's steamers, but her boiler history was unfortunate, new ones being fitted in 1921, 1935 and 1948. Otherwise she was a very good vessel. The engines were massive, the diagonal forged steel diagonal struts being particularly so, and needed no central stay, as usually fitted to diagonal engines. As customary with the older vessels the air pump was driven from the engine cross head (HP), and the engine starting platform was also over the high pressure cylinder. The original boiler was the lightweight haystack type and the others were Scotch type and heavier. She was scrapped in 1956.

5) Port of Bristol, P. S. 'Ravenswood', Messrs P. & A. Campbell
SER 778

Type:	Diagonal compound condensing
Photo taken:	1955
Maker & Date:	Barclay, Curle & Co, Clydeside, 1909
Cylinders:	25^1/$_2$in and 50in x 4ft 6in – Piston and slide valves
Hp: ?	*Rpm:* 36 *Psi:* 150
Service:	Coastal passenger services

The vessel was built by McKnight of Glasgow in 1891, and originally fitted with a diagonal single cylinder engine 56in x 6ft 0in. She was re-engined and boilered in 1909 with the compound engines seen in the print, but after a period of disuse, she was scrapped in 1955.

6) Port of Bristol Authority, S. S. 'Bulldog' SER 406a

Type:	Two vertical tandem single crank
Photo taken:	1951
Maker & Date:	Finch & Co, Chepstow, 1884
Cylinders:	12in and 24in x 1ft 2in – Slide valves
Hp:	*Rpm:* 120 *Psi:* 100
Service:	Twin screw general service tug

Bulldog was a very useful general service vessel, and was fitted with a deck crane, also pumping and salvage gear. Each engine was fitted with a small balance wheel, and with vertical condensers in the corners of the engine room were very compact. Two boilers were fitted which could steam either or both engines, but she was broken up in the early 1960s when the hull was found to be unsound.

7) *Port of Bristol Authority, S. S. 'Tredegar'* **SER 405**

Type: Single cylinder condensing
Photo taken: 1951
Maker & Date: G. K. Stothert, Bristol, 1892
Cylinders: 20in x 1ft 6in – Slide valve
Hp: 35 *Rpm:* about 140 *Psi: 50*
Service: Screw coal carrier. Bristol Channel ports.
 97ft x 17ft 6in x 8ft 0in deep

The power plant and the hull were built by Stotherts as was the new twin furnace Scotch boiler, which was supplied in 1917. The foundry work in the engine was of high quality, the exhaust and feed pump passages, and the hotwell being cast in the frame. She carried coal from South Wales to most of the Channel ports, giving little trouble in 64 years as a steamer. Converted to diesel drive about 1956, she was scrapped about 1963.

8) *Port of Bristol, 'Dredger B D 6'* **SER 340**

Type: Inclined single cylinder non-condensing
Photo taken: 1947
Maker & Date: Bush & Beddoe, Bristol, 1843
Cylinders: 16in x 3ft 0in
Hp: *Rpm:* *Psi:*
Service: Mud scraper. Chain hauled. Hull 51ft x 15ft x 7ft 6in

This vessel was designed by Brunel to replace a smaller one, and was built in 1843 at a cost of £749. It operated by lowering a large flat scoop into the mud, and then pulling the vessel, to which the scoop was attached, to deposit the mud where the dredger could reach it. The engine was geared to a chain winding barrel, the chain being anchored to the quayside. The mud scoop was 8ft 0in wide x 4ft 6in deep, and carrying about 10 tons of mud, required all the power available, although it only dragged the mud along the bottom of the dock. She ceased work in 1960 when a diesel grab dredger was built (No. B D 7). The engine is preserved in Bristol Maritime Museum. [Harlech TV made a film of this when it was operating in Bristol Docks, some time in the 1950s. An actor, dressed as Brunel, was at the controls. It is not known if a copy of this film survives. Ed]

9) *Port of Bristol Authority, 'Dredger B D 4'* **SER 406b**

Type: Horizontal compound non-condensing
Photo taken: 1951
Maker & Date: Marshall & Co, Gainsborough, No 37730
Cylinders: About 9in and 16in x 1ft 0in – Slide valves
Hp: About 50 *Rpm:* 70 *Psi:* 140
Service: Bucket dredger. Harbour and canal service

Built at Sudbrook by C. H. Walker & Co. in 1903, B D 4 was fitted with lowering gear to the bucket ladder to allow her to work above the low fixed bridges on the Feeder Canal. The horizontal engine was unusual in marine service, but well suited here to give reduced height. The drive was by a side shaft and to the bucket tumbler shaft by bevel wheels and a vertical shaft. She raised 22 buckets per minute, which loaded the attending hoppers with 68 tons of mud in 30 minutes. A vertical boiler was fitted in place of the original Scotch return tube one in 1959, but she was replaced by a diesel grab dredger a few years later, and broken up.
Note: See additional entry on page 132

CAMBRIDGESHIRE

10) *Cambridge, S. S. 'Artemis'* *SER 1438a*

Type:	Two crank quadruple expansion, reversing
Photo taken:	1972
Maker & Date:	Simpson, Strickland & Co, Dartmouth, 1900
Cylinders:	2in, 2³/₄in, 3³/₄in and 5in x 3in – slide valves
Hp: 10	*Rpm:* 600 *Psi:* 250
Service:	Steam yacht's tender. Hull about 27ft x 5ft x 2ft draught
	Propeller – 17in diam. 33in pitch

Built as a harbour tender for the yacht, the original boiler was a water tube type for 250 psi, but this is now unusable. The Merryweather 'B' type boiler only carries 120 psi, but with this 7-8 mph [is achieved]. There is a keel condenser of about 7ft of flattened 2in copper tubing. The original feed pump has been replaced by one driven from the forward engine coupling flange. Only rain water is used as make-up feed water for the numerous runs she makes on the Cam each year

11) *Cambridge, S. S. 'Artemis'* *SER 1438b*

Type:	Water tube boiler
Photo taken:	1972
Maker & Date:	Simpson, Strickland & Co., Dartmouth, 1899
Dimensions:	Casing 24in high x 2ft 4in deep x 16in wide
Hp: ?	*Rpm:* *Psi:*
Service:	Original boiler

Artemis was the shore-going tender for a steam yacht, and lightly built to allow lifting with the steam plant into the davits on deck. The boiler was very light, with large heating surface, and very little water, and was fitted with fan draught to allow rapid steaming. Tubes of larger bore than the main generating tubes were fitted at the sides to protect the casing, the fire being between the side tubes, beneath the hook-shaped ones over the fire. It was last steamed in 1940, and is almost certainly the only remaining example of this design.

CHESHIRE

12) *Northwich, Imperial Chemical Industries, S. S. 'Herald of Peace'* *SER 472*

Type:	Twin cylinder vee type non-condensing
Photo taken:	1952
Maker & Date:	Watt Bros, Liverpool, 1877
Cylinders:	13in and 13in x 1ft 2in – Slide valves
Hp: ?	*Rpm:* 120 *Psi:* 110
Service:	Wooden steam canal salt barge
	Built by Thompson, Northwich, 1877. 84ft x 20ft x 8ft

This was a typical salt flat carrying about 120 tons of salt from the Mersey to Winsford in 6 hours, which included passing 6 locks. She was fast and the exhaust sounded more like a diesel engine. The feed water pumps were at the end of the crankshaft, driven by a small crank, and the feed water was heated in a jacket around the exhaust pipe on the way to the boiler, which forward of the engines was 8ft 6in diameter with two furnaces. The engine main frame comprised two castings only, and since the cylinders were in line one bottom end was split to clear the other. The use of bottled gas to light the engine room was unusual. The engine only took 2ft 6in of space fore and aft.

13) Birkenhead Docks, S. S. 'Vale Royal' SER 432a

Type: Double cylinder non-condensing
Photo taken: 1952
Maker & Date: W. Allen & Co, Manchester, 1883
Cylinders: 10$^1/_2$in x 1ft 0in – Slide valves
Hp: About 60 *Rpm:* 100 *Psi:* 600
Service: Steam barge. Wooden hull, ex-salt barge
 Built by Deakin, Winsford, 1877

This was one of a large fleet of salt carrying vessels for the chemical plant in Cheshire, many of which had wooden hulls to resist corrosion by the salt. Most of them had double cylinder engines as in the print, controlled from the deck, and of the simplest design. The boilers were usually twin furnace Scotch return tube type, and in Vale Royal it was set across the vessel, i. e. fired from the starboard side. The engine stood about 4ft 0in high, and exhausted into the funnel.

14) Birkenhead Docks, Sand Barge No 8 SER 432b

Type: Double cylinder condensing,
 later compound with tandem HP cylinders
Photo taken: 1952
Maker & Date: W Simons & Co, Renfrew, 1877
Cylinders: 2 x 30in x 2ft 3in when built
 HP cylinders about 18in bore added
Hp: *Rpm:* 125 *Psi:* 120
Service: Built as sand dredger. Converted to barge. 150ft x 25ft x 12$^1/_2$ft

Built as a bucket dredger for Birkenhead Docks, this had a double cylinder low pressure engine exhausting to the condenser through the back columns. No record remained of the original drive but she appeared to have used the one engine driving the dredging gear by a shaft forward and was self propelling by the same engine, the drives having jaw clutches. She was made into a tandem compound by adding high pressure cylinders about 18in bore together with a new boiler, but no date can be traced for this, i. e. it is not in Lloyds Register as compound, but was working after it left Lloyd's Register.

15) Birkenhead Docks, West Float, The 87 ton fixed crane SER 1407

Type: Double cylinder horizontal
Photo taken: 1970
Maker & Date: Unknown
Cylinders: 10in x 1ft 3in – Slide valves
Hp: 45 *Rpm:* 120 *Psi:* 150
Service: General hoisting to and from barges

This was an old crane built for hand-operation with an 87 ton lifting capacity, and was converted to steam operation in the early 1900s, as far as was known. The entire plant for the heavy and the light lifts, and the boiler, were all mounted in one cabin, and the entire crane rotated upon a circular rail track. It was little used in later years but was maintained and well kept, and passed its 92 ton lifting test in 1970. With increasing maintenance costs its future was then uncertain, but it was useful to transfer heavy cases or machinery from barges for land or rail transport or vice versa.

CORNWALL

16) Fowey, Steam tug, 'Fighting Cock', ex 'Mona' SER 410

Type: Compound marine engine
Photo taken: 1951
Maker & Date: Chas Burrell, Thetford, 1884
Cylinders: 20in and 40in x 2ft 0in – Slide valves
Hp: 300: *Rpm:* 100 *Psi:*
Service: General towing

The hull was 97ft 0in by 19ft 0in x 11ft 0in and built by K. Smit of Kinderdyk, Holland. The Burrell engines and boiler were fitted when new in 1884. The engines and boiler were large for the hull, but other than having a new boiler in 1912, little was altered, except for fitting hydraulic reversing gear, until she was broken up in 1964. She was at Queenstown for 18 years, and then Liverpool for over 44 years, with a short time in London and the rest at Fowey. These were the largest engines and boiler that Burrells made.

CUMBERLAND

17) Workington, Steam Tug 'Solway' SER 1454

Type: Triple expansion marine
Photo taken: 1973
Maker & Date: A. Hall & Co, Aberdeen, No 345
Cylinders: About 15in, 24in and 39in x 2ft 3in
Hp: 900 *Rpm:* 120 *Psi:* 160
Service: Harbour towing. Screw propeller

Solway was built as *Empire Ann* to take part in the invasion of Europe and came to Workington about 1950. With the reduction of traffic at Workington is likely to be scrapped in 1974. [It is not known if this happened then. Ed.] The engines were a very plain well-built set, with circular cast iron columns in the front and square ones with slipper guides at the rear. The air pump was driven from the high pressure crosshead, with a separate circulating pump. A single 3 furnace Scotch boiler, oil fired, provided the steam and retained its 160 psi working pressure in 1973.

DEVON

18) Devonport, H. M. Paddle Tugboat 'Industrious' SER 409

Type: Double diagonal oscillating compound
Photo taken: 1951
Maker & Date: Barclay, Curle, 1902
Cylinders: 31in and 55in x 5ft 0in – Piston valve HP – Slide valve LP
Hp: 1200 *Rpm:* 35 *Psi:* 75
Service: Dockyard tug. Independent engines

The engines were disconnecting i. e. each could drive one paddle wheel, giving great manoeuvring capacity, but there was a clutch to connect them together as they were not allowed to be disconnected in a seaway. The paddles were 18ft 3in diameter, with floats 9ft 0in wide. The power plant of the 4 oscillating-engined vessels was almost identical, with a 3 furnace boiler fore, and one aft, of the engines. The after boiler was out for repair in 1950, and a new funnel was then fitted.

16

DORSET

19) *Weymouth, Cosens & Co., P. S. 'Consul'* SER 487

Type:	Diagonal compound
Photo taken:	1952
Maker & Date:	J. Penn & Sons, Greenwich, 1896
Cylinders:	23in and 46in x 3ft 0in – Slide valves
Hp: 106 nominal	*Rpm:* 50 *Psi:* 120
Service:	Excursion paddle vessel
	Hull 175ft x 20½ft x 8¼ft. Builder R. & H. Green, London, 1896

She was built as the *Duke of Devonshire* for the Devon Dock and Pier Co, and was bought by Cosens in 1938. Very little was altered in her, except that the boilers were converted to oil firing in 1946. The main frame of the engines was of cast iron, but in most engines this was of forged steel, and the condenser was cast with the main frames, whereas this was usually separate, and placed below the crosshead guides. The whole design was very massive and typical of the high class work of the London engine builders of the period. The mahogany lagging was still on the cylinders when she was scrapped in the 1960s.

20) *Weymouth, Cosens & Co., P. S. 'Emperor of India'* SER 487a

Type:	Diagonal compound
Photo taken:	1952
Maker & Date:	J. I. Thornycroft, Southampton, 1906
Cylinders:	30in and 57in x 5ft 0in – Piston and slide valves
Hp: 210	*Rpm:* 42 *Psi:* 140
Service:	Excursion paddle vessel. Engines and hull by J. I. Thornycroft

She was built as *Princess Royal* for the Southampton Co, 195ft x 25ft x 8½ft, but was not accepted by them, and in 1907 she was made 21ft 8in longer, and purchased by Cosens in 1908. The engine design was essentially modern, with forged steel framing, and a separate steel plate condenser. It was in fact the standard design used as long as paddle engines were constructed. The condenser pumps were driven from the low pressure side crosshead. She remained in Cosens's service until she was scrapped in 1957.

21) *Weymouth, Cosens & Co., P. S. 'Empress'* SER 397

Type:	Twin cylinder oscillating
Photo taken:	1951
Maker & Date:	John Penn & Sons, Greenwich, 1879
Cylinders:	30in x 2ft 9in – Slide valves
Hp: 50	*Rpm:* 34 *Psi:* 25
Service:	Passenger paddle excursion vessel 160ft x 18ft x 8.3ft. Built by Samuda, London

Typical Penn's oscillating paddle engine, built for jet condensing. It was altered to surface condensation, possibly when the original oval boiler (found to be too small) was replaced in 1884. The air pump was driven off the usual centre crank, with a separate engine for the condenser water circulation. The boiler was again replaced in 1904, and this served until she was broken up in the 1950s. The engine is preserved in the Maritime Museum, Southampton.

21

22) Weymouth, Cosens & Co., P. S. 'Victoria' SER 398a

Type:	Twin cylinder oscillating
Photo taken:	1951
Maker & Date:	John Penn & Sons, Greenwich, 1884
Cylinders:	35in x 3ft 0in – Slide valve
Hp: 75	*Rpm:* 34 *Psi:* 30
Service:	Passenger excursion vessel. 175ft x 19.3ft x 8.7ft
	Builder J. K. Smit, Kinderdyk, Holland

This was also built with jet condensing, and converted to surface condensing when the hull was lengthened in 1888. The hydraulic reversing gear was probably a late addition, the starting platform being on deck level, whereas *Empress* was operated below. Both engines retained the Penn's special nuts, with the washer forged with the nut, all their lives, and they were probably the last surviving Penn's oscillating engines.

23) Weymouth, Cosens & Co., P. S. 'Victoria' SER 398b

Type:	Rectangular boiler
Photo taken:	1951
Maker & Date:	Hodge & Co, Millwall, 1912
Dimensions:	14ft high, 13ft wide, 8ft 6in long
Hp:	*Rpm:* *Psi:* 30

This was made to the same design as the original one by Penns, and actually fitted the cross section of the deck, with the steam chest above the tubes narrowed in to allow for the deck. It was almost certainly the last rectangular boiler in sea service, but having got badly salted during war service, it was difficult to steam in the 1950s, and with the interior full of stays and tubes was impossible to clean, the wings under the deck being totally inaccessible. Vessel scrapped about 1956.

DUNBARTONSHIRE

24) Loch Lomond, P. S. 'Maid of the Loch' SER 1260a

Type:	Paddle driven passenger vessel
Photo taken:	1966
Maker & Date:	A. & J. Inglis, Pointhouse, Glasgow, 1953
Dimensions:	193ft long x 28ft beam, x 7ft 3in depth
Service:	Paddle driven passenger vessel. Tourist excursions on Loch

This was probably the last paddle vessel that will be built for such service in the United Kingdom. The previous vessels were smaller and were floated up to the loch on high tides, but the *Maid* was too large for this, and after partial assembly at Pointhouse, she was dismantled and shipped piecemeal, and launched from the repairing slip on the loch. She carries 1,000 passengers, on a gross tonnage of 557, and makes 14 knots. With poor weather over too many seasons, with restricted numbers of passengers, her fate has frequently been in doubt, but she is still in use in 1973, since in fine sunny summers the trips are very popular.

25) Loch Lomond, P. S. 'Maid of the Loch' SER 1260b

Type:	Diagonal compound
Photo taken:	1966
Maker & Date:	Rankin & Blackmore, Greenock, 1953
Cylinders:	24in and 48in x 4ft 3in piston and slide valves
Hp: 900	*Rpm:* 55 *Psi:*
Service:	Propelling machinery. Feathering paddle wheels 15ft 3in diameter

The engines are a typical Rankin & Blackmore set, plain, simple and reliable, with the usual forged bar frame, and the condenser placed below it, with the main service pumps driven from the engines. The boiler is unusual, being of the Admiralty pattern (through tube type with three circular furnaces and the fire tubes in line), 10ft 6in diameter x 17ft 6in long. The engines and paddle wheels were installed complete before launching, but the boiler was shipped after launching by railway breakdown crane. She was designed for oil firing, probably only the second vessel on the Clyde passenger system so built.

26) Loch Lomond, P. S. 'Princess May' SER 558

Type:	Double cylinder diagonal jet condensing
Photo taken:	1953
Maker & Date:	A. & J. Inglis, Renfrew, No 394, 1898
Cylinders:	2 cylinders 34in x 4ft 0in – Slide valves
Hp: ?	*Rpm:* 36 *Psi:* 60
Service:	Passenger excursion vessel on Loch Lomond
	Vessel made by A. & J. Inglis 165ft x 24ft x 6ft 0in

Princess May remained literally unaltered in nearly 60 years running on Loch Lomond, and was always jet condensing, as she ran on fresh water on the Loch. She was fitted with a haystack boiler (invented by Napier in the 1820s) which, being light and free steaming, made her fast and reasonably economical. The very attractive wooden railings around the engine space were typical of the Clyde passenger vessels of the 19th century. The hull was shallow, and the upper casing of the boiler room followed the shape of the boiler crown above the deck, as the boiler was taller than the hull depth, and everything was typical of the best of Clydeside. She was broken up about 1958.

27) P. S. 'Duchess of Fife' SER 559

Type:	Two crank triple expansion paddle
Photo taken:	1953
Maker & Date:	Fairfield Shipbuilding & Engineering Co, No 432, 1903
Cylinders:	2 x 16$\frac{1}{2}$in, 1 x 35$\frac{1}{2}$in, 1 x 52in x 4ft 6in stroke
Hp: 199	*Rpm:* 45 *Psi:* 150
Service:	Passenger excursion running west coast from Glasgow to Largs
	Hull 210ft x 25ft x 8ft 3in also by Fairfield Co.

This was a special engine design to give triple expansion with only two cranks, one rarely used in marine service, and with the two high pressure cylinders tandem at the rear of intermediate and low pressure cylinders, which were attached to the diagonal framing. This was well suited to the narrow hull and gave ample passage way beside the engines. A new boiler was fitted in 1903, and she was probably broken up about 1962.

GLOUCESTERSHIRE

28) *Gloucester Docks, British Waterways, S. S. 'Firefly'* SER 1224a

Type:	Vertical marine compound non-condensing
Photo taken:	1965
Maker & Date:	W. Sisson & Co, Gloucester, about 1900
Cylinders:	6in and 10in x 8in – Piston valves
Hp: 50?	*Rpm:* 250 *Psi:* 110
Service:	Floating fire extinguishing vessel

Firefly was converted from a barge to a firefloat, but no dates were known. The Merryweather fire pump was horizontal and, placed in a house upon the deck. It was made largely of bronze and comprised twin cylinders directly connected to the pump piston rods, with cross-heads, and short connecting rods driving back to a central crankshaft. The steam cylinders were about 9in and the pumps 6in diameter. The boiler was a large Spencer-Hopwood cross water tube type, new in 1950, 4ft 6in x 10ft 0in high, and the screw propelling engines seen in the print were the Sissons commercial cast iron framed type, with Marshall's valve gear. The boiler can be seen in the centre ahead, and the auxiliary bilge, feed and general service pump on the left. The engine exhaust to the waste pipe astern can be seen passing above the auxiliary pump. She was for sale in 1965, and was probably broken up.

29) *Gloucester Docks, British Waterways, S. S. 'Mayflower'* SER 1224b

Type:	Vertical marine compound condensing
Photo taken:	1965
Maker & Date:	W. Sisson & Co, Gloucester, 1896
Cylinders:	10$\frac{1}{2}$in and 21in x 1ft 2in – Slide valves
Hp: 180?	*Rpm:* 150 *Psi:* 120
Service:	Steam tug. Screw propelling engines.

Sissons's heavy duty marine type, this had the condenser cast in one with the main frames but with the crosshead guides separate, and bolted to facings on the front of the columns. There were plain flat slide valves, operated by Sissons's patent valve gear, which was patented in 1896. It was entirely radial, operated from a short cross shaft in the top of the connecting rod, with motion controlled by links attached to the rear column and the reversing weigh shaft at the front. There were no eccentrics with this type, which worked with little friction, but needed careful adjustment. The boiler was forward and was a twin furnace Scotch return tube type 8ft 6in diameter and 8ft 0in long with 66 return tubes. *Mayflower*, too, was for sale in 1965, and also probably scrapped.

30) *Gloucester Docks, British Waterways, 'Dredger No 4'* SER 1224c

Type:	Vertical marine compound jet condensing
Photo taken:	1965
Maker & Date:	de Klop, Holland, No 146, 1938
Cylinders:	About 9in and 16in x 1ft 3in – Piston and slide valves
Hp: ?	*Rpm:* 120 *Psi:* 140
Service:	Bucket ladder drive engine. 10in belt off each side

The whole dredger was built by de Klop, and was the usual bucket and ladder type. The engine drove by a belt on each side, to a cross shaft at the top, to drive the bucket tumbler shaft through high ratio reduction gearing. The engine was simply a large tug type reversing compound, but unusual in that it was jet, not surface condensing. The boiler was a single furnace Scotch return tube, with one oil fired furnace. There were four dredgers in service in 1965, No. 1 and No. 4 being steam driven. All were then in regular use.

31) Tewkesbury, British Waterways, 'Dredger No 3' SER 1478

Type:	Inverted vertical compound non-condensing
Photo taken:	1975
Maker & Date:	Plenty and Co, Newbury, 1933
Cylinders:	7½in and 13in x 10in – Slide valves
Hp: About 30	*Rpm:* 120 *Psi:* 120
Service:	River mud dredger

The hull was built by Charles Hill of Bristol in 1934 – yard No 206. She is a ladder dredger emptying 36 buckets per minute. The main drive to the bucket chain tumbler at the top is by two belts 10ins wide from the ends of the crankshaft. The belts are inside of the casings and give 3 to 1 reduction, with a further 6 to 1 by gearing on the top structure, to the tumbler shaft. Steam is provided by a two-furnace Scotch boiler by Anderson's of Motherwell, oil fired and fed by injectors. There is a Hindleys of Bourton generating set and turbine driven deck washing pump. Ship handling for cut was by a multi-purpose windlass on deck.

HAMPSHIRE

32) Portsmouth, H. M. Dockyard, P. S. 'Sprite' SER 848

Type:	Twin diagonal compound disconnecting
Photo taken:	1957
Maker & Date:	J. I. Thornycroft & Co., Southampton, 1915
Cylinders:	2 x 15in and 2 x 30in x 3ft 6in – Piston and slide valves
Hp: ?	*Rpm:* 40 *Psi:* 150
Service:	Dockyard paddle tug

These were representative of the later designs which followed the last of the oscillating-engined vessels of around 1900 (see SER 404, SER 409 and SER 418), and all of the later paddle dockyard tugs were similar to these. Each engine was completely separate, with a boiler fore and one aft of the engines. The steam tugs were gradually superseded by diesel engine driven vessels, six of which were diesel electric paddle driven, which in 1954 superseded the earlier steam ones noted above.

33) Portsmouth, H. M. Dockyard, H M S 'Volatile' SER 404

Type:	Double diagonal compound oscillating
Photo taken:	1951
Maker & Date:	Barclay, Curle & Co, Clydeside, 1898
Cylinders:	31in and 55in x 5ft 0in – Piston valve HP – Slide valve LP
Hp: 120	*Rpm:* 35 *Psi:* 75
Service:	Paddle tug. General towing duties

Built as *Volcano* this was one of the last four oscillating-engined Navy vessels (see SER 409 and SER 418). There was a separate engine to each paddle wheel, but there was also a clutch to couple the two engines together when in a seaway. Each engine was completely independent, with its own condenser with air pump driven by an eccentric from the crankshaft. There were two Scotch boilers, one fore and one aft of the main engine room, with separate funnels. These vessels were replaced by six-diesel electric paddle vessels in the 1950s, but some of these went to docks outside the United Kingdom.

33

34) Portsmouth, The Royal Yacht 'Victoria and Albert' SER 764a

Type:	Four cylinder triple expansion
Photo taken:	1955
Maker & Date:	Humphrys & Tennant, Deptford, 1899
Cylinders:	26½in, 44½in, 53in and 53in x 3ft 3in
Hp: 7,500	*Rpm:* 140 *Psi:* 300
Service:	Screw propulsion. Twin screws

These were the last remaining Thames-built high power engines, and the vessel throughout was of the highest quality. Even the engine room stairs and indeed all of the engine room valves were of Admiralty quality, the stair treads having "V & A" cast on each one. The engines were Humphrys & Tennant's standard design, with the air pumps attached directly to the low pressure cylinder pistons, and their usual bar link motion for reversing. The engine room was cramped originally, and latterly the need for added generating plant made it worse as additional lighting capacity was needed for reviews and other displays, and eventually other generators were installed outside of the engine room. She was broken up in the North when 52 years old. [This date does not accord with the date George Watkins claimed he took the photograph. Ed].

35) Portsmouth, The Royal Yacht 'Victoria and Albert' SER 764b

Type:	18 Belleville boilers
Photo taken:	1955
Maker & Date:	Humphrys & Tennant, Deptford, 1899
Dimensions:	26,000 square feet of heating surface
Hp: 7,500	*Rpm:* *Psi:* 300
Service:	Boilers for main engines

These were probably the last Belleville boilers in existence, and also possibly the last large coal fired boiler room in the Navy. They were the pure Belleville type, with elements of 7 tubes high, and with the water level about half way up the tubes, and also with economiser elements above the generating sections. Other than the added generators, little had been altered in her lifetime, so she remained a fine piece of Victorian engineering, and Thames side engineering of a high order. It is said that this unique plant was scrapped in 1956.

36) Southampton, The Maritime Museum, P. S. 'Empress' SER 1424a

Type:	Double cylinder oscillating marine
Photo taken:	1971
Maker & Date:	John Penn and Sons, Greenwich, 1879
Cylinders:	30in x 2ft 9in – Slide valves
Hp: 52	*Rpm:* 26 *Psi:* 30
Service:	Paddle vessel engines. Preserved

The general details of the engines are given in SER 397, when she was in service. She was scrapped in the 1950s when repair costs became too great, and the engines' existence and condition are a tribute to the shipbreakers who presented them, and the marine engineer cadets and their department at Southampton College of Technology who brought them to such fine condition. They are also a tribute to the craftsmen of Thames-side who made them. They are the only remaining set of oscillating marine engines in the United Kingdom and except for the conversion to surface condensing soon after they were built, remain as they left Penn's works in 1879, a fitting tribute to Penn's who really developed the oscillating engine to its widespread use.

37) *Southampton, The Maritime Museum, P. S. 'Empress'* SER 1424b

Type:	Double diagonal side rod
Photo taken:	1971
Maker & Date:	Beck's patent Climax, Sheffield, 1879?
Cylinders:	About 4in x 5in – Slide valves
Hp: ?	*Rpm:* 100 *Psi:* 30
Service:	Steering engine. Hand or steam operation

A very compact hand or steam steering gear. The engine is of the extremely short side rod type in which the crosshead is carried as twin side rods down the sides of the cylinders in guides, with the connecting rod straddling the outside, down to the bottom of the side rods. It is as short as an engine could be, with the double acting cylinders necessary for rapid handling. The response was instantaneous with this layout and the whole steering gear appears to have been little changed in its long service, but there is no positive record of when it was actually fitted; it could have been much later than 1879. Again all concerned are to be congratulated that this very rare little unit has been so well preserved, and like the main engines of *Empress* it is probably the only surviving working example of the type.

38) *Southampton, The Maritime Museum, S. S. 'Thornycroft Bee'*
SER 1424c

Type:	Marine compound screw
Photo taken:	1971
Maker & Date:	J. I. Thornycroft, Southampton. Date unknown
Cylinders:	5¹/₂in and 10in x 9in – Slide valves
Hp:	*Rpm:* 200 *Psi:* 120
Service:	Launch propulsion

Bee was a launch which acted also as a work vessel ferrying men and material to vessels around the yard at Woolston. Built for general service rather than the high speeds of the Thames launches, the engine is heavier in general build, with ample bearing surfaces, and with counterbalanced cranks which permitted high running speeds. An inboard surface condenser was fitted, with circulating, air, feed and bilge pumps driven directly from the crossheads. With the open forged steel framing and counterbalanced cranks, yet otherwise massive build, it is a design between the very light high speed river boat and the heavy tug engine types which, with the best features of both types gave very good service, and it appears to have had very little repair.

39) *Woolston, River Itchen Floating Bridge, 'Vessel No 8'* SER 84a

Type:	Overhead grasshopper beam engine
Photo taken:	1934
Maker & Date:	Day, Summers & Co, Southampton, 1890
Cylinders:	9¹/₄in and 16in x 3ft 3in – Slide valves
Hp: ?	*Rpm: ?* *Psi:* 75
Service:	Passenger and vehicle ferry. Propelled by steel rope. Hull 92ft long x 38ft wide

The ferry crosses the tidal reach at Woolston, the longest run at high tide being 376 yards. A maximum of 250 passengers was carried with a central space for 8 or 10 vehicles. Up to 55 passages were made per day, with a weekly coal consumption of under two tons. The earlier ones were driven by a single rope only, but this appears to have been altered to the use of a driving rope on either side. The single boiler was of through tube design with a circular furnace. The cable barrel on each side was driven by cross shaft and gear wheels 2ft and 8ft in diameter from the engine crankshaft. Diesel units were used after 1960.

40) Woolston, River Itchen Floating Bridge 'Vessel No. 9' SER 84b

Type:	Overhead centre beam compound condensing
Photo taken:	1934
Maker & Date:	Mordey Carney & Co, Southampton, 1900
Cylinders:	About 9in and 18in x 3ft 0in – Slide valves
	Beams 10ft 0in long
Service:	Similar design but larger. Gear wheels 3ft 0in and 9ft 0in

This as No. 9 had link motion reversing gear, with guide bars for the crosshead, but with a Scotch type of boiler, for 85 psi pressure. The large gear again was fitted with mortise teeth, which were held in place by wooden wedges between the tails, not the usual metal pins driven into the tails. Vessel No.10 was similar, but built by Day, Summers & Co., in 1928, with a Scotch boiler – 100 psi.

KENT

41) Dover Harbour Board, S. S. 'Dapper' SER 413a

Type:	Vertical marine compound	
Photo taken:	1951	
Maker & Date:	J W Sullivan & Co, New York, 1916	
Cylinders:	18in and 40in x 2ft 3in – Piston HP – Slide LP valves	
Hp: 69	*Rpm:* 120	*Psi:* 120
Service:	General towing duties. Hull by the New York Shipbuilding Co,	
	1915. 124ft x 30ft x 12ft 8in.	

There were several features not usual in European practice in this engine. The strap and cottered eccentric rod ends, the counterbalanced cranks, the rectangular bar type cross-head guide bars were uncommon here as too was the separate circular condenser, and the use of all separate pumping engines. European practice was to cast the condenser with the main engine columns, and drive several of the pumps from the main engine motion, which was more economical although less flexible. *Dapper* was probably broken up early in the 1960s. The American engine room telegraph had been retained.

42) Dover Harbour Board, S. S. 'Snapper' SER 413b

Type:	Vertical compound marine	
Photo taken:	1951	
Maker & Date:	Armstrong Mitchell, 1884?	
Cylinders:	22in and 36in x 3ft 0in – Slide valves	
Hp:	*Rpm:* 100	*Psi:*
Service:	Crane and general service vessel	

Mr. J. M. Sutton stated that she was built as a gunboat H.M.S. *Excellent*, by Armstrong Mitchells, Newcastle upon Tyne, 1884, although the engine was not certain to be their make. A 25-ton crane was fitted in 1920, possibly when she came to the Harbour Board, and she was said to have been broken up in the late 1950s. An interesting feature was that the auxiliary pumps were driven from the crosshead, by a crossbar, not the usual lever system which gave the pumps a shorter stroke.

43) *Isle of Grain, The Naval Fuel Depot* **SER 481**

Type:	Rectangular marine boiler
Photo taken:	1952
Maker & Date:	Keyham Navy Yard, 1900
Dimensions:	11ft 0in high, 10ft 6in wide, 9ft 6in long
Hp:	*Rpm:* *Psi:* 30
Service:	Heating heavy fuel oil

This was the last boiler of the type in the Navy, and was said to have been a test job for the boilermaker apprentices at the yard to work on. As with all rectangular boilers the interior was very inaccessible for maintenance or inspection, being a mass of stays and tubes, and the platework was a fine example of the plater's art. It was marked H.M.S. *Hecate*, but the ship was not identifiable, and as often with this type it was shaped to fit the ship's hull, sloping at the back to meet the shape of the ship's side, as the boilers were probably placed across the hull with a centre firing aisle. It was condemned when fifty years old and replaced by a Cochran vertical fire tube boiler.

44) *Sheerness Dockyard, H. M. Paddle Tugs 'Cracker' and 'Advice'*
SER 418

Type:	Double diagonal oscillating compound
Photo taken:	1951
Maker & Date:	London & Glasgow Shipbuilding Co, Glasgow, 1899. No 301 and 2
Cylinders:	31in and 55in x 5ft 0in.
Hp: Total 1200	*Rpm:* 35 *Psi:* 75
Service:	Dockyard paddle tugs

The naval paddle tugs built in the 1890s were largely Admiralty standard designed, as SER 404 & SER 409. They were about 680 tons, 144ft 0in x 27ft 4in x 10ft 6in draught, with a 3 furnace Scotch boiler fore and aft of the engines, paddles 9ft 0in wide and making up to 12 knots. The cylinder centre lines were offset so that each had a single crank pin bearing; had they been in line one of the bearings would have had to be split to fit either side of the other.

LANARK

45) *Dumbarton Pier , Clydeside , P. S. 'Leven'* **SER 557**

Type:	Single cylinder side lever jet condensing
Photo taken:	1953
Maker & Date:	Robert Napier, 1824
Cylinders:	About 36in x 3ft 6in – Slide valve
Service:	Paddle tugboat engine. Preserved

This is probably the only side lever engine preserved, and was the first engine built by the later celebrated engineer Robert Napier. Installed in P.S. *Leven* it ran until the 1870s between Dumbarton and Glasgow, and when the vessel was broken up, the engine was presented by members of the Napier family and re-erected close to where it was built. It is said to have been moved since 1954, but still preserved on the Clyde. Reversing the engine was by working the slide valve by hand, until it was reversed, when the eccentric would move to the correct point on the crankshaft, and run thus. It was, in fact, a slip eccentric held by stop blocks on the crankshaft.

45

PRESENTED BY
J.R. & J. NAPIER, Esquires,
ENGINEERS;
TO THE PROVOST MAGISTRATES & TOWN COUNCIL
OF THE
ROYAL BURGH DUMBARTON JULY 1877

46) *Renfrew Ferry, Glasgow, Ex P. S. 'Clyde'* SER 556

Type:	Side lever grasshopper jet condensing
Photo taken:	1953
Maker & Date:	A. & J. Inglis, 1851
Cylinders:	33in x 4ft 8in – Slide valve
Service:	Paddle tugboat. Engines preserved at Renfrew Ferry, Glasgow

These engines were designed by Andrew Brown, for a vessel built by Messrs Inglis for the Clyde Navigation Trust in 1851. They are the standard grasshopper side lever type, in which either paddle can operate independently, but with a coupling clutch for working in a seaway, when disconnected engines were not permitted. Such engines were used in tugs on almost every dock in the United Kingdom; the last were upon the Tyne where France, Fenwick used them into the late 1950s regularly. They were steady and easy working units, and one was worked across the ocean to San Francisco for preservation intact with the vessel *Eppleton Hall*.

LANCASHIRE

47) *Burnley, Burnley Depot , Leeds & Liverpool Canal* SER 553a

Type:	Vee twin tandem non-condensing	
Photo taken:	1953	
Maker & Date:	Possibly canal make? Early 1900s	
Cylinders:	5in and 8in x 8in each side – Slide valves	
Hp: About 50	*Rpm:* 140	*Psi:* 100
Service:	Canal carrying	

These were a standard barge engine design on the Leeds and Liverpool, although vee types were little used elsewhere on the canals. They were very compact and powerful, and were fitted with vertical Field tube boilers, and feed water heaters. The print shows how compact the whole plant was with everything very simple. The engine movements were controlled from the Captain's position above the engine, and some boats at least were fired as well as steered by one man, many having only two crew members. Having had new tubes, the boiler needed further heavy repairs a few years later, and she was scrapped.

48) *Burnley, Burnley Depot , Leeds & Liverpool Canal* SER 553b

Type:	Vertical single crank non-condensing tandem	
Photo taken:	1953	
Maker & Date:	Possibly Canal Co., date unknown	
Cylinders:	5in & 8in x 8in – Slide valves	
Hp: About 20	*Rpm:* 140	*Psi:* 100
Service:	Canal maintenance. Vessel No 57	

No. 57 was one of the canal maintenance vessels, so had more room available for the power plant which, since she was not carrying, needed less speed and power. There were several differences between this and the barge engines, which suggest that this may not have been made by them although the boiler was the same as the barge's. Thus the engine was fitted with a bar type crosshead guide, the valve gear was Hackworth type, and the feed pump was separate, all features at variance with the barge's. She was scrapped together with all the steam plant when diesel engines were generally adopted in the late 1950s, and regrettably none of the steam plants were preserved as a record.

49) Burnley Depot, Burnley. Leeds & Liverpool Canal *SER 553c*

Type:	Single expansion vee twin non-condensing
Photo taken:	1953
Cylinders:	6in x 6in – Slide valves
Service:	Canal maintenance. Pump boat

This was almost the same as the barge engines but simple expansion; economy was less important since it was, as with No. 57, only propelling to the working site. Again there was more room available, and it was controlled from the deck. She was probably a pumping vessel, so also needed a separate feed pump.

50) Fleetwood , S. S. 'Sea Maid' *SER 1433*

Type:	Single cylinder vertical marine non-condensing	
Photo taken:	1971	
Maker & Date:	Maker unknown, date c1880?	
Cylinders:	6in bore x 9in stroke	
*Hp:*30	*Rpm:*120	*Psi:*100
Service:	Collecting cod liver oil from trawlers	
	Hull 1949 by Dunstons, Thorne	

The engine has been fitted into three hulls, and still runs the vessel (1970), and was under the water when one hull sank. The exhaust steam is passed up the chimney, and the feed water to the vertical centre flue boiler is pumped by a single duplex horizontal pump with no other auxiliary feed. The boiler is similar to that of a steam crane. The vessel collects the cod liver oil extracted from the fish caught, which is collected in tanks on the trawlers, and is transferred to 40 gallon drums on the *Sea Maid* by creating a vacuum within the drums by a vacuum pump on deck driven by a diesel engine. There was a steam stand-by set driven from the steam windlass used to lift the 40 gallon drums on to the quay. It is the simplest possible layout, a suction pipe to the trawler tank (liver oil) being connected to the 40 gallon drum, and a connection is made to the vacuum pump. Once the engine is started, the vacuum fills the drum, and the suction pipe is transferred to the 50 or so, 40 gallon drums on the *Sea Maid* in turn. This may involve visiting several trawlers on a tide, and the trips are made daily.

51) Manchester Ship Canal, P. S. 'Rixton' *SER 97*

Type:	Disconnecting side lever grasshopper twin engine	
Photo taken:	1935	
Maker & Date:	Hepple & Co, South Shields, 1905	
Cylinders:	30in x 4ft 6in – Slide valves	
Hp: 66	*Rpm:* 20	*Psi:* 30
Service:	Paddle tug. Ship handling in the canal	
	Hull by J. T. Eltringham. 100ft x 20ft x 10ft deep	

This was one of six similar vessels built about the same time, on the Tyne. All were fitted with single cylinder jet-condensing engines, with a sliding clutch to couple the two engines together in a seaway, as required by Board of Trade regulations. They were late examples of an early type, which continued to be built virtually without alteration from the 1830s to around 1912. The extreme manoeuvrability of independent working was valuable in close docking, the engines being uncoupled by a sliding disc which slid over one of the crankpins. Jet condensing, the use of slide cut-off valves on the back of the main valve chest and slip eccentric reversing were features of the earliest design that remained unaltered. The last examples were those at Seaham scrapped in 1968-69.

52) Manchester, Manchester Docks, Floating Grain Elevators SER 1335

Type:	Vertical marine type compound condensing
Photo taken:	1968
Maker & Date:	Crichton & Co, 1916?
Cylinders:	18in and 30in x 2ft 0in – Piston and slide valves
Hp: 300	*Rpm:* 90 *Psi:* 160
Service:	Pneumatic transfer of grain from vessel to silos by vacuum

There were 7 of these vessels in 1968, all built between 1914 and 1921, six by Crichton and one Dutch. They are not self propelling. They have receiving hoppers at high level into which the grain flows as the vacuum (up to 10in for the highest lift) draws it up the suction piping, and they could move up to 240 tons of grain per hour. There was a double acting vacuum pump at each end of the crankshaft, and the print shows the tops of the cylinders of the driving engine, in the centre, with the vacuum cylinders on either side, i.e. at the end of the crankshaft. Most of these vessels remained although less used in 1973. There was a single two-furnace Scotch boiler in each. A guide was fitted at the top of each vacuum cylinder to keep the piston in line. There were slight differences in the engine designs but the later diesel boats may differ.

53) Manchester, Salford Docks, Floating Heavy Lift Crane SER 1340b

Type:	Compound marine engine
Photo taken:	1968
Maker & Date:	Werf Gusto, Schiedam, 1921
Cylinders:	7³/₄in and 17³/₄in x 1ft 1in – Slide valves
Hp: 76	*Rpm:* 250 *Psi:* 160
Service:	Lifts up to 60 tons by electrically driven cranes
	Hull 115ft x 56ft x 11ft. 619 gross tons

The vessel was twin screw, self propelling, and the engines were also used to drive through clutches, the generators providing the current for the crane motors. She was thus very handy, needing no tug to work her about, although the speed was low, about 4 m.p.h. The engines were condensing, with the auxiliaries in one engine room and the generator in the other, with a single twin furnace Scotch oil fired boiler in a separate room between them. The vessels will probably be retained as long as the loads justify them, but replacement by diesel-engined units must follow later when hull or boiler repairs are heavy.

54) Manchester, Salford Docks, Messrs Cooper & Co,
S S 'Alpha' SER 433

Type:	Two non dead centre quadruple expansion
Photo taken:	1952
Maker & Date:	Fleming & Ferguson, Paisley, 1890
Cylinders:	9in, 12in, 16in & 24in x 1ft x 9¹/₂in
Hp: 96	*Rpm:* 120 *Psi:* 160
Service:	Ex-dredger spoil carrier. Twin screw.
	About 135ft x 30ft x 10¹/₂in. Scrapped 1956

The non-dead centre design comprised coupling two cylinders to each crank through a triangular connecting rod, an arrangement which beside being very compact, also, by applying the cylinder effort at an angle to the crank, avoided the dead centre. The print illustrates the compactness of the design since each of the engines shown has four cylinders, yet occupies less space than many compounds. Musgraves of Bolton also made this type under licence for mill driving (see SER 169, SER 632, SER 713, SER 983)

55) Mersey Docks & Harbour Board, Floating Crane 'Mammoth' SER 1406

Type: Marine triple expansion
Photo taken: 1970
Maker & Date: Plenty & Co, Newbury, 1920
Cylinders: About 10in, 17^1/$_2$in and 28in x 1ft 2in – Piston and slide valve
Hp: 400 *Rpm:* 180 *Psi:* 160
Service: Propelling and generator drives

The hull was 154ft x 88^3/$_4$ft x 12^1/$_2$ft deep, and built by A. P. Smulders of Schiedam in 1920. The Plenty engines were arranged to drive a screw propeller on each side through jaw clutches to the stern, and forward each drove Metropolitan Vickers generators for the crane hoist motors, at 240 volts D.C. The crane could lift 200 tons at 110ft radius at 3^1/$_2$ft per minute with maximum height of 145ft, and 60 tons at 16^1/$_2$ft per minute. The entire crane could turn a complete circle in 10 minutes and the total hull beam of 92ft gave great stability. There were two twin furnace Scotch boilers midships between the two engines. The cost of running was high and she was due for replacement by a diesel-engined vessel in the early 1970s. It was heavily used in the 1960s, except for the survey periods. The ship's service generators were in the port engine room, and the condenser for both engines, with its auxiliaries was in the starboard engine room.

56) Mersey Docks & Harbour Board , Floating Crane 'Titan' SER 1408

Type: Two marine triple expansion
Photo taken: 1970
Maker & Date: Lobnitz and Co, Renfrew, 1952
Cylinders: 10in, 17^1/$_2$in and 28in x 1ft 2in
Hp: 390 each *Rpm:* 183 *Psi:* 160
Service: Floating crane, self propelled. 25 ton lift.
Built by Lobnitz on the Clyde, 1952. Cost £173,000

The propelling engines and generator for the crane motors were all in the single engine room which took the whole beam of the hull. The hull is 144ft long x 42ft beam x 10ft 3in deep. There were two Scotch boilers with the back heads in the engine room. The propelling engine speed was certainly high, i.e. 183 rpm, but they did not drive the current generators for the cranes, which had Sisson compounds sets of 125kW each, running at 500 rpm. The condenser was in the after end of the engine room, the whole making a light and attractive layout, with everything under the engineer's attention from the starting platforms. The total crew is 14 men.

57) Mersey Docks and Harbour Board, Floating Crane 'Birket' SER 1409

Type: Two compound marine
Photo taken: 1970
Maker & Date: Fleming & Ferguson, Paisley, 1942
Cylinders: 17in and 34in x 2ft 0in – Piston and slide valves
Hp: 400 each *Rpm:* 90 *Psi:* 135
Service: Floating crane, self-propelled, 60 ton lift.
Sir Wm Arroll, 1942. Cost £65,000

Birket and *Atlas* are identical, and the only ones with steam driven hoisting machinery in service in 1969. The two boilers and the engine starting platforms are forward of the engines. The hull and crane were built by Sir Wm. Arroll Ltd., and is 180ft x 58ft x 12^1/$_2$ft deep. The engines were made by Fleming and Ferguson and the slow speed was a great contrast to that of *Titan's* 183 rpm. The crane motions were direct steam drive. (See SER

1409a for the steam driven crane hoisting engines). The propelling engines were typical Clyde type with double guides working on both columns, and were very massive. As with the others, steam reversing gear was fitted, and a multiple collar thrust block, and hand turning gear. The engines certainly handle very well, considerable manoeuvring being called for. Here too running cost may determine her life.

58) Mersey Docks and Harbour Board, Floating Crane 'Birket' SER 1409a

Type:	Double cylinder horizontal
Photo taken:	1970
Maker & Date:	Sir Wm Arroll? 1942
Cylinders:	10in x 1ft0in – Slide valves
Hp: 60-70	*Rpm:* 200 *Psi: 135*
Service:	Steam driven hoisting machinery

The hoisting machinery is controlled from the captain's bridge, with rods for all of the controls down to the crane engine room. This is in the rotating part of the crane structure, with steam and exhaust connections made through the central column of the crane, to the engine room and the condenser. One double cylinder engine hoists the load and also handles the luffing motion which controls the angle and reach of the crane jib.

There is a separate similar, but smaller, engine for the rotation of the crane, and the position of the counterbalance weights. All of the motions are controlled by 16 rods from the bridge to the clutches and steam valves in the hoisting engine room. The hoisting cable drum is treble geared from the very powerful hoist engines reducing 40 to 1 at least. The turning and counterbalance engine cylinders are 8in x 10in stroke, and again very effective through the high gear reduction provided. All of the Mersey Docks cranes are very active, and finding where they were working was no easy job. i.e. often in two or three docks in one day.

59) Wigan, Wigan Depot, The Inland Waterways Board SER 707

Type:	Double cylinder, vee twin, non-condensing
Photo taken:	1955
Maker & Date:	Made in Canal Co workshops?, date unknown
Cylinders:	6in x 6in – Slide valves
Hp: ?	*Rpm:* 120 *Psi:* 100
Service:	Canal service vessels - pump boat

This was the type of plant widely used on the Leeds and Liverpool Canal. The engines were deck controlled and hard driven with Field tube vertical boilers, and exhaust steam feed water heaters. The plant was very compact and simple, but the boilers did need much maintenance, since they used canal water for feed. The through barges on the Leeds – Liverpool run, ran non-stop with double crews, and were latterly fitted with twin compound engines (SER 553). All of the steam plant was scrapped in the 1950s and diesel engines installed, but the trade fell off badly afterwards.

LONDON

60) Port of London Authority, S. S. 'Leviathan' SER 577

Type:	Twin screw horizontal compound
Photo taken:	1953
Maker & Date:	Hunter & English, Bow, London, 1885
Cylinders:	9in and 18in x 1ft 6in – Slide valves
Hp:	*Rpm:* 100 *Psi:* 80
Service:	Self propelling floating crane

The engines were horizontal to reduce the deck height and they were manoeuvred from the captain's cabin on deck. These were propelling engines only, but there was a drive by the friction discs (latterly little used and seen in the foreground) to the deck capstans. The surface condenser was circular and vertical, and can be seen behind the small Willans circulating pump engine, near to the other engine. This print is actually the wrong way round; it is of the starboard engine, and shows the two main engines well.

61) Port of London Authority, S. S. 'Leviathan' SER 577a

Type: Engine room
Photo taken: 1953
Maker & Date: As SER 577
Service: As SER 577

This shows the two furnace Scotch return tube boiler, forward of the main propelling engines, and the clutch by which the propelling engines were uncoupled when the capstans were worked without the propellers. The simplicity of the engines and the compactness of the layout was admirable. She was condemned and broken up when well over 70 years old.

62) Port of London Authority, S. S. 'Leviathan' SER 577b

Type: Vertical three cylinder, single acting, Willans type
Photo taken: 1953
Maker & Date: Hunter & English, Bow, London, Willans, No 193, 1885
Cylinders: Sizes unknown
Hp: About 5 *Rpm:* 300 *Psi:* 80
Service: Circulating pump engine

Hunter and English made the Willans engine under licence (following Penns of Greenwich who made the first ones in 1874), until the Willans and Robinson company was founded at Thames Ditton. The type was extremely quiet; the only evidence that this was working was the rotation of the shaft coupling, and it would reverse instantly without a sound, by the cock controlled by the lever at the top. There were no valves, the steam events of one cylinder being controlled by a tubular trunk on the top of another piston. This engine is now preserved in the Birmingham Museum of Industry, and the compactness of the design is confirmed by the height, i.e. about 2 ft above the cast iron bed plate.

63) Port of London Authority, S. S. 'Leviathan' SER 577c

Type: Willans three cylinder single acting
Photo taken: 1953
Maker & Date: Hunter & English, Bow, Willans, No 229
Cylinders: Sizes unknown
Service: Traversing engine

Heavy lift cranes require movable ballast to offset the weight lifted, particularly when the lift is fully athwartships, i.e. working into or out of a vessel's hold. In *Leviathan* the weight was a very large iron tank and pig iron (seen at the right) which was mounted upon rail track, and traversed by the two large square threaded screws in the foreground, which were probably double start to reduce the speed. The traversing engine, again, was controlled from the deck, and instantly reversible by lever and cock as SER 577b. The drive was very simple and direct, just a pair of bevel wheels on the end of the engine cross shafts and the screw spindles.

64) Port of London Authority, Floating Crane, 'Hercules' SER 745a

Type:	Twin cylinder horizontal screw propelling engines
Photo taken:	1955
Maker & Date:	Hunter & English, Bromley-by-Bow, London, 1903
Cylinders:	12in x 1ft 0in – Slide valves
Hp:?	*Rpm:* 120 *Psi: 120*
Service:	Heavy cargo lifts in docks

In contrast to *Leviathan* (SER 577) of 1885, which were compound, the engines of this later vessel were double high pressure type, again surface condensing. The engine room layout was very similar, except that there was no provision for deck capstan drives in *Hercules*, and the auxiliary engines were of modern, not the Willans type. As with Birkenhead, these heavy lift floating cranes were continuously in use, moving from dock to dock through the open river fairway under their own engines, but the London ones were all under deck control, whereas the Mersey vessels were engine room controlled by telegraph.

65) Port of London Authority, Floating Crane 'Hercules' SER 745c

Type:	Twin cylinder horizontal
Photo taken:	1955
Maker & Date:	Hunter & English, Bow, 1903
Cylinders:	10in x 1ft 0in – Slide valves
Service:	Crane driving engines

The hoisting engines were identical to the propelling ones but slightly smaller, and they also drove the crane slewing motion. The main hoisting cable drum was on the left being driven at a reduction of about 80 revolutions of the engine to one of the drum through the worm gear at the extreme edge of the print, and a cone friction clutch. The crane slewing or turning motion was by the double helical bevel wheels at the right, again through cone clutches and under deck control, the only attention needed being engine lubrication and condensed water drainage. She was running in the 1960s.

66) Woolwich, Woolwich Free Ferry SER 419

Type:	4 Paddle vessels double ended
Photo taken:	1951
Maker & Date:	J. S. White & Co, Cowes
Cylinders:	Vessel size 166.4ft x 44.1ft x 6.8ft
Service:	Vehicle and passenger ferry across River Thames

These replaced two similar vessels built by R. & H. Green and engined with similar plant by John Penn, Greenwich, in 1889. *Squires* was the first in 1922, followed by *Gordon* (1923) and completed by *John Benn* and *Will Crooks* in 1930. They were slightly larger than the first two and with slightly higher steam pressure; but the engines were the same size and layout. They were replaced in the mid -1960s by diesel engine vessels with Voith Schneider propellers fore and aft, with seven cylinder engines which are very noisy. These were very expensive vessels, but the service has to be maintained, and fuel (coke) and labour made the steam vessels too costly to run.

67) *Woolwich, Woolwich Free Ferry* SER 419a

Type:	Double diagonal simple expansion condensing
Photo taken:	1951
Maker & Date:	J. S. White & Co, Cowes
Cylinders:	33in x 2ft 9in – Slide valves
Hp: ?	*Rpm:* 28-30 *Psi:* 30
Service:	Paddle engines

These engines were similar to those made by John Penn & Co for the ferries built in the 1880s, i.e. a double diagonal engine to each paddle driving independently, and in the charge of two engineers. The engines were completely independent with their own condensing system, but whereas the Penn sets had the pumps driven off the main engine the later ones had independent pumps. This was an advantage in that the vacuum was constantly maintained, whereas with the engine driven pumps there was often little vacuum until the crossing was completed. Each vessel had 2 gunboat boilers with twin furnaces, one fore and one aft of the engines, coke fired.

MIDDLESEX

68) *Staines, Taylor's Yard* SER 746c

Type:	Twin tandem compound marine condensing
Photo taken:	1955
Maker & Date:	Simpson & Denison, Dartmouth, c1885?
Cylinders:	2in and 6in x 4in – Slide valves
Hp: 10	*Rpm:* 500 *Psi:* 150
Service:	Screw propulsion. Launch up to 30ft long

Typical Simpson design with the main engine frame a single bronze casting with the bedplate, with double slipper guides, straight link reversing motion, and the air and boiler feed pumps driven from the engine crossheads. The steam vents for the high and low pressure cylinders were controlled by a single long slide valve of the Kingdon patent design which was used by Simpson Strickland for some 150 engines over 30 years. This, long disused, was later purchased by Mr. W. Lowe and fitted into his vessel *Lady Sophina*, propelling the 30 ft. vessel up to 10 m.p.h. It was in service in 1973.

Editorial note: The Steam Engine record lists an entry No 745a for this site, but the card has not been found. The heading notes that it was a twin cylinder marine engine, non-condensing. Details may be found in the field notebooks at Swindon.

NORFOLK

69) *Yarmouth, Paddle Tug 'United Services'* SER 70

Type:	Grasshopper side lever
Photo taken:	1936
Maker & Date:	T. R, M. & J. Scott, North Shields, No 149, 1872
Cylinders:	35in x 4ft 9in – Piston valves
	Beams 11ft 0in long
Hp: 30?	*Rpm:* 30 *Psi:* 40
Service:	Propulsion

Typical Tyneside design, with the fine forged hand levers for manual valve handling. Jet condensing, it ran on salt or harbour water when towing sailing fishing vessels and was broken up in 1939.

NORTHAMPTONSHIRE

70) Aynho, Steam Launch 'Emma' SER 1475

Type:	Compound engine and water tube boiler
Photo taken:	1974
Maker & Date:	T. A. Savery engine – custom built
Cylinders:	3in and 6in x 3$^{1}/_{2}$in – Piston valves
Hp: 20	*Rpm:* 800 *Psi:* 150
Service:	Pleasure boat

The engine is Savery compound with piston valves driven by Joys valve gear. Saverys were the best built engines for the steam launch sizes, with all steel valve gear, ground and hardened throughout. The boat was to run later upon the River Ribble, near Preston. She made up to 10mph, with a propeller 18ins diam., and 30ins., pitch.

NORTHUMBERLAND

71) Newcastle Museum of Science & Engineering SER 1035a

Type:	Triple expansion non-condensing marine
Photo taken:	1960
Maker & Date:	W. Sisson & Co., Gloucester, No 431
Cylinders:	About 3in, 4$^{1}/_{2}$in and 6in x 5in – Slide valves
Hp:25	*Rpm:*400 *Psi:* 160
Service:	Exhibit

William Sisson was a clever engineer, who, following training in the North, took over the Gloucester business of Belliss & Seeking in 1888. He patented many inventions, among which was the radial valve gear seen on the engine in the print. Patented in 1896, the valve events were effected entirely by linkages from the top of the connecting rod. Sisson's designs were extremely fine, very light and strong, with the metal scientifically placed yet with ample bearing surfaces, and with the propeller shaft thrust block usually fitted, as in this case, in the after main bearing. The later engines were designed with piston valves throughout, but this one shows the wide ports and ample area which Mr. Sisson provided to give the free running at high speed for which his engines were famed. Designed for running short river trips, the engines were fitted only with oil holes for the bearings, since they were oiled at every lock stop. In design and construction they were craftsmanship of the highest order, and their engines were virtually standard for the English river trip boats, and they also did a large export business. The firm closed after some 80 years, latterly making large numbers of high speed engines for all purposes, as well as many experimental engines for colleges all over the world.

72) Newcastle Museum of Science & Engineering SER 1035b

Type:	Double high pressure marine
Photo taken:	1960
Maker & Date:	Maker unknown, c1890s
Cylinders:	About 5in x 5in – Slide valves
Hp: 15	*Rpm:* 300 *Psi:* 100
Service:	Exhibit

Another very well designed and made engine, of a type used for shipyard work boats which ferried the men to the vessels around the yard, but were well adapted for any small vessel or steam launch. The increased fuel consumption due to twin high pressure cylinders was not a serious matter where usage was incidental, and the complete absence of pumps suggests that it was a river boat engine, with the boiler fed with injectors. In contrast to

SER 1035a, this is fitted with the usual Stephenson's link motion which like the rest of the engine has ample bearing area, giving long life with little attention. These two engines illustrate the best small high speed marine engine designing of contrasting schools of thought.

73) *Newcastle Museum of Science & Engineering* SER 1460a

Type:	S. S. *Turbinia* steam turbine drive
Photo taken:	1973
Maker & Date:	Parsons & Co, Newcastle-upon-Tyne, 1894
Hp: 2000	*Rpm:* 1750 *Psi:* 210-150
Service:	Exhibit

Turbinia was the first turbine propelled steamer and is now preserved intact. She was fitted with three propellers – driven by a high-intermediate and low pressure turbine, and a reversing turbine on the centre shaft as well. She is in an air-conditioned room, and the machinery can be seen through the glass case through apertures where hull plates have been removed to show the layout of boiler and turbines. Steam control was from a house on the main deck – there was no room below, and at full speed, the two stokers, one each end of the double ended Yarrow water tube boiler, would have accurately to feed over $1^1/_4$ tons of coal each into the furnaces hourly.

74) *Newcastle Museum of Science & Engineering* SER 1460c

Type:	Triple expansion passenger boat engine
Photo taken:	1973
Maker & Date:	Sisson & Co, Gloucester, No 431, c1890
Cylinders:	About 3in, $4^1/_2$in and 6in x 5in – Slide valves
*Hp:*about 25	*Rpm:* 350 *Psi:* 160
Service:	Steam boat propulsion

A typical early example of Sisson's craftsmanship, this could be 1889 or 1890 (No. 501 was 1896), before the use of piston valves was standardised. Sisson's own patent radial valve gear, which requires no eccentrics, allows the whole length of the bed except the crank webs, to be used for the 4 main bearings, and the whole is typical of the design craftsmanship of the founder William Sisson. This is probably the last remaining Sisson of such a small size, or equipped with slide, rather than piston valves – it was a fresh water marine engine – so non-condensing. (same as SER 1035a)

75) *Newcastle upon Tyne, Paddle Tug 'Houghton'* SER 1083

Type:	Grasshopper side lever jet condensing twin
Photo taken:	1962
Maker & Date:	Hepple & Co, South Shields, 1906
Cylinders:	28in x 4ft 0in – Slide valves
Hp: ?	*Rpm:* 30 *Psi:* 40
Service:	General towing service

These were almost the latest sets of the type, which were used on the Tyne for well over a century, many of them built by Rennoldsons or Hepples at Shields. They were probably the last vessels to work with salt water jet condensers, and worked on the Tyne and round to Sunderland so using muddy fresh as well as salt water for the boilers. The boilers were the last of the flue type, i.e. with flues (not the usual return tube Scotch type), in use and they were necessary owing to the mud and salt in the feed water, and were accessible for scaling, and simple to repair. The last of these were made by Rileys at Stockton-on-Tees in 1947, for one of these vessels. There were two oval shaped furnaces joined at the back to a cross combustion chamber, from which a flue returned forward to the funnel uptake, which came from the side of the shell. Electric lighting was fitted, with a Stuart Turner enclosed engine seen near the top of the print.

73

TURBINIA

S.Y. "TURBINIA"

FIRST VESSEL TO BE DRIVEN
BY STEAM TURBINE.
DESIGNED IN 1894 BY
SIR CHARLES PARS[...]

76) Newcastle upon Tyne, Messrs France, Fenwick, P S 'Eppleton Hall' SER 1297

Type:	Double cylinder jet condensing grasshopper
Photo taken:	1967
Maker & Date:	Hepple & Co, South Shields, No 632
Cylinders:	30in x 4ft 3in – Slide valves
Hp: ?	*Rpm:* 18-20 *Psi:* 30
Service:	General ship towage. 100.5ft x 21.1ft x 10.8ft.

The Tyne tugs with their flue boilers fed with salt water from the jet condensers, and disconnecting side lever grasshopper engines were almost certainly the last of the type in service. They worked in salt or fresh water, from Newcastle to Sunderland or lower down the coast, the condensers being chambers below the cylinders. The engines were fitted with clutches to allow independent working, but had to be coupled when at sea. The boilers were unique survivors of the earliest steamboat days, with two semi-oval furnaces at one side connected at the back to a cross flue from which a flue returned toward the front, to emerge at the side to the funnel; there were usually two boilers side by side. *Eppleton's* boilers only were replaced by Rileys of Stockton-on-Tees in 1946, and were the last to be made as the dying race of old platers could work the intricate plating. Reversing the engines was by hand, with slip eccentrics to release the valves. *Eppleton Hall* is now preserved in California, having been almost certainly the last vessel in the world to make a 10,000 mile trip on salt water feed.

77) Newcastle upon Tyne, Paddle Tug 'President' SER 514a

Type:	Side lever grasshopper twin jet condensing
Photo taken:	1952
Maker & Date:	J. Readhead, South Shields, 1876
Cylinders:	30in x 4ft 4in – Slide valves
Hp: ?	*Rpm:* 16-18 *Psi:* 35
Service:	General towing. Hull 100ft x 20ft x 10ft.
	Made by France, Fenwick & Co, Newcastle-upon-Tyne

These were an archaic type, probably the last surviving salt water jet condensing engines in service and there were 8 or 9 on the Tyne in 1948, the last of which were disused by 1970. *Eppleton Hall*, however, a similar vessel was steamed to San Francisco in the 1960s and preserved there. The cylinders stood upon the jet condensers, and the sea water injection cock can be seen in the lower left hand corner, and to the right is the cross lever by which the connecting rod drove to the crankshaft. The engines had remained unaltered but the original Tyne flue boilers were replaced by Scotch return tube ones, some years before.

78) Newcastle upon Tyne, Paddle Tug 'Lumley' SER 514b

Type:	Tyne flue boiler
Photo taken:	1952
Maker & Date:	Hepple & Co., South Shields, 1907
Cylinders:	8ft 9in diameter x 11ft 0in long
Service:	Towing. Hull 96ft x 20ft x 10ft

The Tyne flue boiler was well adapted to working in fresh or salt water with jet condensing. They were the most primitive type to remain in use, comprising a circular shell with two oval furnace flues which met at the back in a cross combustion chamber, the gases then returning by another oval flue, and passing to the funnel out of the side of the shell. The platework was very complex and Rileys of Stockton made the last of the type as late as 1948. France, Fenwick's fleet is now all diesel engined and screw propelled.

OXFORDSHIRE

79) Oxford, Salter's Steamboats SER 658b

Type:	Marine vertical triple expansion
Photo taken:	1954
Maker & Date:	W. Sisson & Co, Gloucester
Cylinders:	6^1/$_4$in, 8^1/$_4$in and 10^1/$_4$in x 7in – Piston valves
Hp: 80	*Rpm:* 360 *Psi:* 160
Service:	Passenger service. Non-condensing.

Salters used Sissons triple expansion engines as a standard, which were always run non-condensing, to avoid cylinder oil in the boilers. Pumps were not fitted to these engines, the boilers being fed by a separate steam pump or injector. This was probably the engine from S .S *Sonning*, built about 1903, and converted to diesel drive about 1956. This was Sissons own patent valve gear, without eccentrics, and with the motion taken from the connecting rod top end jaw. They used this until the early 1900s.

80) Oxford, Salter's Steamboats, SER 658c

Type:	Marine vertical triple expansion
Photo taken:	1954
Maker & Date:	W. Sisson & Co., Gloucester
Cylinders:	6^1/$_4$in, 8^1/$_4$in and 11in x 7in – Piston valves
Hp: 80	*Rpm:* 360 *Psi:* 160
Service:	Passenger service

This is the design that followed that of SER 658b, and was fitted with Hackworth's valve gear with single eccentric, and a slipper block sliding in a guide on the reversing gear weigh shaft. The eccentric rod and half eccentric strap were a single bronze casting. Sissons were the finest commercial river boat engines in general production, very light and free running without vibration or noise. Many were said to have been sold for other use; it is doubtful if any were scrapped.

81) Oxford, Salter's Steamboats, S. S. 'Grand Duchess' SER 658d1

Type:	Marine vertical compound condensing
Photo taken:	1954
Maker & Date:	J. S. White & Co., Cowes, date unknown
Cylinders:	11in and 19in x 1ft 6in approx. – Piston and slide valves
Hp: 130	*Rpm:* 250 *Psi:* 160
Service:	Passenger service

This was the only condensing engine in the fleet of a dozen or so steamers in the 1950s, the boat having been bought second-hand, and retained unaltered. She was in regular service for some years, but the engine was greatly in contrast to the Sissons, and more like a tugboat engine.

82) Oxford, Salter's Steamboats, S. S. 'Grand Duchess' SER 658d2

Type:	Engine room view with boiler
Photo taken:	1954
Maker & Date:	
Cylinders:	
Hp:	*Rpm:* *Psi:*
Service:	

The boiler was by Abbott and Co., Newark, who regularly made the boilers for the fleet. The boilers did not vary greatly in design or size. (See SER 797)

83) Oxford, Salter's Steamboats SER 797

Type:	Marine triple expansion non condensing
Photo taken:	1956
Maker & Date:	W. Sisson & Co, Gloucester, 1896
Cylinders:	$6^{1}/_{2}$in, 8in and $10^{1}/_{2}$in x 7in – Piston valves
Hp: 80	*Rpm:* 350 *Psi:* 180
Service:	Passenger boat propulsion

This was typical of the earlier engines with Sisson's own valve gear, and retaining the mahogany lagging of the cylinders. The splash plates were removed to take the photograph which indicates the conditions maintained by a good conscientious engineer such as Wm. Arnold of Warwick, who was then running Henley, and spent many seasons with Salters. The ringed effect was achieved by polishing with fine emery cloth, each ring being made by rotating the emery cloth in opposite directions, one right handed and the next left handed. All steam was replaced by diesel engines by 1968.

84) Oxford, Salter's Steamboats SER 797d

Type:	Single furnace Scotch return tube boiler
Photo taken:	1956
Maker & Date:	
Cylinders:	4ft 9in diameter x 5ft 6in long
Hp:	*Rpm:* *Psi:*
Service:	Boiler from *Streatley*

The boilers were very similar, with single furnace 2ft 3in diameter and about 68 tubes returning to the smoke-box at the front, and the funnel. The engines were non-condensing, probably to avoid trouble with cylinder oil in the boilers, but it was the cost of replacing boilers (together with the difficulty of getting good men to handle them) which led to the diesel installations in the 1960s. A boiler replacement then cost over £1,000 with a life of some 7-8 years only. This boiler was sold later and photographed in the workshops.

85) Oxford, Salter's Steamboats, S. S. 'Cliveden' SER 797e

Type:
Photo taken: 1956
Maker & Date:
Service: Passenger trip service

Cliveden was probably the last steamer to be built for Thames passenger service, in 1931, possibly by Salters themselves. She was still in service in 1973 but was converted to diesel drive in the mid-1960s. Typical of the Thames service boats at their best in many ways, she was about 120ft long.

PEMBROKESHIRE

86) Pembroke, Neyland Vehicle & Passenger Ferry SER 1011a

Type: Paddle vessel
Photo taken: 1959
Maker & Date: Abdela, Mitchell & Co, Queensferry, 1923
Cylinders: About 15in and 30in x 3ft 6in
Hp: 115 *Rpm:* 30 *Psi:* 140
Service: Passage across the River Cleddau Estuary

The ferry greatly shortens the distance between the west coast and Pembroke, passing across the point where the River Cleddau estuary widens out into Pembroke Dock. The land journey around the top is many miles. *Alumchine* was 80ft x 17$\frac{1}{2}$ft x 31ft wide over paddles and carried 200 passengers and 5 motor vehicles. She had a single boiler, and a diagonal compound engine which was directly connected to both paddles. She was replaced in the 1950s by *Cleddau Queen*, to cope with the greatly increased traffic and *Queen* was herself replaced some 10 years later by a diesel engine screw vessel. As *Alumchine* was standby to *Queen*, so now is *Queen* the relief vessel to the new one, which has much greater carrying capacity, needed since this once remote area is now degenerating into development

PERTHSHIRE

87) Loch Katrine, S. S. 'Sir Walter Scott' SER 1261

Type: Jet condensing triple expansion marine
Photo taken: 1966
Maker & Date: Matthew Paul, Dumbarton, 1904
Cylinders: About 9in, 13in and 19in x 1ft 0in – Piston and slide valves
Hp: 120 *Rpm:* 180 *Psi:* 160
Service: Passenger service. Screw propeller. 400 passengers

These engines are the last jet condensing screw engines in the United Kingdom, having been in continuous use for 70 years, taking trippers around the loch. The load between the cylinders is very well balanced, with steam chest pressures of 145,30 and 3 psi. They work very quietly, and are interesting in that the water injection has to be altered every time the steam is varied. The boilers, which have always been horizontal through tube type, now with circular, but at one time with pinnace type half round fireboxes, have been replaced three times, in some 70 years work. The boilers are 6ft diameter x 8ft long with 70 tubes in each, the last two made by Marshall and Anderson, Glasgow. She has always been popular with passengers and the loch scenery is very fine. Capacity trips are frequent in good weather.

88) Loch Katrine, S. S. 'Sir Walter Scott' SER 1261a

Type:	Passenger trip service
Photo taken:	1966
Maker & Date:	Wm Denny & Co, Dumbarton, 1904. No 623
Service:	Passenger trip vessel. 110.6ft x 19.1ft x 8.9ft

Running on the loch, which is a water reservoir for Glasgow, she has given 70 years of fine service, carrying 400 passengers fully loaded, and in good weather capacity passenger numbers are often carried, despite the motor car. The lake scenery is very fine indeed, and the quietude and smoothness of the run is greatly valued. Good saloon facilities are available aboard for the two hour trip, which is made several times daily in the summer. With rising costs and wet summers, continuation of running is often in doubt and her age tells, but on the pure water her hull may have survived well. She is the property of Glasgow civic water undertaking and very well maintained.

RENFREWSHIRE

89) Erskine, Nr Paisley, The Erskine Ferry SER 1274

Type:	Vertical compound marine condensing
Photo taken:	1966
Maker & Date:	Fleming & Ferguson, Paisley, 1935 (Hull and engine)
Cylinders:	10in and 20in x 1ft 4in – Slide valves
Hp: ?	*Rpm:* 140 *Psi:* 100
Service:	Vehicle and passengers. Chain on river bed.
	Was 83^1/$_2$ft x 48ft later 83^1/$_2$ft x 61ft.

This was the lowest crossing on the river (i.e. the farthest west) to operate with a chain, and was replaced by the Erskine Bridge about 1970, when the ferry was scrapped. There was a single chain at each side, of 1^1/$_4$in round metal with links 7^1/$_2$in long. The vessel was propelled along the chains as it passed over the chain barrels, which were about 8 ft diameter. The two were on a single cross shaft which was driven by worm gear from the engine which was a light marine type, handled from the navigator's bridge. It was surface condensing, with the condenser in line fore and aft with the engine. The drive was by a small diameter worm gear to a shaft across the vessel, which then drove the main chain wheels by a further spur reduction gear, with a total reduction ratio about 16 to 1. There was a Cochran vertical boiler at each end of the engine room, which was on one side of the vessel, with the drive shaft to the chain wheel on the other side passing under the vehicle deck. The boilers were oil fired, only one being in use at a time.

SOMERSET

90) Bristol, Steam Launch 'Eythorne' SER 1326

Type:	Double tandem quadruple expansion condensing
Photo taken:	1968
Maker & Date:	Simpson, Strickland & Co., Dartmouth, 1891
Cylinders:	1^3/$_4$in, 2^3/$_4$in, 4in and 6in x 3^1/$_2$in
Hp: 7	*Rpm: 500* *Psi:* 175
Service:	Screw propelling engine

This was the first design that followed the twin tandem engines made under G. Kingdon's patent of 1879, of which there were many single and double crank tandems constructed. This particular engine has proved very economical, although, with the low steam pressure of 120 psi (the working pressure of the only boiler available at the refit) and the full lines of the hull, the speed was disappointing at 5 m.p.h.. It is seen as it was removed at the first re-fit at Hill's Yard, Bristol in 1968. It is now fitted in the traditional hull of S L *Vixen* which

will be based on the River Thames from 1973. There are only some 8 or 10 of these
quadruples of this and the later design for 250 psi known to exist in 1973.
Note: This entry strictly should be under Bristol – page 24

91) Bridgwater, Bridgwater Dock, The Scraper Dredger SER 1116

Type:	Hull with diagonal engine
Photo taken:	1962
Maker & Date:	Lunell & Co, Bristol, c1844?
Cylinders:	14in x 3ft 0in – Slide valve
Service:	Mud scraper to clear channel. Chain haulage. Hull 50ft x 13ft 3in

The vessel was similar to BD 6 at Bristol Docks and almost certainly designed by Brunel for a similar purpose, i.e. to scrape mud from the bottom to a point where it could be dredged or scoured out. The engine flywheel can be seen and the barrel for the chain which pulled the hull for the dredging run. The scraper blade was attached to a massive spud seen at the rear, which had separate depthing gear. It was geared down 3 to 1 from the engine.

SUFFOLK

92) Lowestoft, Fishing Vessel 'Pecheur, LT228' SER 523

Type:	Two crank semi tandem triple expansion	
Photo taken:	1952	
Maker & Date:	Elliott & Garrood, Beccles, Suffolk, Date unknown	
Cylinders:	9^1/$_2$in, 15in and 26in x 1ft 2in	
	Piston valves for H. P. and I.P. and slide valve L. P.	
Hp: 230	*Rpm:* 145	*Psi:* 150
Service:	North Sea fishing. Screw propeller. 9 knots.	

This was a compact design taking the same space as a compound, but giving the economy of triple expansion. A balance wheel 2 ft 6 in diameter was fitted between the two cranks. The engine was said to run very steadily and she used about 14-16 tons of coal per week, and ran about 7,000 miles in the 4 months season. The condenser pumps were driven by a large separate eccentric from the crankshaft, and since the cranks were at 180 degrees one set of link motion served for all of the valves. The vessel was probably in service until the early 1960s, but was replaced by the diesel drifters soon after. She was certainly running out of Shields in 1951. [It is not known if this was North Shields or South Shields. Ed]

WARWICKSHIRE

93) Birmingham, W. Melville SER 1474

Type:	Quadruple expansion launch engine	
Photo taken:	1974	
Maker & Date:	Simpson, Strickland & Co, Dartmouth, c1900	
Cylinders:	2in, 2^3/$_4$in, 3^3/$_4$in and 5in x 3in – Slide valves	
Hp: 7	*Rpm:* 600	*Psi:* 250
Service:	Launch propulsion	

This shows design details whilst the engine was being overhauled. It is Kingdon's patent type in which the tandem cylinders are fitted with a single slide valve that controls the steam events for the two cylinders. The high and first intermediate cylinders drove one crank and can be seen at the rear right (upside down), showing the valve chest and ports, with the air pump bucket and rod in front. At the back are the bronze main frame, and bedplate with integral thrust block collars machined from the solid bed. In front are the low pressure piston, feed pump, and combined slide valve for the other cylinders. Although simple the design needed very skilled workmanship and expertise to produce.

94) Solihull, L. V. Nelson, Steamboat 'Brindley' SER 1470a

Type:	Twin cylinder engine and Merryweather boiler
Photo taken:	1974
Maker & Date:	Gabriel Davis, Abingdon, 1890s
Cylinders:	3in x 3^1/$_2$in – Slide valves
Hp: 7-8	*Rpm:* 350 *Psi:* 100
Service:	Propelled steam boat. 24ft long

The steel canal type hull was built in the 1960s, and the plant fitted by the owner in 1970-71. The engine is well finished and a good example of the fine steam launch engineering which was done at the time all along the Thames. It is light and powerful with turned steel columns and fine mahogany insulation covering, which was replaced by the owner, the original having rotted away. The hull was on shore when photographed in 1974.

95) Solihull, L. V. Nelson, Steamboat, 'Catherine de Barnes' SER 1470b

Type:	Water tube boiler and single cylinder condensing
Photo taken:	1974
Maker & Date:	Boiler made 1960s, engine nothing known
Cylinders:	3^1/$_2$in x 3^1/$_2$in – Slide valve
Hp: About 4	*Rpm:* 300 *Psi:* 100
Service:	Propelled steam boat

The boiler is the Illingworth-pattern radial water tube type, with a very efficient hose type oil burner under automatic control. The wooden hull is a traditional fantail type, some 50 years old and in very good condition. The oil burner was fitted by the owner, an accomplished engineer, and works entirely without supervision with a pressure variation of 2-3 psi on the boiler.

96) Solihull, L. V. Nelson, Steamboat 'Catherine de Barnes' SER 1470c

Type:	The engine
Photo taken:	1974
Maker & Date:	
Service:	

This is a close-up to show the Hackworth type valve gear which provides for variable steam cut-off and reversing. The design is very unusual, in that it has a single column with the valve gear on one side, and the crank on the other. The crosshead guides are thus at the side instead of the centre of the column; also the crank is a single turned disc. Although so uncommon this does seem to have been the original layout. Wear is evident in the valve gear, but even so the engine runs very well. A keel type condenser is fitted to the underside of the hull, with twin diaphragm air pumps driven from the propeller shaft. The boiler feed pump is driven from the crankshaft.

WORCESTERSHIRE

97) *Worcester, Passenger Boat* SER 894a

Type: Compound non-condensing
Photo taken: 1958
Maker & Date: W. Sisson & Co, Gloucester, date unknown
Cylinders: Sizes unknown but about 7in and 10in x 8in – Slide valves
Hp: About 45 *Rpm:* 300 *Psi:* 120
Service: River tripper.

This was Sisson's heavy commercial design, with cast iron framing, with full columns for the front, and with the rear ones terminating above the reversing weigh shaft, and supported by turned steel columns from that point down. Marshalls valve gear was fitted with flat slide valves, with double column guides for the crosshead. Counterbalance weights again were fitted to the crank webs, but in contrast to the triple expansion engines, the valves were at the end of the engine, not at the sides as with SER 894.

YORKSHIRE

98) *Hull, Paddle Ferry, 'Lincoln Castle'* SER 889

Type: Diagonal Triple expansion
Photo taken: 1957
Maker & Date: Ailsa Shipbuilding Co, Troon, 1940
Cylinders: 16$\frac{1}{2}$in, 26in and 41in x 4ft 6in – Piston and slide valves
Hp: About 600 *Rpm:* 45 *Psi:* 180
Service: Vehicle ferry service across River Humber from Hull to Barton
 Hull built by A. & J. Inglis. 199.7ft x 33.1ft x 8.8ft.

Three vessels maintained the service, two in use and one on standby or overhaul, carrying passengers and vehicles across the Humber. A single Scotch return tube boiler was fitted to each, forward of the engines, and fitted with forced draught. The trip took about 30 minutes and saved much mileage on the journey from Hull to Grimsby, and these were probably the last steam paddle vehicular ferries operating in the United Kingdom, as they were in use in 1972, and will probably remain so until the Humber bridge is constructed.

PART 2:

- SITES MISSING FROM THE SERIES

- NEW CONTENTS TO VOL. 1

- WHERE ARE THEY NOW?

- STATIONARY STEAM ENGINES OF GREAT BRITAIN
 VOLUMES 1 - 9, COMMENTS AND CORRECTIONS

- VOLUME 2. NEW NOTES ON THE ENGINES AT DARLINGTON
 WATERWORKS.

- COMMENTS ON DRAINAGE ENGINES BY K. S. G. HINDE

- *TRACTION ENGINES AND OTHER PORTABLE ENGINES* ERRATA

- VOLUMES 1 - 10 MAKERS INDEX

INTRODUCTION
by A. P. Woolrich

This part of the book brings together:

20 Sites missing from the series
The serial way the series was produced meant that some sites were missed when the selections were first made. This was mainly because of the way the original headings were written by George. These were transferred to the initial computer listing, and so were recorded in an incorrect geographical sequence, which was not picked up until after the first volume had appeared.

Revised list of headings for Vol 1, by Colin Bowden
The headings of Volume 1 were printed as they were written by George. This revised list places them in the correct alphabetical order, and accords with the standard of the rest of the series.

Where are they now? By Chris Allen and ISSES
The section reproduces the serial as originally printed by ISSES, with the minimum of editing. It notes the present locations of around 25% of the relics George photographed. This is quite an extraordinary number, and maybe even more will be found!

Full list of corrections mostly by Colin Bowden but with help from others
Colin has made a systematic list of corrections and comments. More readers mostly noted wrongly-printed photographs, or minor spelling or layout mistakes. Several readers sent notes which duplicate information covered by Colin and Chris, so these notes are not included here.

Revison of the entries for the Darlington Water Works, Coniscliffe Road PS in Vol 2
This has been provided by J. F. Prentice who has worked on their preservation and restoration since 1978.

Comments on East Anglian drainage engines by K. S. G. Hinde

Traction engines and other portable engines – Errata
Reproduced by kind permission of the Road Locomotive Society.

Acknowledgements – additional to those at the back of the books.
Colin Bowden has been of enormous editorial help throughout the production of this series. Without his efforts it would not be of the quality it is now. Lindsey Porter (publisher) and James Allsopp (designer) have worked tirelessly to design the books and see them through the press. My wife Jane has proof read all of them. But the errors are my responsibility. There has been a fine response from the world of Stationary Steam. It would be invidious to attempt to list everyone, but all the help the project has received has been greatly appreciated.

SITES MISSING FROM THE SERIES

DORSET: Vol 7

1) Gillingham, The Gillingham Pottery, Brick & Tile Co. SER 1380

Type:	Horizontal single cylinder condensing
Photo taken:	1969
Maker & Date:	E. S. Hindley, Bourton, Dorset, 1870 - 80
Cylinders:	$19^{1}/_{2}$in x 3ft 0in – Slide valve
Hp: About 120	*Rpm:* 90 *Psi:* 120
Service:	Plant drive, by spur gears.

The works were started in 1865, but the engine and plant were probably installed later after the business developed. The engine and the one remaining of the two boilers had E. S. Hindley-Engineer-Bourton, on them. The engine bed is a single casting 16ft 6in long. The condenser was probably added later and at one time, all of the plant, the crushing rolls, clay working and brick moulding machines, as well as the haulage for the clay from the pit were driven from the one engine. The works were extensive, and the engine was certainly greatly overloaded unless the various machines were put to work in careful sequence. This may well account for the many alterations evident in the drives and plant, as there were once shafts passing under the road. The works were closed about 1968, and the stock gradually sold off, but the engine and one boiler remained in 1970, and it was hoped to preserve the engine. One interesting feature was that the inserted wooden teeth in the main gear on the engine were simply driven into the mortise slots, i.e. there were no pins in the tail of the teeth to keep them in place.

HAMPSHIRE: Vol 7

2) Havant, Portsmouth Waterworks SER 10a

Type:	Grasshopper beam
Photo taken:	1934
Maker & Date:	Easton & Anderson, c1860
Cylinders:	12 in x 1ft 4in stroke – Slide valve
Hp:	*Rpm:* *Psi:*
	Beam 4ft 0in long. Flywheel 4ft 9in diameter
Service:	Was town supply from well. Probably three throw pumps, similar to SER 8b

Typical middle period Easton's design preserved after the Farlington supply was abandoned when the well became contaminated. The date could not be traced, but the 'A' frame for the parallel motion radius rod pins suggests post-1860 as a date, and the 'V' section of the eccentric strap is pre-1871.

LANCASHIRE: Vols 3:1 (A-L) and 3:2 (L-W)

3) Accrington, Messrs Chambers & Co, Cotton Manufacturers SER 981

Type:	Horizontal cross compound
Photo taken:	1959
Maker & Date:	W. & J. Yates, Blackburn, 1877
Cylinders:	15in and 30in x 4ft 0in – Corliss and slide valve
Hp: 260	*Rpm:* 48 *Psi:* 130
Service:	Cotton weaving. Gear drive. No 1 shed.

This was a typical Yates engine which, built with slide valves, was fitted with a new Corliss valve high pressure cylinder and the low pressure one re-bored about 1914. It remained otherwise unaltered except that a new governor was fitted with the new high

pressure cylinder. The drive was by teeth on the flywheel rim, which was very quiet. The engine speed was reduced to 42 rpm in 1925 when, with bad trade each weaver attended eight instead of four or six looms. No. 2. shed engine was also by Yates – 1883, which retained the slide valves until the mills were closed in 1960. The Company restarted at Church and ran for at least ten years there, but all of the Accrington plant was scrapped on the closure. (See SER 1145 for the engine at Church).

4) Ashton-under-Lyne, The Tudor Mill Co, SER 1135

Type:	Inverted vertical triple expansion
Photo taken:	1963
Maker & Date:	George Saxon, Manchester, 1903
Cylinders:	22^1/$_2$in, 34in and 56in x 4ft 0in – Corliss valves
Hp: 1400	*Rpm:* 75 *Psi:* 160
Service:	Cotton spinning. 40 rope drive off flywheel about 22ft diameter

Tudor engine, although always busy, remained as built until motor driven ring frames took over the entire spinning load in the 1960s. It was a typical Saxon triple of the later period, and gave very little trouble. An interesting feature was that the cylinder lagging in later years at least, had no metal casing. It was a sound engine which ran the mill with virtually no stops, until, when the change to electrically driven frames was completed, it was scrapped about 1965. Tudor then ran for some years until the mill was completely destroyed by fire in 1970, the walls partly collapsed, and the remainder was a dangerous demolition job to clear.

5) Ashton-under-Lyne, Stamford Commercial Weaving Co, Carrs Mill SER 838

Type:	Horizontal cross compound condensing
Photo taken:	1956
Maker & Date:	George Saxon, Manchester, 1886
Cylinders:	26in, 54in x 6ft 0in – Corliss and slide valves
Hp: 600	*Rpm:* 42 *Psi:* 160
Service :	Cotton weaving. Gear drive

This was a large engine for the load which at one time was 1,350 looms. It was christened *Ella* and *Blanche* after the daughters of Mr. Rowley the founder of the business, which was called Carr's Mills originally, and was always in good engineers' hands. The Corliss high pressure cylinder was probably fitted in the early 1900s, with new boilers giving high economy to equal the new sheds then rapidly being built. The slide valves and the drive by gearing off the flywheel arms were Saxon's features of the 1880s. After a successful life the mill was closed in the re-organisation of the trade, and all scrapped about 1960.

6) Atherton, Brackley Colliery SER 932

Type:	Horizontal double cylinder
Photo taken:	1958
Maker & Date:	J. Musgrave and Sons, Bolton, 1870
Cylinders:	36in x 6ft 0in – Drop valves
Hp: 800	*Rpm:* 40 *Psi:* 100
Service:	No 1 shaft winder

This was virtually as built when the colliery was closed around 1960, the only alteration being the addition of safety slow banking, and heavier brake gear. The drop valves were placed in the corners of the cylinders; there was no automatic cut-off near, with Allan link motion. One alteration was a steel plate drum to replace the original cast iron armed one. There were eight boilers at the colliery, five usually in steam to run the two winding engines, and one of the two air compressors. All was scrapped when the pit closed. The air compressors were made, one by Walkers and the other by Yates & Thom.

5

7) Atherton, Chanters Colliery SER 1192a

Type: Double cylinder horizontal
Photo taken: 1965
Maker & Date: Greenhalgh & Co, Atherton, 1896
Cylinders: 28in x 5ft 0in – Cornish valves
Hp: ? *Rpm:* 25 for man winding *Psi:* 100
Service: Coal winding. Shaft 490 yards. Men-winding only from 1968.

The colliery was sunk in the 1890s, and produced 1,800 tons per day in full
production from two shafts. Four seams were worked from 177 to 484 yards deep.
There were eight boilers by Hewitt & Kellett, and Tetlows, and others unidentified,
and the colliery was completely self contained under Fletcher, Burrows control, with
exhaust steam turbines from 1903, and with three air compressors, steam fan, and two
winding engines. There were steam pumps underground, also a Waddle fan 40 ft. in
diameter, and all was run off the eight boilers. A very unusual feature of the
Greenhalgh engine was that the valves were outside each other: they were usually along
the cylinder.

8) Atherton, Chanters Colliery, SER 1192b

Type: Horizontal single cylinder non-condensing
Photo taken: 1965
Maker & Date: J. Musgrave & Son, Bolton, 1896
Cylinders: 28in x 4ft 0in - Corliss valves
Hp: 175 *Rpm:* 46 *Psi:*
Service: Ventilating fan drive
 Waddle fan 40ft diameter. 186,000 cubic feet per minute.

Waddle fans often had Waddle's own engines to drive them, but it is probable that the
Musgrave fan and compressor engines here were a single order at the start of the
colliery. The engine was very plain, and drove the fan for well over 60 years until the
electric one was installed. Although the weight of the Waddle fan was very great, and
the peripheral speeds high, they gave little trouble, certainly not at Chanters where this
was heavily used. Pit closed and all was scrapped in 1968-9.

9) Atherton, The Howe Bridge Spinning Co., No 2 Mill SER 756

Type: Horizontal cross compound condensing
Photo taken: 1955
Maker & Date: Hick, Hargreaves, Bolton, 1883
Cylinders: About 24in and 45in x 5ft 0ft – Corliss and slide valves
Hp: About 1000 *Rpm:* 75 *Psi:* 160
Service: Cotton spinning. 4 mills in one group

Howe Bridge was one of the largest group of mills in the trade with a total of over
400,000 spindles in 1923, having four mills with two boiler plants and chimneys. This
engine, although generally unaltered, had certainly had a new high pressure cylinder
added when new boilers were installed about 1920. The low pressure was original
however, retaining the original wooden lagging on the cylinder and cover. The Corliss
valve gear on the high pressure cylinder was the Spencer-Inglis type, not the later crab
claw form. The mills were converted to high speed electrically driven ring frames,
beginning with the No 1 mill (which had a Yates and Thom cross compound engine) in
1958, the machinery giving the same output in two as the previous four mills had
produced.

10) Billington, Green Bros, Abbey Mill SER 1097

Type:	Horizontal cross compound
Photo taken:	1962
Maker & Date:	W. & J. Yates, Blackburn, 1885?
Cylinders:	16in and 30in x 4ft 0in – Slide valves
Hp: 350	*Rpm:* 55 *Psi:* 100
Service:	Cotton weaving. Gear drive to shed mainshaft.

This, like the Jubilee mill engine, of nearly the same date, gave some eighty years of fine service with no alteration, even the governor and steam cut-off system and speed controls being unchanged. The speed control was by variable cut-off, the governor controlling the admission by a single cross slide valve working on the back of the main slide valve. The drive was by a gear ring on the arms of the flywheel, to a single pinion on the shed main driving shaft. Each of the engines, this and Jubilee, were a great credit to Yates, and worked on perfectly, and with good economy when well over eighty years old, driving plain Lancashire looms to make a very sound cloth. As often with Yates, there was a separate safety governor (quite independent of that for the cut-off) which operated a wing type throttle steam shut-off valve, by releasing a weight to close the throttle valve, on over speed.

11) Haslingden, Messrs Lamberts, Hall Carr Mill SER 160a & b

Type:	Pusher compounded single beam
Photo taken:	1935
Maker & Date:	Horizontal - Stott, 1887?
	Beam - J. Clayton, Preston, 1851
Cylinders:	Horizontal = 18in x 3ft 0in – slide valves
	Beam = 24in x 4ft 0in – ?slide valves [the record is ambiguous. Ed]
Hp: 180-200	*Rpm:* 42 *Psi:* 85
Service:	Cotton weaving. Gear drive off 12ft 0in flywheel rim to 5ft 0in pinion. 3,000 mule spinning spindles. 100 looms – 54in - 82in

This also had been rebuilt, probably when the pusher engine was added in 1887. The boiler was renewed at the same time and remained in service at 85psi, 50 years later. The original Meyer slide valve on the HP cylinder had been replaced by a plain 'D' one, with throttle governing.

LONDON: Vol 8

12) Stoke Newington, Metropolitan Water Board, Green Lanes Pumping Station SER 659

Type:	Exterior of the beam engine house
Photo taken:	1954

This was typical of the mid-Victorian period, a medieval style building containing the large Watt and Co. beam engines *Lion* and *Lioness,* and two Simpson compound engines, all built in the 1850s. The building was retained long after the engines were superseded by electrically operated pumps in the 1950s.

SHROPSHIRE: Vol 4

13) *Donington, Wolverhampton Waterworks,*
Cosford Pumping Station *SER 39c*

Type:	Cornish beam
Photo taken:	1936
Maker & Date:	Lilleshall Co, c1885
Cylinders:	70in x 8ft 0in
Hp: -	*Rpm:* 8-10 *Psi:* 40
Service:	Town supply from wells
	Well pumps off the end beam in use 1935, but surface force pump disused.

This appears to have been designed for Davey differential engine control, since there were no "Y" posts for the usual Cornish valve gear, neither were there any bearings on the fluted equilibrium trunks. All of the steam plant was scrapped soon after the electric sets were installed in 1938.

14) *Donington, Wolverhampton Waterworks,*
Cosford Pumping Station *SER 39d*

Type:	Two double diagonal differential engines
Photo taken:	1936
Maker & Date:	Hathorn, Davey & Co, Leeds, 1891
Cylinders:	56in x 5ft 0in when built. No 4 compounded later
Hp: 150	Rpm: 12 Psi: 50
Service:	No 4 well lift. No 5 force pump
	Balance discs 7ft 6in diameter, 20ft 0in to shatf centre.

No. 4 was built for well service only, with pumps $27^1/_4$in x 4ft 6in to lift from 140ft in well to surface, about 2,900 gallons per minute. No. 5 was a forcing engine, pumping to 190ft head. No. 4 engine was compounded in later years by having one 56in cylinder replaced by one of 32in bore probably to use steam of higher pressure supplied to the later high-speed-engine driving ram pumps, and a turbine. The original plant was two beam engines by Perry of Bilston, station units Nos.1 and 2.

YORKSHIRE: Vol 1

15) *Earby, The Dotcliffe Manufacturing Co., weaving shed* *SER 920*

Type:	Horizontal single cylinder condensing
Photo taken:	1958
Maker & Date:	Maker unknown, 1880s?
Cylinders:	$18^1/_2$in x 2ft 6in – Corliss valves
Hp: 172	*Rpm:* 99 *Psi:* 60
Service:	Cotton weaving. Rope drive

This was an old water power site, but the waterwheel had been replaced by a turbine in the 1890s, because the water volume had fallen and the turbine was disused after about 1950. The engine was nondescript, and there were features of several engineers in the alterations that had been made. The bed resembled Roberts's work, possibly with a slide valve driven from the outer side, but the connecting rod, eccentrics, and governor as well as the valve gear were certainly not Roberts's work. The valve gear suggested Musgraves, the connecting rod anyone's make, as was the governor. Latterly, it was certainly developing far more than the designed power, probably having a larger cylinder, and there were also some electrical drives as well. It was, however, a good engine that earned its keep, probably driving on until the plant was closed in the early 1960s.

16) Earby, 'Victoria' Mill SER 162

Type: Double McNaught beam
Photo taken: 1935
Maker & Date: W. & J. Yates, Blackburn, 1856. Rebuilt by Petries, 1897
Cylinders: 29in x 3ft 6in – Corliss valves. 46in x 3ft 6in – piston valve
 2 x 40^1/$_4$in x 7ft 0in – Piston valve
Hp: 1000 *Rpm:* 34^1/$_2$ *Psi:* 160
Service: Cotton weaving. Gear drive off flywheel rim. Once drove 2000
 looms and spinning section. Electric drives – 1960

Victoria Mill began as a combined spinning and weaving plant, with 400 looms in 1856. Another shed of 400 looms was added in 1891, and another 400 in 1897. Much of the later weaving was in a new shed of 1902 away from the main blocks, driven by a long shaft over a brook, with 850 looms; most of the early looms being replaced. Spinning ceased about 1911, and after 1928, only the new shed of 1902 was used. The beam engine remained in use despite the heavy frictional losses until the need to work various parts of the shed for room and power necessitated separate drives to each shaft. The engine is still in the mill, but little remains of the original one.

17) Low Bentham, Ford, Ayrton & Co. SER 1099

Type: Inverted vertical single cylinder condensing
Photo taken: 1962
Maker & Date: Hick, Hargreaves & Co, Bolton, 1886. No 726
Cylinders: 24in x 2ft 6in – Corliss valves
Hp: 120 *Rpm:* 88 *Psi:* 120
Service: Silk preparation. Direct drive to mill shaft

The plant had a long history from 1785, and started with a water wheel, with new buildings added in 1852 and 1928. A beam engine was installed possibly in 1852, if not earlier, and the whole power system was altered to two water turbines, of 30 and 50 h.p., with rope drive to the mill shaft, and the Hick engine in the 1880s. There were boiler changes, and latterly a Yorkshire boiler of the 1920s was used. The water head was some 20ft, and always a major source of power, using either or both turbines as the water allowed. A heavy overhaul of the engine, with the valves replaced and the chests bored out, which cost £2,000 in 1961, saved a considerable amount of fuel, and had paid good dividends by the time the mill was closed, soon after Mr Ford passed away in the late 1960s. The engine most certainly is that preserved at Bolton, where it causes much interest, being rotated by a motor.

18) Saddleworth, The Knarr Mill Co. SER 1054

Type: Inverted vertical side by side compound
Photo taken: 1961
Maker & Date: Victor Coates & Co, Belfast, 1901
Cylinders: 10in and 18in x 1ft 6in – Corliss valves
Hp: 100 *Rpm:* 100 *Psi:* 120
Service: Woollen preparation (carding, spinning etc).
 5 rope drive to original mill shafts.

This was said to have been new from Coates and replaced a beam engine and water wheel, which drove through gearing and a vertical shaft to the mill floors. The Coates engine was arranged to drive to the original floor shafts by ropes from the flywheel

Continued on page 174...

17

Continued from page 170...

rim. The mill had at one time been in the hat trade, and there was a steaming chamber in the mill for this but later it was a woollen mill. The history was confused as there was a new brick section added to the mill in 1914, and the fact that it would require power suggests that the Coates engine may have been needed then. Knarr mill was closed in 1962 when the work was transferred and taken to the owners' Bailey mill in Delph. All probably scrapped at Knarr.

19) Saddleworth, The Saddleworth Woollen Co., Delph SER 1053

Type:	Horizontal single tandem condensing
Photo taken:	1961
Maker & Date:	Thos Broadbent & Sons, Huddersfield, 1899
Cylinders:	18in and 29in x 3ft 6in – Corliss and slide valves
Hp: 500	*Rpm:* 80 *Psi:* 160
Service:	Woollen mill drive. Rope drive to alternator

This was believed to have been the last of the six or so small mill engines made by Broadbents. They were all similar to design, and this, called *Alice*, was supplied new to the mill. Most of the load was later by motors from an alternator driven by the engine. The business started in 1810, and until this was installed, had been powered by a beam engine in the same room, as well as a beam engine and waterwheel in the older mill buildings. A new boiler was installed in 1954, and the engine continued to supply power until, with rising fuel and reduced current costs, power was taken from the Grid. The engine was not removed.

20) Todmorden, Joshua Smith & Co, (1908) Ltd, Cornholme SER 622

Type:	Horizontal cross compound condensing
Photo taken:	1953
Maker & Date:	Wm Roberts, Phoenix Foundry, Nelson, 1897
Cylinders:	$24^{1}/_{2}$in and $43^{3}/_{4}$in x 5ft 0in – Corliss valves
Hp: 900	*Rpm:* 70 *Psi:* 140
Service:	Cotton weaving. Rope drive

This was a large shed with an engine that was almost as powerful as any in weaving service. It was Roberts's standard design, but the cylinder lagging was exceptionally fine in that the mahogany covering was carried entirely over the covers as well as the cylinder barrel, a feature almost unknown in this country. The shed contained 1,756 looms in 1914, but everything was scrapped when the mill was closed in the 1950s.

NEW CONTENTS TO VOL. 1

By Colin Bowden

After Vol 1 was published, it became obvious how unreliable were the details of the location on the notes George made to accompany the photographs, which were copied in that book. In some cases he made a mistake, in others he tended to record the nearest post town, which was not always the right place. This caused several problems where a site was near a county boundary, and the post town was in the next county. All the remainder of the series was carefully checked by Colin and the wording of the headings altered where appropriate. For this final volume he has revised the contents pages of Vol. 1 to match this convention and re-indexed it here.

No	Revised location	SER	Page
65	Midgley, Murgatroyds, Oats Royd Mills	551	102
59	Midgley, The Spindle Shop, Booth	268	94
134	Mirfield, George Lyles & Co., Ledgard Bridge Mills	692	194
135	Mirfield, George Lyles & Co., Ledgard Bridge Mills	692A	194
39	Mirfield, Rawdon, Briggs Limited, Ravensthorpe	1111	66
136	Mirfield, James Walker & Co.	693	198
137	Mirfield, James Walker & Co., Butt End Mill	1401	198
1	Morley, Thomas Ambler & Co., Ardsley Mills, East Ardsley	1155	18
48	Morley, Henry Booth & Co., Moorhead Mill, Gildersome	1234	78
68	Mytholmroyd, Roger Shackleton & Co., Hawksclough Mill	60	106
63	Mythomroyd, Standeven & Co., Whitelee Mill	367	98
138	Ossett, J. M. Briggs & Co., Runtlings Mill	1468	198
141	Oxspring, Winterbottoms, Oxspring Wire Mills	354a	202
142	Oxspring, Winterbottoms, Oxspring Wire Mills	354b	206
139	Pateley Bridge, Atkinsons, Foster Beck Flax Mill	1084	202
211	Pontefract, Ackton Hall Colliery	1341	298
146	Pontefract, The Prince of Wales Colliery	1344	210
147	Pudsey, G. Hartley & Foster, Union Bridge Mills	1001	210
120	Pudsey, The Leigh Mills Co., Stanningley	697	174
148	Pudsey, John G. Mohun & Co., Alma Tannery	1351	214
24	Queensbury, Fosters, Black Dyke Mills	270a	46
25	Queensbury, Fosters, Black Dyke Mills	270b	50
161	Rawmarsh, Kilnhurst Colliery	187	226
162	Rishworth, J. W. Wheelwright & Co., New Mill	58	230
158	Rotherham, The Park Gate Iron & Steel Co.	733c	226
157	Rotherham, The Park Gate Iron & Steel Co.	733d	226
159	Rotherham, The Park Gate Iron & Steel Co.	733d	230
160	Rotherham, The Park Gate Iron & Steel Co.	733f	230
156	Rotherham, The Park Gate Iron & Steel Co.	993a	222
154	Rotherham, The Park Gate Iron & Steel Co.	1385	222
155	Rotherham, The Park Gate Iron & Steel Co.	1385a	222
152	Rotherham, Steel, Peech & Tozer Ltd.	1039a	218
153	Rotherham, Steel, Peech & Tozer Ltd.	1039b	218
215	Ryhill, Aire & Calder Navigation	380a	302
216	Ryhill, Aire & Calder Navigation	380b	302
164	Scarborough, Scarborough Waterworks, Osgodby Station	114	234
175	Sheffield, The Abbeydale Forge	256	246
166	Sheffield, George Clarke & Co.	1042	238
180	Sheffield, Eaton & Booth, Bradfield Rolling Mills, Owlerton	358	254
165	Sheffield, The English Steel Corporation, River Don Works	1040	234
167	Sheffield, The English Steel Corporation, Stevenson Road Works	1073	238
174	Sheffield, Kayser, Ellison & Co., Carlisle St	255	246
184	Sheffield, Sanderson Bros. & Newbould, Attercliffe	922	262
176	Sheffield, Sheffield Forge & Rolling Mill Co., Millsands	336	246
177	Sheffield, Sheffield Forge & Rolling Mill Co., Millsands	356b	250
178	Sheffield, Sheffield Forge & Rolling Mill Co., Millsands	356c	254
179	Sheffield, W. A. Tyzack & Co., Clay Wheels Forge	357	254
172	Sheffield, Tyzack Sons & Turner, Little London Works	355a	250
173	Sheffield, Tyzack Sons & Turner, Little London Works	355b	250
170	Sheffield, Tyzack Sons & Turner, Little London Works	1469	242

No	Revised location	SER	Page
171	Sheffield, Tyzack Sons & Turner, Little London Works	1469a	242
169	Sheffield, The Wardsend Steel Co.	1169	242
181	Sheffield, John Wood & Co., Wisewood	383a	258
182	Sheffield, John Wood & Co., Wisewood	383b	258
168	Sheffield, Wragg & Co., Refractory Clay Products, Loxley	1168	238
23	Shelf, E. Illingworth & Co., Shelf Mills	269	46
186	Shepley, Ben. Armitage & Co.	1237	262
185	Shepley, Firth Bros., Shepley New Mills	1154	262
187	Shipley, G.R. Morrison, Orbic Works	1152	266
189	Shipley, Stuart Bros.	62	266
190	Silsden, Taylor Bros., Waterloo Mills	1150	270
89	Skelmanthorpe, Naylor Bros	924	134
9	South Elmsall, Frickley Main Colliery	630	26
194	South Kirkby, South Kirkby Colliery	629	274
195	Sowerby Bridge, Clay & Horsfall, Wharf Mill	569	274
67	Sowerby Bridge, Lees Ltd., Dene Mill, Triangle	59	106
100	Steeton, Dixon & Co.	1188	150
8	Tankersley, Wharncliffe Silkstone Colliery	626	26
44	Thorne, Thorne Colliery, No. 1 Shaft	1429	74
12	Todmorden, William Barker & Co., Wadsworth Mill	152b	30
203	Todmorden, Dawson & Co.	511	286
210	Todmorden, Dawson & Co.	928	294
205	Todmorden, Fielden Bros, Waterside Mill	61	290
206	Todmorden, Fielden Bros, Waterside Mill	61a	290
208	Todmorden, The Joint Stock Co.	623	294
202	Todmorden, Lord Bros., Stackhills Mill	510	286
200	Todmorden, Nelson Bros, Millsteads Mill	1144	282
201	Todmorden, Sandbach & Co., Calder Vale Mill, Cornholme	508	282
207	Todmorden, John Stott & Son, Der Street Mill	621	290
204	Todmorden, Temperleys	550	286
209	Todmorden, Woodhouse Mill	69	294
17	Wakefield, Matthew Walker & Co., Alverthorpe Mills	1058	38
212	Walton, Walton Colliery	1345	298
217	Wath upon Dearne, Wath Main Colliery	628	306
218	Wilsden, Denison's Ltd., Ling Bob Mills	64	306
219	Wombwell, Wombwell Main Colliery	385a	306
220	Wombwell, Wombwell Main Colliery	385b	310
107	Woodlesford, Water Haigh Colliery	1343	158
183	Wortley, Wortley Low Forge	384	258
140	Wortley, Wortley Top Forge	353	202
221	Yeadon, James Ives & Co., Leafield Mill	1236	310

LANCASHIRE

197	Swinton, Holdsworth & Gibb, Moorside Mills	1065	278

WHERE ARE THEY NOW?

By Chris Allen

This is a compilation of a series of articles published by the International Stationary Steam Engine Society (ISSES) in their Bulletin. Each article deals with a volume in this series and details those SER photographs where the illustrated artefact still survives in some form. These have been reproduced as originally written.

Each section begins with a statistical summary about the survivors. Overall some 23% of the artefacts George photographed still survive.

It is hoped that this information will allow interested readers to track down significant items of surviving steam heritage for their personal enjoyment and to share in some small measure the engines that so enthralled George.

VOLUME 1

I am sure that most of our members are aware that Landmark Publishing Ltd are reproducing George Watkins's photographs that comprise the Steam Engine Record (SER), now housed at the National Monuments Record Centre, Swindon. Volume 1 covers Yorkshire and contains 221 photographs of steam engines, waterpower sites and buildings. These were taken between 1930 and 1975.

Having read Volume 1, I was struck by how many of the items illustrated still remain and felt that it would be worthwhile to record this and share it with our members; some of whom will probably be fellow 'stamp collectors' or 'rivet counters'. Given the enormous number of engines that once existed and the huge decline in their numbers over many years, it is most surprising and heartening that so many significant engines and other sites do survive. It is to be hoped that most of these hardy survivors will continue to exist for the delight and education of future generations.

In addition to the engines included in the SER, there are many that Watkins did not include and some of these have survived down to the present day. These survivors would be worthy of a separate article, or even a volume to themselves, but it is not my intention to address this issue here.

THE FACTS AND FIGURES

The subject matter of 31 of the 221 photographs published still survives (14%). These consist of:-

25 photographs representing 23 steam engines (one is shown by two different views and one is seen on two different sites).

5 photographs of water power sites (either waterwheels or driven machinery).

1 photograph of a building.

The current disposition of the 23 steam engines is as follows:-

7 remain on the sites where Watkins last photographed them (including two engines on display in museums).

11 have been moved off-site to a location where they have been re-assembled and are available for viewing.

4 have been moved off-site and remain in a dismantled condition. The whereabouts of the last engine is currently not known.

The following section lists the surviving items, including the figure number, the site name as given by Watkins and the SER number. This is then followed by any necessary corrections and the current fate or location of the item, be it an engine, waterwheel or building.

THE SURVIVORS

4) *Nutter & Co, Bancroft Shed, Barnoldswick* SER 1186a

The mill closed in 1978 and the weaving shed was subsequently demolished to make way for a housing development. The engine house, boiler house and chimney were all retained due to the efforts of the Bancroft Mill Engine Trust and the William Roberts cross compound engine is steamed on several occasions each year.

5) *Nutter & Co, Bancroft Shed, Barnoldswick* SER 1186b

This small horizontal single cylinder engine is believed to have been acquired for preservation but its present location is not known. 1 would be grateful if any member could enlighten me with regard to its whereabouts.

13) *John White & Co, Leather Tanners, Bingley* SER 1151

As stated in the caption, this horizontal single cylinder engine is on display at the Bradford Industrial Museum's Moorside Mills. It was re-erected by volunteer labour and can be either run on steam or turned with an electric motor.

77) *Marshall Flax Mills, Holbeck, Leeds* SER 1020

This superb Egyptian-style building survives much as it was in 1960.

78) *Watkinsons, Washpit Mills, Holmfirth* SER 1091

This magnificent Pollit & Wigzell tandem compound was only the second engine that I had seen working, back in 1976, and made a lasting impression. It remained at work until 1980 and was then maintained in working order for several years. Following the death of Herbert White, its effective guardian, it was removed for preservation in 1998 and is now in a workable condition at Markham Grange Nursery, Brodsworth.

85) *The Fieldhouse Engine, The Tolson Museum, Huddersfield* SER 1402

This elderly and interesting horizontal single cylinder, return connecting rod engine remains much as it was when photographed by Watkins in 1970. It remains outside, beneath its canopy and surrounded by a railing. It is a sad end for an early machine and one hopes that it will eventually come in from the cold!

90) *Hull Waterworks, Springhead Station* SER 115

This 1876 Cornish engine, photographed in 1935, ceased work in 1952 and was subsequently preserved in situ. The site is now Yorkshire Water's company museum. The engine is little altered, although the colour scheme is interesting to say the least, but the house is now cluttered by various exhibits. Unfortunately, regular opening has now ceased and permission must be sought for a visit.

93) *Chambers & Fargus Ltd, High Flaggs Oil Mill, Hull* SER 379b

Watkins stated that this Willans generating set might have been preserved. He was right in that it is now on display at the Science Museum in South Kensington, London.

94) *The West Dock Sewage Pumping Station, Hull* SER 888

This site contained three inverted vertical compound rotative pumping engines, built by James Watt & Co in 1883. According to Watkins, these were scrapped when electric pumps were installed in 1957-1958. However, one was in fact acquired for preservation and is now on public display at Thinktank, Birmingham's museum of science and discovery that opened in 2001. This is a large machine that has been well conserved and is now demonstrated turning on an electric motor drive.

99) Peter Green & Co, Bradley, Near Keighley SER 1105

This horizontal tandem compound engine ceased work in 1978 and was preserved in situ by Barry Fray Design, the current owners of the mill. Unfortunately, the space is now required and the engine was largely removed in 2002. The majority of the engine is in store at Bancroft Shed (see No. 4 above) but at the time of writing the flywheel and most of the bed remained on site at Bradley. It is to be hoped that the various parts will be reunited eventually and put on display.

100) Wilson's Silk Mill, Lothersdale, Near Keighley SER 164

This large and impressive high breast shot waterwheel remains in situ. It was seen on an ISSES visit on 18 September 1993. It is intact but would require some work to return it to an operable condition.

108) Hardcastle & Co, Dyers and Finishers, Wortley Road, Leeds SER 1346

This horizontal tandem compound by Wood, Baldwin of Brighouse, was removed to the Armley Mills site of Leeds Industrial Museum and is referred to under entry No. 112.

109) Hodgson & Co, Craven Mills, Bramley, Leeds SER 1387

This is one of three surviving Cole, Marchent & Morley horizontal tandem compound engines and is fitted with Morley's patent piston drop valves. The mill is now owned by Winerite, purveyors of alcoholic beverages, and the premises are extremely secure, ensuring that the engine remains intact but a little rough. There has been recent concern (2002) that the owners may wish it to be removed but it remains in situ for the time being. It is too large for its preservation to be an easy matter and its long-term future is at best uncertain.

112) Leeds Industrial Museum, Canal Street, Leeds SER 1492

This is the engine illustrated in photograph No. 108 (see above). Since the photograph was taken, in 1975, the engine has been moved into an original engine house and completely rebuilt by volunteer labour. It is now in a highly restored condition and is run under steam several times a year.

118) Kirkstall Forge, Leeds SER 368

This water wheel and shingling helve hammer remain preserved in the midst of this large operating forge. In a nearby building there are two preserved steam hammers, whilst the working site contains several large hammers operating on compressed air. This site was visited by an ISSES party in 1997.

122) Job Beaumont & Co, Woollen Spinners, Linthwaite SER 1490

I saw this J. & E. Wood horizontal tandem compound in September 1976, less than a week after it had ceased operating. This was the first in situ stationary engine that I had seen and it was to start an association that continues to the present day. The engine itself is currently

lying dismantled in Bolton and is the property of the Council. There seems to be little chance of it being erected in the foreseeable future.

123) Hearl, Heaton & Co, Crown Street Works, Liversedge SER 1233

This small horizontal single cylinder engine, built by J. B. Clabour of Guiseley, is now on display in Bradford Industrial Museum, Moorside Mills. It can be turned by a motor.

127) Fisher, Firth & Co, Cellars Clough Mills, Marsden SER 1090

This rare example of a McNaughted single beam engine has been re-erected in the museum of the Northern Mill Engine Society at Bolton. It is a large and impressive engine and is the sole re-erected example of a once numerous class. The NMES cannot be over-congratulated for this achievement.

134) George Lyle & Co, Ledgate Bridge Mills, Mirfield SER 692

The correct appellation of the site is Ledgard Bridge Mills. The now unique pusher compound beam engine, illustrated in this and the subsequent photograph, is now the property of a private collector and has been languishing in the vegetation at Wortley Top Forge for about 20 years. It is to be hoped that it will eventually be resuscitated, as it richly deserves to be.

135) As above SER 692

138) J M Briggs & Co, Runtlings Mill, Ossett SER 1468

This horizontal tandem compound engine, built in 1908 by Marsden's Engines Ltd, still remains in situ. The site is now owned by Oakliffe Engineering Company Limited and the engine remained in reasonable condition when seen in January 2001 by some members of the Claymills Pumping Engines Trust.

139) Atkinsons, Foster Beck Flax Mill, Pately Bridge SER 1084

This location is correctly Pateley Bridge and is located in Nidderdale. The mill is now private accommodation and when seen in 2004 the wheel did not look to be operable.

140) Wortley Forge, Near Penistone (Founded 1713) SER 353

Now known as Wortley Top Forge, this site has been preserved by the Sheffield Trades Historical Society and looks much as in Watkins's photograph from 1950. The site is also host to a variety of off-site steam engines that are variously erected or mouldering in the undergrowth (see Nos. 134 & 135).

143) Pontefract & Goole Waterworks, Roall Pumping Station SER 1077

The A-frame Woolf compound beam engine seen in Watkins's photograph, has now been preserved, off-site, at Forncett Industrial Steam Museum, Forncett St Mary, Norfolk. The engine is steamed regularly and may be seen on the frequent open days.

148) Mohn & Co, Alma Tannery, Pudsey SER 1351

The correct appellation of this company is John G Mohun & Son Ltd. The horizontal single cylinder Corliss engine worked until the works closed in 1978. It was subsequently re-erected at the Calderdale Industrial Museum, Halifax and was regularly demonstrated on steam. The museum is currently closed and the collection is mothballed.

165) The English Steel Corporation, River Don Works, Sheffield SER 1040

This huge 12,000 hp inverted vertical three cylinder rolling mill engine remained in occasional use until 1978. It has now been re-erected at Kelham Island Museum, Sheffield and can be demonstrated on steam; a truly spectacular sight.

168) Wragg & Co, Refractory Clay Products, Loxley Valley, Sheffield SER 1168

This massively built horizontal single cylinder engine spent a period in the long grass at Wortley Top Forge (see No. 140), before being re-erected at Walkleys Canal Wharf Mill in Hebden Bridge. The engine has been squeezed into part of the former boiler room and looks decidedly out of place. There is also no apparent prospect of it being restored to steam. This site has now closed (2003) and the engine's future there is uncertain.

175) The Abbeydale Forge, Sheffield SER 256

This part of the site, the water-powered blowers and tilt hammers, remains much as it was when Watkins photographed it in 1938. Not more than 20ft from the door to this building, there is an elderly horizontal single cylinder engine that has now been restored to an operable condition.

185) Fisher, Firth & Co, Shepley New Mills, Shepley SER 1154

This company was correctly known as Firth Brothers Ltd. The 600 hp triple expansion mill engine remained operable until about 1980. It was subsequently removed by the Yorkshire Branch of the Northern Mill Engine Society and is now awaiting its restoration at Tommy Nuttall's Markham Grange Nursery.

193 The Colne Vale Dye & Chemical Co, Slathwaite SER 1238

The correct spelling of the given location is Slaithwaite, but most would agree that it was in Milnsbridge anyway! I saw this engine working for its living in 1980, by which time it was in a very poor condition. It was removed by Mr Peter Williams of Shropshire and eventually found its way to the National Trust, who re-erected it at the Home Farm on the Tatton Park estate. The engine was restored to its former glory and a suitable boiler was provided so that it could be run on steam. However, it has not run for some time and the National Trust is seeking volunteers to give it some care and attention and return it to steam.

213) Caphouse Colliery, Overton, Near Wakefield SER 1410

This small horizontal duplex winder has been preserved as part of the National Mining Museum, based at this site. It can be operated on steam.

VOLUME 2

Volume 2 covers Scotland, Cumberland, County Durham and Northumberland with 109 illustrations of steam engines, waterwheels, buildings and a swing bridge. As before, a surprising number of the illustrated examples survive and these are listed below.

THE FACTS AND FIGURES
The subject matter of 31 of the 109 photographs published still survives (28.4%). These consist of:-

27 photographs representing 25 steam engine sites (two sites are illustrated by two photographs).
2 photographs of water wheels (each site also has a surviving steam engine).
1 photograph of a gas engine driving pumps (this site also has a surviving steam engine).
1 photograph of a winding engine house (this site is also illustrated by two interior views).

The current disposition of the 25 steam engine sites is as follows:-
11 remain on the site where Watkins last photographed them (including two engines on display in museums).
5 have been moved off-site to a location where they have been re-assembled. and are available for viewing.
1 has been moved off-site and re-assembled in a private collection where it is not freely visible.
7 have been moved off-site and remain in a dismantled condition or part dismantled condition (including one that is rumoured to have been scrapped but not confirmed definitely).
1 has been moved several times and its current location is not known beyond county level.

THE SURVIVORS

6) *Auchinleck, Highhouse Colliery, No 2 shaft* SER 1252

The colliery closed in 1983 but the horizontal duplex winding engine, its house and the headgear all survive within a small industrial estate. The engine is now believed to date from 1896 and the original wooden headgear was replaced in the late 1960s. Unfortunately, it is claimed that the engine is not currently accessible.

12) *Dunbar, Sir James Hope's Estate, East Barns Farm* SER 1294

This early horizontal single cylinder engine by James Skedd is now preserved in the private collection of Alan McEwen at Farling Top Boilerworks, Cowling, near Keighley. My thanks go to Colin Bowden for making this connection.

14) *Tranent, near Edinburgh, Prestongrange Colliery* SER 561

This Cornish beam pumping engine survives in situ as part of the Prestongrange Industrial Heritage Museum. Research by Kenneth Brown (*Journal of the Trevithick Society*, 9, 1982, pp 42-51) has shown that only the beam was built by Harvey and Co in 1874; the engine having been built originally by J. E. Mare of Plymouth Foundry in 1853 and working on four sites for a total of 101 years. George Watkins noted that there was no air pump bucket and Brown reveals that this was because the engine was fitted with a siphonic (barometric) condenser extending down the shaft.

17) *Glasgow, The Kingston Dock Swing Bridge* SER 1273

According to ISSES member Brian Hillsdon, this horizontal duplex bridge opening engine is preserved at the Scottish Maritime Museum. Despite recent financial difficulties this site is believed to be open currently.

19) *Glasgow, Lean & Co, Muslin Manufacturers,*
Reid Street SER 555

This very nice example of a twin McNaught compound beam engine is in store at Summerlee Heritage Park, Coatbridge. Unfortunately it is believed that the flywheel has been lost. The engine is also of interest as it was built as a McNaught compound rather

than being a conversion of a single cylinder engine (as per McNaught's original patent). The only known comparable engines, also by Turnbull, Grant & Jack, are at the former Powers Distillery site in Dublin.

24) Stepps, nr Glasgow, Cardowan Colliery SER 1445

Although Watkins states that the pit was due to close in 1972, it actually worked through to c.1983. The number 2 winding engine, without tail rods, was subsequently scrapped but the number 1 engine was removed to Summerlee Heritage Park, Coatbridge. It is now on display in a part-erected condition, intended to simulate a manufacturer's erecting shop.

29) New Craighall, New Craighall Colliery, No 3 Shaft SER 1293

Watkins states that this horizontal duplex winding engine is 'preserved in Scotland'. I would contend that this is true in parts, as the engine has been partly re-erected on a tall brick base adjoining the Prestongrange beam engine (see No. 14 above). The engine has been in this state for very many years and it is hoped that all the smaller motion parts remain in store somewhere.

30) Newtongrange, Lady Victoria Colliery SER 1290

This magnificent horizontal duplex winding engine is preserved in situ as part of the Scottish Mining Museum. It had been hoped to run the engine on steam and this was achieved once, before cost gained the upper hand. Indeed, the Museum has had troubled finances recently but is currently remaining open.

34) Blairgowrie, Thompson & Co, Keithbank Works SER 1262a

The correct appellation for this site was – Thomas Thomson (Blairgowrie) Ltd, Keathbank works. The mill has passed from the ownership of the Thomsons and was opened as a visitor attraction. The waterwheel has been preserved and was on public display. The current status of the site is uncertain as it was up for sale in early 2003 and may no longer be open.

35) Blairgowrie, Thompson & Co, Keithbank Works SER 1262b

This is the same site as above and the horizontal single cylinder steam engine is also preserved and was on display, albeit in a static condition.

36) Blairgowrie, Thompson & Co, Ashgrove Works SER 1263a

This is the same company as above (Nos. 34 & 35) and should also be Thomas Thomson. The waterwheel remains in situ and was seen by ISSES's President during 2003.

37) Blairgowrie, Thompson & Co, Ashgrove Works SER 1263b

This is the same site as above and the horizontal single cylinder engine also remains in situ and was seen by our President in 2003. An adjoining room contains a horizontal four cylinder diesel engine.

43) Selkirk, George Roberts & Co, Philiphaugh Mill SER 1019

This company later became known as Roberts, Thorburn & Noble Yarns Ltd. The Petrie horizontal twin tandem compound engine has now been re-erected at New Lanark World Heritage Village, New Lanark. The engine has fittingly been re-erected in the house that used to contain a 550 hp Petrie engine driving No. 3 mill by means of a rope drive. The

engine can be turned electrically although it was intended to drive it by steam. It is to be hoped that this latter option will come to pass.

44) Alva, Glentana Mills SER 1258

This horizontal single cylinder Corliss engine ceased work in 1979 and was placed into store by the Royal Scottish Museum. It has now been restored and is on display in the new building of the Museum of Scotland in Edinburgh. The engine can be demonstrated turning on compressed air. Ironically, Glentana Mills is now home to a visitor centre and the engine could have become an attraction in its own home had it remained.

48) Silloth, Carr's Flour Mill SER 1249

This magnificent horizontal cross compound engine, built in Belgium, ceased work in 1973 and was preserved by the owners. It can be turned at a very creditable speed by an electric motor and is a splendid example of in situ preservation. There is an inverted vertical compound Belliss and Morcom generating set in the same room. The owners remain in business on the site and the whole is a credit to them.

49) Whitehaven, Haig Colliery, No 4 Shaft SER 1444

This horizontal duplex winding engine remained at work until closure in 1986 and was then left to lie fallow for some time. The site is now the Haig Colliery Mining Museum and No. 4 engine can be run on compressed air. The larger No. 5 engine is also undergoing restoration.

50) Workington, Workington Iron & Steel Co SER 1247

This horizontal duplex rolling mill engine ceased work in November 1981 and was then dismantled for preservation. On a visit to the site in November 1986, I learnt that the dismantled engine was allegedly stored in railway wagons and had not yet been re-erected. The site remains in operation, now under the ownership of Corus and it is alleged that the engine was transferred to Kelham Island Industrial Museum, Sheffield and subsequently scrapped. I would welcome confirmation of this before deleting it from the list of survivors.

53) Beamish, Beamish Colliery, Chop Hill Pit SER 614

The entire engine and house were relocated a short distance from the North of England Open Air Museum, Beamish. The engine is now regularly demonstrated running on steam and is the sole example of the area's eponymous vertical winding engine.

54) Beamish, Beamish Colliery, Chop Hill Pit SER 614a

As above. Also see No. 104 below.

66) Dalton, nr Seaham, Sunderland Waterworks, Dalton Pumping Station SER 372

This pair of Cornish pumping engines ceased work in 1942 and it is amazing that they have survived to the present day. For many years they were essentially derelict and the building was largely bricked up. In more recent years the water company sold the premises for development and the engines are now nicely restored. It is intended to complete conversion of the buildings and open the site as a public restaurant.

67) Darlington, Darlington Waterworks, Coniscliffe Road, Pumping Station SER 513

This late example of a Woolf compound beam pumping engine has been preserved by a trust and is regularly demonstrated in steam. This site is now known as Tees Cottage Pumping Station.

68) Darlington, Darlington Waterworks, Coniscliffe Road, Pumping Station — SER 1496

This is the same site as above. The twin cylinder gas engine has been restored and runs very well on one cylinder (the other running idle). However, the suction gas plant has not been restored and the engine runs on an alternative gas.

80) Ryhope, Sunderland Waterworks, Ryhope Pumping Station — SER 371a

This site, once described as 'the finest industrial monument in the north-east', has long been in the care of a preservation trust. The two superb Woolf compound beam pumping engines are regularly demonstrated in steam and admission is currently free.

81) Ryhope, Sunderland Waterworks, Ryhope Pumping Station — SER 371b

A different view of one of the above engines.

84) Staindrop, near Barnard Castle, Maudes, Clog Soles — SER 1277a

This Tangye horizontal duplex engine is currently in store, in the open air, at the Marley Hill site of the Tanfield Railway near Gateshead. It is to be hoped that it will be re-erected eventually.

92) Warden Law, National Coal Board Colliery — SER 373

This single cylinder beam haulage engine has been in store at the North of England Open Air Museum, Beamish for very many years. It is to be hoped that it will be re-erected one day.

93) Washington, nr Sunderland, Washington Colliery, F Pit — SER 1300

This horizontal duplex winding engine ceased work in 1968 and was preserved in situ. This site is operated as the Washington 'F' Pit Industrial Museum and it is believed that it has reopened following a period of closure.

100) Mitford, near Morpeth, Brown & Co, Sawmill — SER 1276

Foster No. 14724, a single cylinder overtype portable engine, was in the care of the North of England Open Air Museum, Beamish but according to the latest edition of *The Traction Engine Register* is now in the Cramlington area. As an aside, the photograph is printed reversed.

101) Newcastle upon Tyne, Museum of Science & Engineering — SER 1460b

This picture was taken at the now closed Exhibition Park site and the two beam engines are currently in store in the new regional storage building at Beamish.

102) Stocksfield, nr Corbridge, J. Moffatt, Peepy Farm — SER 1295

The owner of this engine was correctly Mr J Moffitt and Peepy Farm later became Hunday Farm, the home of The National Tractor and Farm Museum. This beautiful engine and thrashing machine, known as the Bingfield Thrasher, was at the heart of the stationary engine collection. Unfortunately, Hunday closed in the 1980s and this engine is now stored in a part dismantled collection in the regional museum store at Beamish.

104) Beamish, Beamish Colliery, Chop Hill Pit CPB/SER 614

This is the same site as illustrated by Nos. 53 and 54. The photograph depicts an exterior view of the winding engine house of the preserved Durham vertical winder.

VOLUME 3

Volume 3 was released in two separate volumes, reflecting the enormous number of sites in Lancashire and, for the sake of convenience, each volume will be considered separately.

VOLUME 3.1

Volume 3.1 was released in 2001 and covers Lancashire (A - L) with 149 illustrations of steam engines, waterwheels, buildings and locomotives. As before, several of the illustrated examples survive and these are listed below. Surprisingly, given the size of Lancashire and the extreme density of industry within it, relatively few of the subjects survive and only a small number remain in situ.

THE FACTS AND FIGURES
The subject matter of 18 of the 149 photographs published still survives (12.1%). These consist of:-

16 photographs representing 16 steam engine sites.
1 photograph of a water wheel driving fulling stocks.
1 photograph of a textile mill exterior.

The current disposition of the 16 steam engine sites is as follows:-
6 remain on the site where Watkins last photographed them (including one engine preserved in the open air).
7 have been moved off-site to a location where they have been re-assembled and are available for viewing.
1 has been moved off-site for preservation and remains in a dismantled condition.
1 (or a very similar engine) is in a museum site that is not yet regularly open to the public.
1 has been removed for preservation but its current location is not known.

THE SURVIVORS

19) Blackburn, E. & G. Hindle Ltd, Bastfield Mill SER 985b

This pretty vertical single cylinder engine, by Benjamin Goodfellow of Hyde, is stated to have been bought by an unknown buyer for preservation. It is now on display at the British Engineerium, Hove. This is an outstanding museum of prime movers in a former water pumping station and this engine can be demonstrated on steam.

27) Bolton, Thos. Crook & Co, Engineers, Derby Street SER 1403

This horizontal single cylinder engine, a product of the owners, was removed for preservation and its current location is unknown.

28) Bolton, Thos. Crook & Co. SER 1403a

This small vertical single cylinder engine, also a product of the owners, is now on static display in Bolton Museum and Art Gallery, Le Mans Crescent, Bolton.

47) Bolton, Thos. Walmsley & Sons SER 1120a

This impressive horizontal single cylinder rolling mill engine is now thought to be possibly by J. & E. Wood of Bolton. It and its mill have been re-erected at the Blists Hill Victorian Town Museum, Madeley which is part of the complex of museums administered by Ironbridge Gorge Museum Trust. The engine forms one element of a reconstructed wrought iron works and is occasionally demonstrated running on steam.

49) Breightmet, near Bolton, Constantine & Co. SER 1416b

The Northern Mill Engine Society possesses a virtually identical engine in their museum at Bolton. This was acquired from Fred Dibnah who had acquired it from a dyeworks in the Bolton area. Although this may be the same engine, the maker's plate on the NMES engine is on the front of the bed and the gears are guarded by a sheet metal cover. In any event, it is fair to say that an engine of the type illustrated does survive. Boilermaker Alan McEwen also owns a similar engine.

61) Briercliffe, Harle Syke, Finsley View Manufacturing Co, SER 1388

This medium-sized horizontal cross compound mill engine, built in 1904 by Burnley Ironworks Co, is now the centrepiece of the steam engine display at the Science Museum, London as stated in the accompanying text. The engine can be demonstrated on steam at a reduced speed.

74) Burnley, Sutcliffe, Clarkson & Co, Wiseman Street SER 921

This much-altered horizontal cross compound engine was stopped at Easter 1979. The boiler was subsequently scrapped but the fine chimney remains and the engine is now preserved in situ in the care of the "Friends of the Weaver's Triangle". It is now turned by an electric motor on their open days.

93) Chorley, J. H. Gillett & Sons, Crosse Hall Mills SER 610

This Ferranti inverted vertical cross compound generating engine is a very rare example of an early generating set and its survival is very fortunate indeed. As stated in the accompanying text, Ferranti initially preserved it at their Hollinwood works. However, it is now on display at the Museum of Science and Industry in Manchester in the former Liverpool Road Station. It has been fitted with a flywheel alternator (to give some semblance of its original appearance) and is capable of being turned on steam.

98) Church, W. F. Chambers & Co, Primrose Mill SER 1145

This beautiful Ashton, Frost & Co horizontal cross compound, gear drive engine nearly completed a century of labour, stopping in the early 1980s. It was then acquired by Hyndburn Borough Council and placed in open store at the Howarth Art Gallery, Accrington. Unfortunately it has remained there ever since and a survey of the engine in c.1999, by Century Millwrights, suggested that many major components were not immediately to hand (see IB 21.1, pp 4-5). It seems that this once fine engine has a very uncertain future and may yet end up as scrap.

99) *Clitheroe, James Thornber, Holmes Mill* — SER 1193

This horizontal cross compound engine, built in 1910 by Clayton, Goodfellow of Blackburn stopped in 1973 and has remained in situ ever since. Although the boiler has now been scrapped, the owners keep the engine house reasonably tidy. I last saw it in 1994 and there is no reason to believe that it is no longer there.

107) *Darwen, Mr Grimes, Sunnybank Paper Mill* — SER 1404

This very elderly vertical single cylinder engine is now on open-air display in a tiny public park alongside Blackburn Road, Darwen.

108) *Open space in Darwen* — SER 1405

This J. & E. Wood of Bolton horizontal cross compound remains on open-air display and appears much as it did when Watkins photographed it. Since then it has lost a few minor parts to vandalism and has gained a fence and a plaque.

115) *Finsthwaite, Coward's Bobbin Mill* — SER 1246

As stated in the accompanying text, this site is now preserved as the Stott Park Bobbin Mill and is open on a daily basis from April to the end of October. The horizontal single cylinder engine has been nicely restored and can be demonstrated in steam from Tuesday to Thursday (inclusive).

119) *Haslingden, The Grane Manufacturing Co.* — SER 789

This 1907 built S. S. Stott of Haslingden horizontal cross compound engine stopped in December 1978. Over the following years it deteriorated badly and some of the smaller parts were lost. More recently, pioneer preservationist David Arnfield has been restoring the engine with an eventual planned return to steam. He has made excellent progress and the engine has now become a Scheduled Ancient Monument. This has bolstered his plans and ensured a more certain future for the engine.

124) *Haydock, Richard Evans & Sons Colliery Workshops* — SER 545

This housebuilt single cylinder beam engine is yet another of Lancashire's engines to end up on display at the Museum of Science and Industry in Manchester. This engine is also regularly demonstrated running on steam.

127) *Helmshore, L. Whittaker & Sons, Woollen Mills* — SER 844

As stated in the accompanying text, this site became the Higher Mill Museum, now incorporated as part of the Helmshore Textile Museums. The water wheel driven fulling stocks remain in situ and are on public display. The mill also exhibits off-site steam engines, including a six-column beam engine, steam fire pump and a horizontal single cylinder engine.

135) *Hollinwood, Nile Mill* — SER 102a

Although the massive beam engines have been scrapped, the mill remains much as Watkins photographed it, albeit with a much truncated chimney. The mill is believed to be in use as a warehouse.

149) *Leigh, Leigh Spinners Ltd, No. 2 Mill* — SER 1162

This large and impressive horizontal cross compound engine, built in 1925 by Yates & Thom of Blackburn, remains in situ and is part of a listed building. The engine is sadly rusty and neglected but the owners are forced to retain it, as demonstrated by a refusal to grant listed building consent for its removal or alteration.

VOLUME 3.2

Volume 3.2 was also released in 2001 and covers Lancashire (L - W) with 150 illustrations of steam engines, waterwheels, buildings and a steamroller. As before, several of the illustrated examples survive and these are listed below. In addition there is a supplement including six engines that should have been included in Volume 3.1; none of these survive.

THE FACTS AND FIGURES
The subject matter of 11 of the 150 photographs published still survives (7%). These consist of:-

10 photographs representing 10 steam engine sites.
1 photograph of a water wheel driven pump.

The current disposition of the 10 steam engine sites is as follows:-
2 remain on the site where Watkins last photographed them.
2 have been moved off-site to a location where they have been re-assembled and are available for viewing.
1 has been moved out of the country and re-erected in a private collection.
3 have been moved off-site and restored for a Society museum that is not yet open regularly.
1 has been moved off-site for preservation and remains in a dismantled condition.
1 has been removed for preservation but its current location is not known.

THE SURVIVORS

25 Milnrow, Richard Barnes & Co, Firgrove Mill SER 1030

According to Watkins's text, the "engine was moved to the Manchester Museum store for eventual re-erection". This occurred when the Museum of Science and Industry in Manchester was established in the former Liverpool Road Station. The Museum opened in 1983 and the engine is demonstrated running on steam, although at a reduced speed. The engine is a J. & W. McNaught horizontal tandem compound engine.

37) New Hey, near Rochdale, Ellenroad Ring Mill SER 599

This large and impressive horizontal twin tandem compound engine is now preserved in situ and regularly demonstrated in steam. Unfortunately the mill has been demolished and only the engine house, boiler house and chimney survive. The site's owners, formerly Coates Inks, are to be congratulated for having the extreme good sense and courage to preserve this. The site is also home to the Whitelees beam engine, formerly on display in a glass-fronted building in Rochdale.

41) Norden, near Rochdale, R. Cudworth SER 965b

This S.S. Stott & Co horizontal tandem compound engine lay in a semi-derelict condition for several years while the closed mill deteriorated around it. During 2000, the engine was dismantled by George Drake and subsequently exported to a private collector in Canada. It has now been re-erected and is back in steam.

72) Radcliffe, A. & J. Hoyle Ltd, Park Street Shed SER 1157

This rare inverted vertical non-dead centre engine was acquired by David Arnfield, the first chairman of the Northern Mill Engine Society (NMES) for the princely sum of £25. It was removed by the Society in c.1966 and was subsequently re-erected in their first museum at Atlas Mills, Bolton. Following the loss of that museum, it was moved and has been re-erected in their new museum in the former Atlas Mills cotton store on Mornington Road. It can now be demonstrated turning on an electric motor drive on the few public open days that are now held at the museum.

74) Radcliffe, Mount Sion Bleachworks SER 1417

This water wheel driven pump remains in situ. It is on private property and is deteriorating badly; the wheel has collapsed and the vegetation is beginning to obscure it.

98) Rochdale, Rochdale Steam Laundry, Manchester Road SER 1184

This medium-sized horizontal single cylinder Petrie & Co engine is on display at the Newcastle Discovery Museum, Blandford Square, Newcastle upon Tyne. It is one of the few exhibits to survive a recent re-organisation and it is not known whether it can still be operated on steam. In the Museum it is described as coming from Brimrod Laundry but I have been assured that it is the same engine.

117) Shaw, Hardman, Ingham & Co, Diamond Rope Works SER 1352

This lovely inverted vertical compound (open crank) engine by Scott & Hodgson has been re-erected at the NMES museum in Bolton. It was acquired at the eleventh hour from the scrapman, and restoration included repairing some serious damage incurred during its precipitate removal.

119) Shaw, Fern Mill, latterly Sutcliffe, Speakman & Co SER 1227

This horizontal twin tandem compound by Buckley & Taylor had a hard life and had been much altered before a cracked crankshaft brought it to a halt. In the late 1970s and early 1980s it was nominally in the care of the NMES and was open to the public along with the nearby Dee Mill and Diamond Rope Works. The mill's closure was announced in 1981 and the NMES removed the engine, to a tight schedule, by November 1982. The engine remains in a secure storage compound at Auto-Masters Ltd, Hyde and it is not clear when it may be re-erected. The NMES also removed the single cylinder rotative fire pump and this is now re-erected in the museum in Bolton.

120) Smallbridge, near Rochdale, Law's Chemical Works SER 1453

This company remains in business and enquiries have revealed that the little Hindley inverted vertical single cylinder engine worked into the 1980s. It was subsequently removed for private preservation but we have been unable to trace its current whereabouts. We would be grateful if anyone could inform us of its current location.

128) Tyldesley, Astley Green Colliery (No. 1 shaft) SER 642

As stated in the book, this massive horizontal twin tandem compound winding engine has been preserved on site. It is in the care of the Red Rose Steam Society and is being painstakingly restored towards its former glory. It is intended to install suitable boiler plant and to run it on steam in due course.

140) Wardle, near Rochdale, Leach's Crossfield Woollen Mills SER 365

This elderly twin beam engine is another exhibit in the NMES museum in Bolton. It too has been re-erected twice and is capable of being turned by an electric motor. According to John Phillp of the NMES the photograph is printed "back-to-front".

BITS AND PIECES.

In addition to the whole engines listed above, at least one site has a major component that survives, although off-site in a museum that is not yet open regularly.

69) Radcliffe, The East Lancashire Paper Mill Co SER 1230

Although the main engine has been scrapped, its barring engine survives at the NMES museum in Bolton. This is a substantial and interesting engine. It is a horizontally opposed twin cylinder, single-acting uniflow with poppet steam valves. This is most unlike anything else and is a worthy survivor.

VOLUME 4

Volume 4 was released in 2002, covering Wales, Cheshire and Shropshire, and has 147 illustrations of steam engines, waterwheels, buildings and locomotives. As before, several of the illustrated examples survive and these are listed below.

THE FACTS AND FIGURES

The subject matter of 34 of the 147 photographs published still survives (23.1%). These consist of:-

22 photographs representing 20 steam engines.
5 photographs of water wheel sites, including one with auxiliary steam power.
6 photographs of steam locomotives.
1 photograph of water balance hoists in a slate quarry.

The current disposition of the 20 different steam engines is as follows:-
13 remain on the site where Watkins last photographed them, including 5 sites with no regular public access and 8 museum sites.
3 have been moved off-site to a location where they have been re-assembled and are available for viewing.
4 have been moved off-site for preservation and remain in a dismantled condition.

THE SURVIVORS

1) Bethesda, Penrhyn Slate Quarries SER 652a

This vertical boiler 0-4-0 locomotive, built in 1877 by De Winton & Co, is named *George Henry* and preserved in a static condition at the Narrow Gauge Railway Museum, Tywyn. It was acquired for preservation in 1955 and remains in the condition in which it finished work (down to the dents in the boiler casing as shown in George's picture).

2) Bethesda, Penrhyn Slate Quarries SER 652b

Two of these water balance hoists are preserved, out of use, at Penrhyn. I am not certain whether any of the three in George's picture have survived but they were all basically of the same design.

3) Llanberis, Dinorwic Quarry SER 687

This very large waterwheel that drove the machinery of the Dinorwic Quarry Workshops has been restored and can be seen operating as part of the Welsh Slate Museum. The museum is based in the former workshops and these have been preserved in their entirety.

4) Llanberis, Dinorwic Quarry SER 687a

The early locomotive *Fire Queen* is preserved at Penrhyn Castle Industrial Railway Museum.

5) Llanberis, Dinorwic Quarry SER 687c

Sybil, a 0-4-0 ST locomotive by W. G. Bagnall of Stafford (No. 1760 of 1906) was saved for preservation. Brian Hillsdon has informed me that it is currently undergoing restoration in the works of its owner, Mr James Armstrong-Evans and that it last worked on the Launceston Steam Railway (1987-1992).

6) Llanberis, Snowdon Mountain Railway SER 655 (2)

This rack locomotive remains in commercial use on the Snowdon Mountain Railway.

7) Llanberis, Snowdon Mountain Railway SER 655 (8)

This rack locomotive survives but is currently out of use with no immediate plans for a return to steam.

8) Nantlle, Dorothea Quarry SER 653

This Cornish beam pumping engine remains preserved in situ. However, in this case, 'preserved' is a relative term as the engine has received no attention in many years and access is limited. The wooden sheer-legs have been demolished, the pump rod has been cut above ground and the location of some of the valve gear is uncertain. The two Lancashire boilers are derelict and the chimney has gone. It is understood that the building is to receive some attention in the near future.

11) Nantlle, Pen-y-Bryn Old Mill SER 1413

This vertical single cylinder engine remains in a dismantled condition at the Welsh Slate Museum, Llanberis (see No. 3 above). It is located in a very overgrown area round the back of the main museum buildings and is hardly a fitting testimonial to those who took the trouble to save it from the scrap heap some 30 years ago.

13) Penmaenmawr, Penmaenmawr Granite Quarry Co. SER 651

This vertical boiler 0-4-0 locomotive, built in 1893 by De Winton & Co, is preserved at Penrhyn Castle Industrial Railway Museum. Although Watkins has its name as *Wadkin*, it is actually *Watkin*.

15) Kidwelly, Kidwelly Tinplate Co. SER 943

The two Foden inverted vertical tandem compound engines and a Cole, Marchent and Morley horizontal tandem compound rolling mill engine have all been preserved in situ as part of the Kidwelly Industrial Museum (also see No. 21). This site had become very derelict and a new building has been placed around the Fodens, as their original house had largely disintegrated.

20) *Llangennech, Morlais Colliery* SER 1317a

This horizontal cross compound geared haulage engine, built c.1907 by Andrew Barclay Sons & Co, has been re-erected in the open air at Cefn Coed Colliery Museum, Crynant (see No. 40). Unfortunately, the restoration is not to a very high standard and many of the bearings are without their brasses.

21) *Llangennech, Morlais Colliery* SER 1317b

This duplex winder, built c.1907 by Andrew Barclay Sons & Co, has been re-erected at Kidwelly Industrial Museum. The engine is housed in its own building and the restoration is to a high standard.

25) *Rossett, nr. Wrexham, The Watermills* SER 471

One of the watermills has been converted to a dwelling and retains one preserved wheel and four sets of stones. The mill is apparently workable and the interior can be viewed with the permission of the owner. (The other mill is now offices and both wheels remain in situ)

34) *Cardiff, Canal Pump, Melingriffith, Whitchurch* SER 820

Following a period of dereliction, this waterwheel powered beam pump has been restored to its former appearance; the effect is slightly marred by the extensive use of machine-cut wood (I would personally like to see modern wood roughed up with an adze or similar device).

36) *Cardiff, National Museum of Wales* SER 683

The little four-column beam engine has been re-erected at the Dean Heritage Centre, Camp Mill, Soudley. It is housed indoors and can be turned by an electric motor, representing an advance on its previous setting. The water balance coal hoist also illustrated in this photograph is now on display at Big Pit Mining Museum, Blaenavon.

40) *Crynant, Cefn Coed Colliery* SER 1316

There are very few large winding engines preserved and it is gratifying that this horizontal duplex example, by Worsley Mesnes Ltd, has been kept in situ at Cefn Coed Colliery Museum. It is in good order and can be turned by an electric motor. An adjoining video shows a similar engine at work.

55) *Mountain Ash, Navigation Colliery (North Pit)* SER 1304b

This double-ended horizontal single cylinder fan engine, by the eponymous Waddle Patent Fan & Engineering Co, survived in situ into the 1980s. It was subsequently removed to Big Pit Mining Museum, Blaenavon and remains there in a dismantled state. The large Waddle fan was in a ruinous condition and was scrapped. Big Pit Mining Museum has a smaller, modern Waddle fan from Aberbeeg Colliery. It is believed that the Museum will be re-erecting the engine and fan in 2004-5.

61) *Pontypridd, Tymawr Colliery, Hopkinstown* SER 1312a

The pit closed in 1983 but the Hetty Shaft winder was retained with its house and headgear. It was allowed to deteriorate although efforts were made to keep the vandals at bay. These efforts were largely successful and a group of local volunteers has now restored the engine and has occasional open days when it can be seen turning on compressed air. The engine had been latterly driven by compressed air when in commercial use and has not

had steam in its cylinders for very many years.

64) *Swansea, Yorkshire Imperial Metals Ltd,*
Hafod Works, Landore SER 962

This is a large and early British-built uniflow engine, having been constructed in 1910 by J. Musgrave & Sons of Bolton. It ceased work in 1980 and Swansea Museum Services undertook to preserve it in situ. This attempt can only be described as disastrous, as the engine and house have been vandalised to an appalling extent. The house has had all the slates removed from its roof and the engine has been stripped of anything even remotely movable, including the top halves of the main bearing brasses. I can only see a sad ending to this sorry story.

80) *Crumlin, Navigation Colliery (South Shaft)* SER 1319c

This horizontal twin tandem triple-expansion fan engine was re-erected in the Welsh Industrial and Maritime Museum in Cardiff. It was regularly demonstrated turning on an electric drive and was a most impressive exhibit. Unfortunately, the Museum closed in early 1998 and the engine is now in secure storage at Nant Garw.

83) *New Tredegar, Elliott Colliery (East Pit)* SER 680b

Following the pit's closure, the horizontal twin tandem compound winding engine languished in its secure engine house. Very few people ever saw it and no restoration was undertaken. However, in more recent years it has been renovated fully, fitted with an electric motor drive and opened as a museum.

89) *Pontypool, Glyn Pit* SER 812

This site, including both the vertical winding engine and the nearby single cylinder beam pumping and winding engine, has been passed back to the ownership of the Hanbury family, the site's original owners. Although both engines and engine houses are in a very ruinous state, a local group has been formed and is attempting to preserve the site. According to their website, some stabilisation work has been performed on both buildings but further work will depend on their ability to raise funds.

96) *Portskewett, G.W.R., Sudbrook Pumping Station* SER 847c

As stated by Watkins, both of the Harvey & Co Bull pumping engines were saved for preservation. One is in store for the Science Museum at Wroughton and the other is in store for the National Museum of Wales at Nant Garw. Sadly, neither has ever been re-erected and, as far as we know, there are no immediate plans to re-erect either of these important survivors.

100) *Birkenhead, Mersey Railway Co.,*
Shore Rd Pumping Station SER 260

One of the A. Barclay & Co compound grasshopper beam pumps has been retained. The other was scrapped many years ago and the floor level at that end of the house was raised considerably. The surviving engine has now been restored and is billed as the *Giant Grasshopper*. It can be worked by hydraulic power and is most impressive. The little winch in the left foreground has been replaced by an electrically operated version. However, there are the remains of a large steam winch in a separate part of the building that is not publicly accessible.

106) *Brereton, near Holmes Chapel, Flour Mill* SER 1167

This derelict single cylinder Foden engine continues to survive. The mill was partly
converted to a dwelling many years ago and the engine house had been used as a stable.
Latterly, developers have acquired the site but the local council recently (2002) refused
their application to convert the mill into yet more dwellings. It is understood that the site's
potential as a heritage attraction is being explored.

114) *Kettleshulme, Sheldon Bros, Lumb Hole Mill* SER 1189a

This mill remains in the ownership of the Sheldon family and they have preserved the
engine and adjoining waterwheel (No. 115). The boiler also remains but is not workable.
The site is accessible by prior permission and is in a very pretty location.

115) *Kettleshulme, Sheldon Bros, Lumb Hole Mill* SER 1189b

See *114* above. The waterwheel has had new buckets but may not be workable as there was
flood damage to the weir some years ago.

135) *Eardington, Daniel's Flour Mill* SER 799

This site remains intact and is regularly demonstrated for visitors. This is another
waterpower site in a pretty location, right below a viaduct on the Severn Valley Railway.

139) *Madeley, Ironbridge Gorge Museum Trust,*
 Blists Hill Site SER 1440a1

David and *Sampson*, a set of twin beam blowing engines built in 1851 by Murdoch, Aitken
& Co, remain as photographed by George. In addition, they have since been motorised and
can be turned by an electric motor. They are a most impressive set and their setting (in an
open sided structure with a roof) allows the visitor an appreciation of their form that would
not otherwise be possible.

140) *Madeley, Ironbridge Gorge Museum Trust,*
 Blists Hill Site SER 1440a2

These are the same engines and site as depicted in No. 139 above.

141) *Madeley, Ironbridge Gorge Museum Trust,*
 Blists Hill Site SER 1440b1

This large inverted vertical single cylinder blowing engine remains exactly as photographed
by George, preserved in a static condition at the Blists Hill site of the Ironbridge Gorge
Museum Trust.

142) *Madeley, Ironbridge Gorge Museum Trust,*
 Blists Hill Site SER 1440b2

This is the same engine and location as illustrated in No. 141 above. However, it would
have been better if the text for the captions of Nos. 141 and 142 had been transposed, as it
is more readable in reverse order. Also, the caption for No. 142 refers to features that are
only visible in No. 141

147) *Shrewsbury, Coleham Head Sewage Pumping Station* SER 249

These two small Woolf compound beam pumping engines, built by W. R. Renshaw of

Stoke-on-Trent in 1897, have been preserved by Shrewsbury Council since they ceased work in 1970. They have recently been restored to a steamable condition and first ran in preservation during 2001.

VOLUME 5

Volume 5 was released in 2002, covering The North Midlands (Derbyshire, Leicestershire, Lincolnshire, Nottinghamshire and Staffordshire) and has 186 illustrations of steam engines, plant, buildings and steam vehicles. As before, several of the illustrated examples survive and these are listed below.

THE FACTS AND FIGURES
The subject matter of 50 of the 186 photographs published still survives (26.9%). These consist of:-

39 photographs representing 36 stationary steam engine sites (some sites contain two identical engines, others contain more than one different engine).
3 photographs of plant rooms associated with illustrated steam engines (all in the pottery industry).
3 exterior photographs of buildings.
2 photographs of the same steam tractor.
1 photograph of a steam 'centre engine'
1 photograph of a portable engine.
1 photograph of a scoop wheel associated with an illustrated steam engine.

The current disposition of the 36 different stationary steam engine sites is as follows:-
25 sites remain as Watkins photographed them, including 11 sites with no regular public access and 14 sites with variably accessible preserved engines.
9 have been moved off-site to a location where they have been re-assembled and are available for viewing. This includes 2 sites that had a pair of engines where each member of the pair has gone to a different location (Nos. 81 and 155).
2 have been moved off-site for preservation and remain in a dismantled condition. In addition, No. 45 is a photograph of a building exterior and is not counted as an engine photograph, but the contained engine does fall into this category.

THE SURVIVORS

1) *Bamford, Robert Marsland & Co, Bamford Mill* *SER 994a*

This very nice J. Musgrave & Sons drop valve tandem compound engine is preserved in situ. The mill's former owners, Messrs Carbolite, had preserved the engine in a workable condition and it was occasionally run on steam. This was a spectacular sight as the engine was very fast (103 rpm) and, for a time at least, it retained some of its original driving ropes. Sadly, Messrs Carbolite relocated, the mill was sold for conversion to houses and the engine has not run since. There are, however, possible plans for its restoration by a group including some of the mill's new residents. Unfortunately the two water turbines shown in photograph number 2 (SER 994b) were scrapped when the mill was being converted to housing. There was also a very early Greenwood and Batley condensing impulse steam turbine and a Buffalo duplex steam fire pump that were also scrapped during the conversion.

7) *Church Gresley, Cadley Hill Colliery, No. 1 Shaft* *SER 1221b*

This elderly horizontal duplex winding engine stopped work in 1988 and was removed for

preservation in 1989. It was last seen some years ago in a dismantled state, in the open air at Chatterley-Whitfield Colliery, Tunstall (see No. 174). To the best of my knowledge, it is still there although much material was relocated to the National Mining Museum at Caphouse Colliery, Yorkshire.

12) Cressbrook, Dickie & Co, Cotton Doublers SER 1194

This early cotton mill in its pretty and relatively isolated location survives in a sadly derelict condition. It is to be hoped that it will be eventually rehabilitated from its current ruinous state.

14) Cromford, Leawood Pumping Station, Cromford Canal SER 56

This non-rotative beam pumping engine by Graham & Co is now preserved and is run on steam several times per year. Although described by Watkins as a Cornish engine, analysis of its valve gear and steam cycle shows it to be more akin to a Watt engine cycle.

17) Hartington, DSF Refractories, Friden SER 1480

This Robey & Co horizontal duplex engine is now preserved at the Markham Grange Steam Museum at Brodsworth near Doncaster. It was previously preserved at the Cromford Wharf Steam Museum but was acquired by Tommy Nuttall for Markham Grange when the Cromford venture failed.

28) Pleasley, Pleasley Colliery, North Pit SER 1171

This Lilleshall Co horizontal duplex winder is now preserved in situ. The whole site was nearly lost following closure of the colliery but the winding engine houses and headgear were listed at the last moment, when one engine house had already lost its roof. Following a period of dereliction, a trust was formed and the site's slow recovery started. Both engine houses have had new roofs and the chimney has been repaired. The Lilleshall engine has been stripped down and is currently nearing the end of a comprehensive restoration. The large Markham engine on the South Shaft is patiently waiting its turn for restoration. It is hoped to be able to run the engines on steam eventually.

30) Stanton by Dale, Stanton & Staveley Ironworks SER 1427

The 1897 Glenfield Co Ltd inverted vertical triple expansion hydraulic pumping engine was removed for preservation in 1979. It has now been re-erected at Papplewick pumping station (see No. 127) and can be demonstrated running on steam. It does, however, still require a roof over it. The newer engine was scrapped in 1988 or 1989.

34) Wirksworth, Middleton Incline, Cromford & High Peak Railway SER 22

This pair of low-pressure beam engines, built by the Butterley Company in 1829 (not 1825 as stated by Watkins), is preserved in situ and can be demonstrated running on compressed air. This represents the early phase of railway practice with stationary engine haulage and the site is an extremely important survival.

44) Ibstock, Ellistown Colliery SER 1484a

This horizontal single cylinder engine by Fraser & Chalmers is currently languishing in a field behind the National Mining Museum at Caphouse Colliery. It was initially preserved at the Lound Hall incarnation of the National Mining Museum and had been fully re-erected with its pumps and a boiler so that it could be run on steam. Sadly, this museum

closed and some of the machinery was relocated to Chatterley-Whitfield Colliery Museum and then on its closure to Caphouse.

45) Ibstock, Ellistown Colliery SER 1484b

The Belliss and Morcom inverted vertical duplex (enclosed) engine that lived behind the doors shown in the photograph has followed the same route as the Fraser & Chalmers pumping engine and is also in a field at the National Mining Museum, Caphouse Colliery. Unlike the former engine, it has never enjoyed a period of indoor preservation and has spent over twenty years outdoors.

50) Leicester, Leicester Sewage Works,
Abbey Pumping Station SER 120

The Abbey Pumping Station was preserved as the Leicester Museum of Technology and three of the four Gimson Woolf compound beam engines can now be run on steam. There are also several off-site engines preserved in the former boiler room.

54) Loughborough, Loughborough College SER 124

Loughborough College is now Loughborough University but the beam engine and boiler remain much as they were when photographed by Watkins over 60 years ago. A railing has been placed around the boiler but, that apart, George would have had no trouble recognising it now.

57) Snarestone, Hinckley Water Works,
Snarestone Pumping Station SER 126

This site was partly scrapped following closure but the beams, connecting rods, crankshafts and flywheels of both engines remain in the house. The site has now been converted in to a private dwelling, still retaining the surviving parts of the beam engines.

59) Boston, Messrs Dunmore, Garage Proprietors SER 516c

According to the latest edition of *The Traction Engine Register*, Savage centre engine No.894 of 1922 – *Sanspareil* – is still preserved in Boston. The register does not give details of ownership beyond the nearest large town, so it is not possible to state whether it is still owned by Messrs Dunmore or has been passed on.

63) Boston, Towell & Co, Sawmills, Boston Docks SER 1173

This most interesting ensemble of engine and pumps, built by John Tickle in West Bromwich, is now preserved at the British Engineerium in Hove. It has been erected in the former coal store and can be demonstrated running on steam.

64) Crowle, Belton Brick Co SER 1502

To the best of my knowledge this horizontal single cylinder engine and two inverted vertical (enclosed) engines still survive in the long by narrow engine house. The site closed and was taken over by a firm of scrap dealers who removed the roof from the engine house and totally coated the engines with grey paint. They were hoping to realise these assets but as far as I know they are in the same state as they were over ten years ago. I would welcome any more recent information on the site.

65) Frithville, nr Boston, Mr R Crawford SER 571

Reference to *The Traction Engine Register* reveals that Foden tractor No. 13730 of September 1930 survives in the Boston area. This is likely to be the machine photographed by Watkins but I would welcome confirmation.

66) Frithville, nr Boston, Mr R Crawford SER 571a

As No. 65 above.

73) Owston Ferry, South Axholme Drainage Board, Owston Ferry Pumping Station SER 1501

This site remains just as Watkins photographed it in 1977. The pretty little Marshall horizontal tandem compound engine with drop valves remains in a preserved but static condition. The plant is intact with Cornish boilers and chimney and one could be forgiven for thinking that all it needs is a match.

74) Pinchbeck, Pinchbeck Marsh Pumping Station SER 194a

The single cylinder A-frame beam engine and scoop wheel (see number 75 below) have been preserved by the drainage authority responsible for the area and are regularly open to the public. This is another site that seems ready to steam at a moment's notice.

75) Pinchbeck, Pinchbeck Marsh Pumping Station SER 194b

This photograph illustrates the scoop wheel and this also remains much as it was in 1937 when Watkins photographed it.

81) Sleaford, Bass & Co, Maltings SER 1399

This huge complex of maltings with its power house and chimney still survive on the edge of Sleaford, although conversion work seems to be in progress. The two Robey horizontal tandem compound engines were removed for preservation and both can be seen running on steam in separate museums. The left hand engine, No. 23856, is at the Bass Museum in Burton-on-Trent, whilst. the right hand engine, No. 23857, is at the Forncett Industrial Steam Museum at Forncett St Mary, Norfolk.

86) Stamford, Messrs Briggs SER 517

According to *The Traction Engine Register*, this Barrows & Co single cylinder overtype portable engine remains in the Stamford area.

87) Stamford, Melbourn Bros, All Saints Brewery SER 1398

This Marshall inverted vertical single cylinder engine is preserved in situ in this preserved brewery. Indeed, there are occasional brewing days when the engine is operated but, sadly, the public are not admitted on those days.

88) Tattersall, Dogdyke Pumping Station SER 146

This beam engine and scoop wheel ensemble are preserved in situ and were restored to steam (for the second time) in 2002. There is also an operational diesel powered pumping station in the adjacent building.

95) Bestwood, Bestwood Colliery SER 388a

This vertical duplex winding engine is preserved in situ and access can be had via the Bestwood Country Park ranger service. The engine can now be turned by means of an

electrohydraulic winch operating an endless wire rope round the drum. This is a large and significant engine that largely lacks the recognition that it deserves.

107) Hucknall, Linby Colliery, No. 1 Shaft SER 1364

This is a confused item as the engine illustrated is actually the No. 2 shaft winder (Nos. ß40542-3, 1922, cylinders 24¼" x 40in, 100 psi, parallel drum 9ft 6in diameter). This engine was removed for preservation in 1983 and has been re-erected at Papplewick Pumping Station (see No. 127), where it can be seen in steam on steam days. The larger No. 1 winder was scrapped in 1989. Also, contrary to Watkins's statement, No. 1 was used, at least latterly, for winding men and materials and No. 2 was the coal puller.

117) Misterton, The Soss Drainage Station SER 46d

These two pretty pumping engine houses, situated in a remote corner of Nottinghamshire, have now been converted to dwellings. Nonetheless, they still manage to retain their interesting chimneys and have considerable presence.

125) Nottingham, Turney Bros, Leather Works SER 1493

This impressive inverted vertical single cylinder engine was removed for preservation in 1981 and is now on display at the Nottingham Industrial Museum at Wollaton Park. It was built by Tangye of Birmingham as No. 1053 of c 1889.

127) Papplewick, Nottingham Water Works, Papplewick Pumping Station SER 24c

These magnificent single cylinder beam pumping engines have been preserved and, apart from some safety precautions, remain much as they were when George photographed them in 1935. This is certainly one of the most ornate of the surviving steam pumping stations and can be seen in steam on regular steam days.

129) Sutton Bonington, Hathernware Ceramics SER 1483

I saw this Belliss and Morcom inverted vertical compound (enclosed) engine in November 1990 when it was in a disused but otherwise complete state. To the best of my knowledge it remains on site in the same state and the company is now trading as Naylor Hathernware. I would welcome any more recent information on this engine.

131) Amblecote, J. Hall Co SER 437

This six-column single cylinder beam engine of light construction is now preserved and on display at Thinktank in Birmingham, having been previously on display in the Museum of Science and Industry in Newhall Street. It is turned by an electric motor drive and is a very pleasant exhibit.

138) Brownhills, Potters Clay & Coal Co SER 1369a

This horizontal single cylinder Tangyes engine (No. 10453 of 1896) stopped work in 1975 and has remained in a disused condition ever since. It was last seen by an ISSES party in 2003 and was in much the same condition that it had been for over a decade. Visits may be made by prior arrangement.

139) Burslem, Burgess & Leigh, Middleport Pottery SER 1479a

This horizontal single cylinder engine, built in 1888 by William Boulton of Burslem, is

retained in situ. The owners now go under the title of Burgess, Dorling & Leigh and remain in production. Although the engine has not run since 1977 or 1978, it has recently undergone a degree of cosmetic restoration by the volunteers from Etruria Industrial Museum (see Nos. 152 and 153). The site also retains a working Lancashire boiler and it is possible that the engine may yet be returned to a steamable condition. The owners arrange regular factory tours but will also welcome visitors at other times by prior arrangement.

140) Burslem, Burgess & Leigh, Middleport Pottery SER 1479b

This is the slip room of the above site and now contains less plant and is motor driven, although still recognisable as the room that Watkins photographed.

141) Burslem, Dunn, Bennett & Co, Dalehall Pottery SER 1412

This site is now owned by Steelite International Ltd and they remain in the pottery trade. The small horizontal single cylinder engine remained operational until about 1986 and is still retained in situ. It can be demonstrated running on compressed air and may be visited by prior arrangement.

142) Burslem, Dunn, Bennett & Co, Dalehall Pottery SER 1412a

This is part of the slip room of the above site and remains much as it was although the filter press has gone and the line shafting is motor driven.

147) Eccleshall, Staffordshire Potteries Water Board,
Millmeece Pumping Station SER 1466[1]

This site passed into the ownership of Severn Trent Water and following cessation of steam pumping in 1979 was immediately leased to the Millmeece Pumping Station Preservation Trust. Both of the horizontal tandem compound pumping engines can be seen in steam on regular steaming days. The plant also includes three Lancashire boilers, an economiser plant with engine and a steam winch.

148) Eccleshall, Staffordshire Potteries Water Board,
Millmeece Pumping Station SER 1466[2]

This photograph also depicts the Ashton, Frost engine seen in No. 147. The other details are as for No. 147.

152) Hanley, Jesse Shirley & Son SER 430a

This site is now the Etruria Industrial Museum. Shirley's remain in business in a modern plant immediately behind the old mill. The single cylinder beam engine, *Princess*, was restored to steam in the early 1990s using a Cornish boiler recovered from a local swimming baths. Steam days are held several times a year.

153) Hanley, Jesse Shirley & Son SER 430b

The gear room of the above site remains in original condition except for the addition of necessary guards. It also contains a rare example of a workable Pulsometer pump and a small horizontal single cylinder engine driving a jaw crusher.

155) Hopwas, Tamworth Waterworks,
Hopwas Pumping Station SER 121

Both of these single cylinder beam pumping engines have been removed for off-site

preservation and can be seen running in two widely separated sites. One may be found at Snibston Discovery Park in Coalville, Leicestershire and the other is at Forncett Industrial Steam Museum at Forncett St Mary near Norwich.

156) Lichfield, South Staffs Waterworks, Sandfield Pumping Station SER 253

This nice example of a Cornish engine from the provinces, built by J. & G. Davies of Tipton, is preserved in situ. The water company have recently sold the property but a preservation group is being formed to look after the engine. It is to be hoped that a return to steam may be possible one day.

160) Rugeley, South Staffordshire Waterworks, Brindley Bank Pumping Station SER 1488

This most impressive horizontal tandem compound pumping engine, built in 1907 by Hathorn, Davey & Co Ltd of Leeds, is preserved in situ. However, the company no longer uses the station and a visit in 2001 showed evidence of some deterioration. The museum collection in the former boiler house is also showing signs of deterioration.

161) Rugeley, South Staffordshire Waterworks, Brindley Bank Pumping Station SER 1488b

This is the same engine as above. The horizontal duplex capstan is by John H. Wilson & Co. Ltd of Liverpool and was used for removing the well pump rods. The engine also has a vertical duplex barring engine. The pump house also contains disused filters with internal rakes turned by a water turbine that was driven by mains pressure.

162) Smethwick, Best & Lloyd, Brassfounders SER 849a

This four column single cylinder beam engine by Peel, Williams & Peel of Manchester is preserved on the Blists Hill site of the Ironbridge Gorge Museum Trust. After some years lying around, it has been re-erected as a workshop drive engine in the same building as the iron foundry; an environment where one presumes it feels at home. To the best of my knowledge the engine is a static exhibit although the workshop machinery can be turned, via lineshafts and belts, by an electric motor.

170) Stretton, Burton-on-Trent Sewage Works, Clay Mills Pumping Station SER 68

This magnificent pumping station complex ceased work in 1971 and for a time its future was uncertain. Fortunately, Claymills Pumping Engines Trust was formed and started work on site in 1993. The first beam engine was returned to steam in 2000 and work continues on the preservation of the site. The Woolf compound beam engine illustrated is B engine. A and B engines are in one engine house and stopped work in 1969. This house has become derelict and B engine remains in a poor and incomplete condition. The engines in the other beam engine house - C and D - are now workable and can be seen in steam on steaming days.

171) Stretton, Burton-on-Trent Sewage Works, Clay Mills Pumping Station SER 1358

This horizontal single cylinder Buxton and Thornley engine drives a Crompton dynamo (210V DC) via a flat belt. This is claimed to be the oldest workable dynamo in the country and is regularly demonstrated lighting its own house on steaming days. The pumping

station contains many other steam engines and on a steaming day up to 18 engines may be seen in steam.

174) Tunstall, Chatterley-Whitfield Colliery, Hesketh Shaft SER 1356

This large horizontal duplex winding engine by Worsley Mesnes Ironworks Ltd ceased work in 1976. The site then became a mining museum and the engine was cleaned up and opened to the public until the museum's closure in the 1990s. The engine was displayed in a static condition but was nonetheless an imposing machine. It is understood that consideration is being given to the re-opening of the site.

186) Wombourn, Bilston Waterworks, Bratch Pumping Station SER 761

These two inverted vertical triple expansion pumping engines ceased work in 1957 and 1960. They were retained but the one furthest from the camera was partly dismantled and is incomplete. The one closest to the camera was restored by local traction engine enthusiast Len Crane and returned to steam in 1995. There are occasional steam days although there is concern about the future ownership of the site.

VOLUME 6

Volume 6 was released in 2003, covering The South Midlands (Berkshire, Bristol, Buckinghamshire, Gloucestershire, Herefordshire, Hertfordshire, Oxfordshire, Warwickshire and Worcestershire) and has 163 illustrations of steam engines, plant, buildings, steam vehicles and water power. As before, several of the illustrated examples survive and these are listed below.

THE FACTS AND FIGURES
The subject matter of 45 of the 163 photographs published still survives (27.6%). These consist of:-

31 photographs representing 30 stationary steam engines. Two engines are each represented by two photographs (Nos. 14 and 16 - Victoria Waterworks, Bristol and Nos. 131 and 158 - the hypocycloidal engine formerly at Birmingham Museum of Science and Technology) and a further photograph shows two surviving engines in one house (No. 39 - Thomas Glenister Co, High Wycombe).
5 photographs of waterwheels. One of these is at the same site as one of surviving stationary steam engines.
5 photographs of portable engines.
1 photograph of a model stationary steam engine.
1 photograph of a ploughing engine.
1 photograph of a set of pneumatic hammers associated with one of the above waterwheel sites.
1 photograph of cast iron mill framing.

The current disposition of the 30 different stationary steam engines is as follows: -
Eight engines remain in situ as Watkins photographed them, including three sites with no regular public access and five sites with variably accessible preserved engines. One of the latter is still working commercially.
Thirteen have been moved from the location where Watkins photographed them to a location where they are available for viewing.
Six have been moved off-site for preservation and are not currently on public display, some being dismantled.

The current whereabouts of three engines is uncertain although they are believed to survive.

THE SURVIVORS

3) Maidenhead, Maidenhead Brick & Tile Co. SER 1206

This horizontal tandem compound engine, built in 1899 by Thomas Metcalfe of Bradford, was initially re-erected at Wendron Forge, Cornwall, where it was operated on compressed air. It is now at Preston Court, Kent (see IB 24.3, pp40-50) where it is within the area of the Preston Court Oast Steam Museum. When seen at the end of 2002 it was in a partly dismantled condition but it is earmarked for re-erection as an exhibit.

4) Speen, Sir Richard Sutton's Benham Park Estate SER 1280

This duplex undertype, built by Robey & Co Ltd as No. 32292 of 1913 was removed in c.1979-80 for preservation. It is now owned by Mr J. Bracey and is stored in an unrestored condition at Lambourn in Berkshire. Mr Bracey also removed a side-by-side compound by Robey from a pump house on the site and restored it to workable condition. This machine is mounted on a lorry trailer and has been taken to steam rallies.

5) Bristol City Docks, Prince's Wharf SER 1503

This Stothert and Pitt steam crane is preserved and in the care of Bristol Industrial Museum. It is workable and demonstrated on selected days throughout the year. The museum also uses it to perform occasional heavier lifts, for exhibit maintenance, but these are not publicised and tend to occur the day before a public steaming.

7) Bristol City Docks, Steam Bascule Bridge, Wapping SER 1140b

This horizontal duplex, bridge-opening engine is in the care of Bristol Industrial Museum. It has been on display in the museum but was not visible when I last visited the museum in 2001.

11) Bristol Gas Co., Stapleton Road Works SER 1286 j, k & i

One of the two inverted vertical single cylinder engines, by G. Waller & Co, was acquired by John Huish of Worle, Weston-Super-Mare and was on display in his private collection. This collection was disbanded some years ago and although many engines were moved to the Brecon Mountain Railway, this is thought not to have gone there. Its current whereabouts are unknown and I would welcome any information on this.

14) Bristol Waterworks, Victoria Pumping Station, Oakfield Road SER 11285a

This inverted vertical triple expansion pumping engine, built in 1913 by Hathorn, Davey & Co. of Leeds, remains in situ in a rusty and disused condition. Although it is believed that the water company have no immediate plans for either its renovation or removal, its long term future is best regarded as uncertain.

16) Bristol Waterworks, Victoria Pumping Station, Oakfield Road SER 11285c

Although the photograph is from a different angle, the engine illustrated is the same as that at No. 14 above.

21) J. S. Fry & Sons, Chocolate Manufacturers, No. 3 Factory SER 1037

This fine model is on display in Bristol Industrial Museum, Prince's Wharf, Bristol. The only known extant example of a full-sized Donkin-Farey tandem compound engine is owned by Mr J. Newnham and displayed in his front garden at High Easter, Essex. This particular example came from a London gasworks.

30) Purnell & Panter & Co., Meadow Street SER 7d

This four column, single cylinder beam engine lies dismantled in the store of Bristol Industrial Museum, where it was seen by ISSES members in 1989.

32) Stapleton Glen, Mill on the River Frome SER 294

This site has been excavated and consolidated since Watkins's visit. The waterwheel is intact and still turns idly, but the boiler has been excavated and the remains of the vertical steam engine are also visible within the remains of the mill. The engine consists of two supporting columns, entablature, crankshaft and flywheel; the cylinder and motion are missing. The boiler is externally fired and is a rare survivor.

36) Buckland, Chiltern Hills Water Co., Dancers End SER 142

This very pretty twin six column beam engine has been preserved off-site at Kew Bridge Steam Museum, London. It is demonstrated running under live steam every weekend and complements the rest of the extensive collection of pumping engines.

37) Chesham, Beechwood Brushes Ltd SER 1284

This Robey & Co compound overtype semi-portable engine is now preserved at Hollycombe Steam Collection and Gardens, Liphook, Hants. It is re-erected in a sawmill area and is regularly demonstrated in steam. An interesting feature of the set-up is the system for recirculating and cooling the condenser water by passing it over the roof of the engine shed, with an enclosed high speed engine driving the circulating pump. This is a relatively rare engine and is well presented in its new home.

39) High Wycombe, Thomas Glenister Co. SER 1281

Both of the engines illustrated survive off site. The Marshall compound overtype semi-portable engine is owned by Mr David Price of Churcham, Gloucestershire and is maintained in a workable condition in his private museum alongside his engineering works. The Davey, Paxman horizontal tandem compound engine has passed through the hands of two collector-dealers and is now with a third individual. The engine is currently dismantled and in covered storage.

48) Charfield, Tubbs, Lewis & Co., The Pin Mill SER 316

This tiny horizontal tandem compound engine was initially preserved by John Huish at Worle, Weston-Super-Mare and was re-erected in his private museum. It subsequently passed, along with a large part of his collection, to the Brecon Mountain Railway. The engine has been restored in the workshops of the railway but was nowhere to be seen when visited in 2004.

50) Frampton-on-Severn, Mr White, Fromebridge Mill SER 403

This mill is now a restaurant and although the machinery has been restored it is not

operated. Animal feed production ceased in 1989. As far as I can ascertain, the one water wheel shown still survives but is also not in use.

56) King's Stanley, Marling & Evans, Stanley Mill SER 1113

This textile mill with its ornate iron framing is still standing and is in private ownership. Any members wishing to view the interior would need to make a request of the site's owners.

60) Longhope, Mr Ivor Dodds, Sawmill SER 1244

This R. Hornsby & Sons single cylinder overtype portable engine is preserved off-site by a private owner in Gloucestershire.

67) Minchinhampton, St Mary's Mill, Chalford SER 1243a

Although long out of use, this impressive water wheel survives. The mill remains in private ownership and permission must be sought to visit. There may be rare open days.

68) Minchinhampton, St Mary's Mill, Chalford SER 1243b

This horizontal side-by-side compound engine, built by Tangyes Ltd of Birmingham, has been preserved in situ. It is now known to be engine No. 248 and was built c.1890. It is in reasonable condition and can still be turned on the bar. However, the boiler has long since been scrapped and there are no prospects of its return to steam in the foreseeable future. Access arrangements are as for No. 67 above.

69) Nailsworth, Walker & Co., Dunkirk Mill, Walking Stick Manufacturers SER 1213

This site has now been converted into dwellings but the water wheels survive in situ and are occasionally opened for viewing.

77) Ruspidge, Lightmoor Colliery SER 242c

This delicate four-column beam engine is the first engine to appear in two volumes of *Stationary Steam Engines of Great Britain*, as George not only photographed it in its working location, shown here, but also in preservation in Cardiff (Volume 4, No. 36, SER 683). As stated in *ISSES Bulletin* 24.3, p 35, it is now preserved at the Dean Heritage Centre, Camp Mill, Soudley. It is indoors and can be turned by an electric motor.

84) Stoke Gifford, James Pugsley & Co. SER 407

Although Watkins states that this compound ploughing engine, by McLaren & Co, was probably cut up, according to *The Traction Engine Register* it survives in the Bodmin area.

95) Hereford, Hereford Waterworks, Broomy Hill Pumping Station SER 747

This inverted vertical triple expansion pumping engine, built in 1895 by Worth, Mackenzie & Co Ltd of Stockton-on-Tees, has been preserved in situ and may be seen running on steam at regular open days. A 1906 extension to the engine house contains an inverted vertical duplex pumping engine by the same builder. The site is now known as the Waterworks Museum and is also home to a wide variety of preserved steam and internal combustion engines.

96) Cheshunt, Metropolitan Water Board, Turnford Pumping Station — SER 79

This rare side lever beam engine is preserved in situ. The later high pressure inverted vertical single cylinder engine that exhausted into it (see No. 80 – SER 79a) has long since been scrapped. The engine itself has been painted and somewhat sanitised, and now possesses little of the character that is evident in George's photograph.

101) Hemel Hempstead, Davies & Bailey, Boxmoor Ironworks — SER 344

This fine example of a Woolf compound, A-frame beam engine, built by J. & E. Hall & Co of Dartford, is now on public display in the Science Museum, Exhibition Road, London.

104) London Colney, Mr Eames, Timber Merchant — SER 533

This Brown & May single cylinder portable engine is now preserved at Lackham Museum of Agriculture and Rural Life, Lacock, Wiltshire.

105) Potters Bar, Wrotham Park Estate — SER 534

This small grasshopper beam engine, by Easton & Amos, remains in situ in a disused condition and has changed little in appearance over 50 years. It is believed that there may be plans to make it more publicly accessible as part of a visitor facility. At the moment, access is strictly by prior arrangement with Wrotham Park Estate.

111) Banbury, Hunt, Edmunds Brewery — SER 539

This table engine and a small horizontal single cylinder engine from the same brewery are displayed at Bygones Museum, Claydon, Oxfordshire. They could be demonstrated running on steam on a few occasions during the year but are currently on static display only.

112) Banbury, Mr Stilgoe, Adderbury Fields — SER 427

This single cylinder portable engine, Clayton & Shuttleworth No. 15635 of 1877, is now on public display at the Museum of English Rural Life, Reading.

113) Burford, Garne & Sons, The Brewery — SER 341

This nice vertical single cylinder engine, by Thomas Rose of Burford, was once displayed in the private collection of Mr Huish at Worle, Weston-Super-Mare. It is now in the Preston Court Oast Steam Museum. The cylinder assembly and flywheel assembly are stored separately and it is not known whether it is intended to reassemble the engine or sell it on.

117) Combe, Combe Sawmill — SER 324

This four column beam engine and the adjoining Cornish boiler have been preserved in situ and are demonstrated in steam several times a year. There is now evidence to suggest that Thomas Piggott & Co of Birmingham may have built the engine and boiler in c.1852. The boiler is almost certainly the oldest workable one in the country.

120) Hook Norton, The Hook Norton Brewery Co. — SER 1395

This horizontal single cylinder engine built in 1899 by Buxton and Thornley of Burton-on Trent, remains in commercial use at the brewery. Steam is now supplied by a modern

packaged boiler but, apart from less intrusive guarding around the engine, the engine remains as it was when photographed by George. To the best of my knowledge, this is the first engine to be encountered in this series that remains in genuine commercial use. The brewery has a visitor centre and it is possible to see the engine in action.

121) Kingham, Lainchbury & Co., Contractors — SER 426

This Lampitt portable engine, built in 1862 and possessing an overhung crank survives in private ownership at Long Whatton, Leicestershire.

125) Oxford, Morrell's Brewery — SER 343b

This tank-bed, A-frame beam engine has been preserved off-site at Abbey Pumping Station, Leicester. It is housed in the former boiler house with other exhibits and can be seen running on steam at occasional steaming events. The pumping station's original Gimson beam engines have also been preserved (see Volume 5, No. 50, SER 120). Unfortunately there is no evidence that the table engine seen next to the beam engine has been so fortunate.

129) Bedworth, Hawkesbury Canal Junction Pumping Station — SER 542)

This atmospheric beam pumping engine is preserved in Dartmouth as a memorial to Thomas Newcomen, as stated by Watkins. The engine is in a room off the Tourist Information Office and can be demonstrated moving under hydraulic power.

130) Birmingham, Birmingham Museum of Science and Technology — SER 1465e

These cross coupled beam engines, known as the 'Burman' double engine, have been re-erected in Thinktank, the Birmingham Museum of Science and Discovery at Millennium Point on Curzon Street. The Newhall Street site, where they were photographed, closed in 1997 and the new site opened in 2001. Although these engines were relocated, refurbished and motorised, some twenty two items of stationary steam interest remain away from public display.

131) Birmingham, Birmingham Museum of Science and Technology — SER 1465

This fascinating hypocycloidal engine is claimed to be the third oldest workable engine in the world and can be seen running on steam at Thinktank. It was previously at Newhall Street and has had a major refurbishment to keep it fit for display operation.

135) Leamington Spa, Leamington Spa Sewage Works, Princes Drive — SER 1219

This horizontal duplex tandem triple-expansion non-rotative pumping engine was removed for preservation in 1985 and is now in store at Crossness Pumping Station, London. The engine is dismantled and the large castings are stored in a compound out of doors. It is now known that it was built by James Simpson & Co Ltd, London & Newark as their No. 3040 in 1917.

137) Napton on the Hill, Napton Brickworks — SER 1486

According to Colin Bowden, this horizontal single cylinder engine built by J. Wilkes, Pelsall Foundry, near Walsall, had been partly dismantled in 1976-7 and was subsequently

removed in 1978. Colin's implication is that it was removed rather than scrapped but he does not know of its current whereabouts. Brian Hillsdon also has no record of this engine being preserved. Therefore, we would welcome any confirmation of this engine's fate and current whereabouts.

151) Belbroughton, Mr G. Bowkley, The Sawmill SER 490

This Edward Humphries single cylinder portable engine of 1893 is still preserved in the Hartlebury area and is the property of ISSES member John Selway who maintains it in a workable condition.

154) Churchill, B. Bache & Son, Churchill Forge SER 307a

This water-powered forge is preserved much as Watkins saw it and is opened to the public occasionally.

155) Churchill, B. Bache & Son, Churchill Forge SER 301b

As No. 152 above.

156) Dudley, M. & W. Grazebrook, Netherton Ironworks SER 465a

This non-rotative beam blowing engine has been re-erected, in the open, in the centre of a large roundabout at Dartmouth Circus, Birmingham. It is now largely obscured by trees and is best appreciated on foot. It was originally capable of being moved by hydraulic power but this was abandoned as it allegedly distracted motorists. In recent years it has been looking rather neglected but has now had some needed titivation.

158) Kidderminster, Brinton's Carpet Works SER 95

This hypocycloidal engine is the engine now on display at Thinktank in Birmingham and is also included at No. 131 (SER 1465) above.

162) Stourport, Holbrook & Co., Vinegar and Pickle Makers SER 1439

According to Colin Bowden, this horizontal single cylinder compressor engine, built by S. H. Johnson & Co, Stratford, London was removed in 1975/6. Colin's implication is that it was removed rather than scrapped but he does not know of its current whereabouts. Brian Hillsdon also has no record of this engine being preserved. Therefore, we would welcome any confirmation of this engine's fate and current whereabouts.

VOLUME 7

Volume 7 was released in 2003, covering The South and South West (Cornwall, Devon, Dorset, Hampshire, Isle of Wight, Somerset and Wiltshire) and has 122 illustrations of steam engines, plant, buildings, steam vehicles and water power. As before, several of the illustrated examples survive and these are listed below.

THE FACTS AND FIGURES
The subject matter of 45 of the 122 photographs published still survives (36.9%). These consist of:-

29 photographs of 32 stationary steam engines. These include one photograph showing two engines off site (No. 83) and two photographs showing the same engines in situ (Nos. 85 and 97). A further photograph (No. 54) shows four engines and one (No. 113) shows

two engines.
5 photographs of waterwheels.
2 photographs of road steam engines – one traction engine and one road roller. 2
photographs of portable engines.
2 photographs of buildings – one pumping station and one water powered brass mill.
1 photograph of a water wheel powered beam pump that is associated with one of the
waterwheel photographs (Nos. 65 and 66)
1 photograph of a gas engine.
1 photograph of mine processing equipment, including a set of stamps.
1 photograph of beer fermenting vats associated with a stationary steam engine site.
1 photograph of an annealing oven associated with a brass mill.

The current disposition of the 32 different stationary steam engines is as follows: -
Seventeen engines remain in situ as Watkins photographed them, including the two off site
engines referred to above (No. 83).
Three have been moved from the location where Watkins photographed them to a location
where they are available for viewing. This includes one (No. 16) that has been moved
within its own site.
Six have been moved off-site for preservation and are not currently on public display, some
being dismantled.
The current whereabouts of five engines is uncertain although they are believed to survive.
One engine has been dismantled for preservation but currently remains in its engine house.

THE SURVIVORS

1) Pool, South Crofty Tin Mine, Robinson's Engine SER 814

As stated by Watkins, this venerable 80in Cornish pumping engine is preserved on site by
the National Trust. However it is not publicly accessible without prior arrangement and
Brian Hillsdon reports that it is claimed to have suffered some vandalism.

2) Bovey Tracey, Kelly Mine SER 1463

The Kelly Mine Preservation Society has preserved the stamps, the water turbine, a
waterwheel, and drying and dressing sheds. Access is by arrangement with the Preservation
Society c/o 10 Cardinal Avenue, St Budeaux, Plymouth, PL15 1UK

3) Uffculme, Fox Bros, Coldharbour Mill SER 1114

The mill closed in 1981 and the Pollit and Wigzell cross compound engine ceased operating
at the same time, having been the last mill engine at work in the south-west. Fortunately a
preservation society was formed and has succeeded in maintaining the mill as a tourist
attraction. The Pollit engine remains in workable condition and other engines, both original
to the site and imported, are also workable.

6) Blandford St Mary, Hall & Woodhouse Brewery SER 1425

This horizontal single cylinder engine, built 1899 by Gimson & Co Ltd of Leicester,
stopped work in 1981. The firm has retained it in good order and can demonstrate it in
steam for interested visitors. Erected alongside the Gimson is a small horizontal single
cylinder engine by Ruston, Proctor & Co Ltd Lincoln (No. 25391 of 1902). This came
from the brewery of Skona Ltd in Gillingham, Dorset. This engine is not fully erected and
is not workable.

8) *Bridport, J.C. & R.H. Palmer, The Old Brewery* SER 1459a

This inverted vertical single cylinder engine, built in 1900 by Brown & May Ltd of Devizes, has been retained by Palmers and can be run for visitors although it is no longer in regular use. If past experience is any indicator, warming through has been found to be perfunctory to say the least!

9) *Bridport, J.C. & R.H. Palmer, The Old Brewery* SER 1459b

ISSES members Robert Cox and John Cooper have confirmed that the fermenting room is visually unchanged since Watkins photographed it in 1973. The only significant change is that the vats are now plastic lined but this is not visible externally.

13) *Poole, J.T. Sydenham & Co., Sawmills* SER 1374

This Wren & Hopkinson horizontal cross compound engine spent some years on display in the Arndale Centre, a shopping mall, in Poole. It was then removed and has now surfaced at the Centre for the Conservation of the Built Environment at Bursledon Brickworks, Hampshire. It is currently stored in a part-dismantled condition but it is to be hoped that it will eventually be rebuilt.

15) *Tarrant Gunville, Mr J. Dyer (Farmer)* SER 536

This compound traction engine, Foden Ltd, No. 9052, was actually built in 1919, not 1914 as stated. It is now preserved and on public display at World of Country Life, Sandy Bay, Exmouth. It now carries the name *Rob Roy*.

16) *Weymouth, Devenish Weymouth Brewery* SER 1457

This elderly horizontal single, by Barrett, Exall & Andrewes of Reading Ironworks, was relocated within the brewery to a room visible from the road fronting the property. This room also contains a horizontal single by E. S. Hindley of Bourton. The brewery closed subsequently and the engines are now included in the Timewalk Museum.

21) *Horndean, George Gale & Co., Brewery* SER 1451

This inverted vertical duplex engine has had a chequered career, including being installed in the same site twice. It is believed to have started life as a marine engine in a ferry and was later installed at Horndean. It was removed from the brewery in 1984 and was placed on display at Eastney Pumping Station (see No. 27) where it could be seen in steam. Gales reacquired it and it was placed back in its original location in 1997. It can be run on steam and is part of their regular brewery tours.

22) *Horndean, George Gale & Co., Brewery* SER 1451a

This small inverted vertical single cylinder (enclosed) engine by Belliss and Morcom was also removed in 1984 and is currently in store at the Centre for the Conservation of the Built Environment at Bursledon Brickworks, Hampshire.

25) *Otterbourne, Southampton Waterworks,*
Otterbourne Pumping Station SER 1376c

Otterbourne had four Woolf compound beam engines, by James Simpson & Co, arranged in two pairs (A, B and C, D). A and B were scrapped in 1936 and were never seen by Watkins. The photograph is of C engine and according to Brian Hillsdon it is believed that

this is the engine that has been languishing in the yard of the former gasworks at Sherborne for many years.

27) Portsmouth, Eastney Sewage Pumping Station SER 486

The two Woolf compound beam engines, built in 1887 by James Watt & Co, have been restored and one can be demonstrated in steam. The site is open and in steam on the last Sunday of the month. The site is also home to a small grasshopper beam engine and some large Crossley gas engines.

28) Southwick, Golden Lion Hotel, Home Brewery SER 1378

This home brewery has been preserved and the little horizontal single cylinder engine was restored to steamable condition. However, there were difficulties with HM Customs & Excise and the site has not worked for several years with no prospect of being worked again. A local resident is willing to show visitors round but this is an infrequent event and the site is showing signs of deterioration.

32) Twyford, Southampton Waterworks, Twyford Pumping Station SER 1377

This Hathorn, Davey inverted vertical triple expansion pumping engine has been preserved in situ and can be steamed from one of the original Babcock and Wilcox watertube boilers. The well pumps were situated in the room to the left of the picture and operated by the pitman rod seen in the foreground. This rod and its pumps have been removed. The bellcranks are preserved in the boiler house. This is an unusually complete Edwardian waterworks and includes diesel engines and lime kilns.

37) Cowes, E. Cole & Sons, Shambler's Yard, Ship Repairers SER 1375

This little grasshopper beam engine, by J. P. Almond of North Shields, remained in use on compressed air until 1996. It was subsequently acquired by Mr List-Brain and currently resides at Preston Court near Canterbury. Although dismantled, there are possible plans for its re-erection and return to steam operation.

38) Newport, Ernest Taylor, Albany Steam Museum SER 1473

This Pollit and Wigzell horizontal single cylinder engine was relocated to the Cothey Bottom Heritage Centre, Ryde. This was a joint venture between Westridge Construction Company and Isle of Wight County Council, later renamed Westridge Leisure Centre. Unfortunately it closed over a decade ago and access is by prior arrangement only.

45) Bath, Mr Bowler, Engineer SER 1323

A gas engine, presumed to be this one, is on display in Mr Bowler's reconstructed engineering shop that is part of the displays at the Museum of Bath at Work, Julian Road, Bath. This museum also contains a small horizontal single cylinder steam engine of Mr Bowler's own manufacture.

46) Bath, Stothert & Pitt SER 244

This Stothert and Pitt four column beam engine, of 1866 vintage, is now to be found at Bath University on Claverton Down. It has been erected indoors at the foot of a stairwell and is fairly well hidden. A compressed air supply is present alongside the engine and the

engine has a suitable coupling fitted. However, I have never seen the engine turned and I suspect this is a seldom-to-never procedure. The engine can be seen at any reasonable time and the University security guards have always been friendly and helpful.

48) *Bathampton, Sawmill, nr Station* *SER 1209*

Contrary to Watkins's statement, this Marshall duplex overtype portable engine was never acquired by Mr Huish of Worle. It did, however, pass through two intermediate owners to end up in private preservation at Bishop's Castle.

53) *Blagdon, Bristol Waterworks Co.,*
Blagdon Pumping Station *SER 87*

As stated by Watkins, two of the four Woolf compound engines were scrapped and two retained, including the one illustrated. The boilers were also removed and the chimney has been shortened substantially. In recent years the waterworks company has smartened the engines up and arranged for one to be turned by an electric motor. The station is opened to the public on summer Sunday afternoons.

54) *Bridgwater, Bridgwater Gas Works* *SER 1373a*

Although Watkins states that most of the plant was saved by collectors, the current whereabouts of the engines are unknown. According to Brian Hillsdon's notes, the two smaller Donkin engines were serial Nos. 6101 and 6102, and the larger pair were numbers 7877 and 7878. If any readers know the current location of any of these we would be grateful if they could inform us. A Donkin engine claimed to have been from Bridgwater Gas Works was seen at the 'Great Dorset Steam Rally' in 2004 but there are no further details to corroborate this.

64) *Chelvey, Bristol Waterworks, Chelvey Pumping Station* *SER 32d*

This Lilleshall inverted vertical triple expansion pumping engine has been dismantled within its house and is awaiting collection by its new owner. Unfortunately there remains real doubt about its future and it may yet be lost.

65) *Claverton, Kennet & Avon Canal,*
Claverton Pumping Station *SER 777a*

This amazing waterwheel powered beam pump has now been preserved as stated by Watkins and is operated several times per year.

66) *Claverton, Kennet & Avon Canal,*
Claverton Pumping Station *SER 777b*

As above.

67) *Clutton, nr Bristol, Osmond & Co, Sawmills* *SER 1393*

This Ruston, Proctor & Co single cylinder portable engine is preserved by a private owner in the Bristol area.

70) *Flax Bourton & Long Ashton,*
Barrow & Gatcombe Watermills *SER 318*

I contacted local historian Joan Day and she confirmed that there were mills at Barrow and Gatcombe. She believes that Watkins's photograph is probably of the Barrow wheel and

confirmed that it survived in situ when seen about ten years ago. I would welcome any more recent information on this.

73) Highbridge, N.D. Buncombe, Contractors SER 537

This unique 'Shay-type' Aveling and Porter road roller survives in the Wokingham area according to *The Traction Engine Register*.

74) Keynsham, Gould Thomas & Co., Albert Mills SER 297a

These logwood grinding mills have now been converted to a private dwelling and the waterwheel has been preserved in situ.

78) Keynsham Valley Colour Mills SER 296

This is also known as Chew Mill and according to Joan Day, Evens's should probably be Ivens. The mill closed in the 1870s and the building has now gone. However, the waterwheel does survive as part of the Memorial Park.

82) Othery, Somerset Rivers Board,
Aller Moor Pumping Station SER 92a

This twin cylinder vertical engine, built in 1869 by Easton, Amos & Anderson, has long been preserved in situ by the drainage board. The engine house is virtually unchanged since working days and is a pleasure to visit.

83) Othery, Somerset Rivers Board,
Aller Moor Pumping Station SER 92a [sic]

These two engines are preserved in the coal store at Aller Moor pumping station and show the diversity of Easton's designs. They are illustrated in their working environment by pictures Nos. 85 and 97 below.

84) Othery, Somerset Rivers Board,
Aller Moor Pumping Station SER 92b

This building survives but the loss of the chimney, filling in of the discharge channel and erection of an adjoining extension have changed its appearance somewhat.

85) Othery, Somerset Rivers Board,
Southlake Pumping Station SER 91

This is the same engine illustrated in the foreground of No. 83 above.

87) Paulton, Old Mills Colliery SER 1211

This horizontal duplex winding engine, built in 1861 by Wm Evans & Co, is in the store of Bristol Industrial Museum and was seen there by a party of ISSES members.

91) Saltford, Harford & Bristol Brass Co., Saltford Mill SER 302a

According to Joan Day this brass works building survives as illustrated and is open to the public on a monthly basis during the summer.

92) Saltford, Harford & Bristol Brass Co., Saltford Mill SER 302b

Joan Day reports that this wheel, used for tool grinding, does survive but is on private land

and not publicly accessible. There is a separate 18ft diameter wheel that may be seen when the mill is open to the public.

93) Saltford, Harford & Bristol Brass Co., Saltford Mill SER 302c

This annealing oven does survive as illustrated.

97) Stoke St Gregory, Somerset Rivers Board, Stanmoor Pumping Station SER 89

This unique diagonal duplex pumping engine is preserved at Aller Moor Pumping Station and is seen in the background of photograph No. 83 above.

98) Stoke St Gregory, Somerset Rivers Board, Curry Moor Pumping Station SER 94a

As stated by Watkins, this vertical duplex pumping engine, built by Easton, Amos & Son in 1864, remains preserved in a new circular house. A good view can be had through the large windows but internal inspection requires arrangement via the drainage authority.

101) Taunton, E. & W.C. French, Tannery SER 243

Following a period spent in a part-dismantled state, this beam engine was relocated to the Poldark Mine at Wendron Forge, near Helston, Cornwall. After that site's closure and subsequent re-branding, the engine has again been relocated. It is now the property of a private collector and is in covered storage in Somerset.

102) Taunton, Pearsall's Silk Mills SER 236

As stated by Watkins, this rather delicate Easton and Amos Woolf compound beam engine is now on display at the Somerset County Museum, Taunton Castle, Taunton. The engine can be turned by an electric motor and is set lower than the main floor level, providing a good if somewhat unusual view.

107) Westonzoyland, Somerset Rivers Board, Westonzoyland Pumping Station SER 93

This pumping station is now preserved and administered by the Westonzoyland Engine Trust. The vertical duplex pumping engine, built in 1861 by Easton, Amos & Sons, was restored to steam in 1983 and has continued to delight visitors ever since. The engine no longer pumps and the pump well is dry, so the pump can be seen clearly. The site is also home to many other small engines and is well worth a visit.

111) Devizes, Wadworth & Co., Brewery SER 1218

This independent brewery remains in business and the horizontal single cylinder engine, by George Adlam and Son of Bristol, is retained in situ. It can be demonstrated in steam for interested parties.

113) Great Bedwyn, Kennet & Avon Canal, Crofton Pumping Station SER 411

As stated by Watkins the two Cornish beam pumping engines are preserved and are operated, under load, on several steaming days throughout the year. The Kennet and Avon Canal Trust purchased the station in 1968 and the first engine (the 1812 engine) was returned to steam in 1970. The site has been operated successfully ever since and is now run by the Crofton Branch of the Kennet and Avon Canal Trust.

VOLUME 8

Volume 8 was released in 2003, covering "Greater London & South East" (Kent, London, Middlesex, Surrey and Sussex) and has 143 illustrations of steam engines, buildings, steam vehicles and locomotives. As before, several of the illustrated examples survive and these are listed below.

THE FACTS AND FIGURES

The subject matter of 44 of the 143 photographs published still survives (30.8%). These consist of:-

37 photographs of 37 stationary steam engines. These include two photographs showing two engines (Nos. 118 and 120) and two engines that are each shown by two photographs (Nos. 91- 92 and Nos. 112-113).
3 photographs of two locomotives. 2 photographs of traction engines.
1 photograph of a boiler. It is not certain whether this survives or if a similar boiler survives in the same complex.
1 photograph of a building.

The current disposition of the 37 different stationary steam engines is as follows: -
Thirteen engines remain in situ as Watkins photographed them. Eight of these are regularly accessible to the public, including four on one site. The other five engines may be seen by applying to the owners.
Nineteen have been moved from the location where Watkins photographed them to a location where they are available for viewing.
Two engines are represented by substantial parts only. One is a beam (No. 60) that is preserved on public display and the other is a cylinder assembly (No. 77) that is in a museum store.
One engine (No. 26) has been dismantled for a private collector and is in store. This is not publicly accessible.
One engine (Nos. 112-113) is owned by a private collector who is prepared to show it to enthusiasts.
One engine (one of the two in No. 118) is dismantled and in store at a publicly accessible site (No. 14)

THE SURVIVORS

3) Ashford, Henwood Pumping Station SER 483

Both of the Thomas Horn single column, Woolf compound beam engines have been preserved off-site and can be demonstrated running on steam. The earlier engine that is illustrated is on display at the Preston Oast Steam Museum, Preston, near Canterbury and is publicly accessible on two occasions each year. The other engine, dating from 1885, has been re-erected at the Bredgar and Wormshill Light Railway near Sittingbourne and is also demonstrated running on steam.

4) Bromley, Metropolitan Water Board,
Shortlands Pumping Station SER 12a

This fine pumping station building survives and has been converted into a dwelling.

13) Dover, Dover Waterworks SER 1383

Both of the Worthington-Simpson inverted vertical triple expansion engines survive. The illustrated engine is No. 5056 and this is at Forncett Industrial Steam Museum, Forncett St

Mary, near Norwich. It is demonstrated in steam on a monthly basis during the summer season. The other engine remains in situ at Dover and is deteriorating. The owning company now has little desire to retain it and its future must be regarded as uncertain.

14) Erith, Metropolitan Drainage, Southern Outfall, Crossness Pumping Station SER 15

Following many years of dereliction and decay, the Crossness Engines Trust was set up and has spent 18 years restoring *Prince Consort*, one of the four triple expansion beam engines at this site. This work culminated in the official starting of the engine, under steam, by the Prince of Wales on 15 September 2003. The site is open on selected Tuesdays and Sundays and a number of steaming days take place as well.

15) Faversham, Shepherd Neame Ltd, Brewery SER 1201

This remains as an independent brewery and both the illustrated engine and the Tangye referred to in the text have been preserved in situ. Both engines can be demonstrated running on steam and permission to visit can be obtained from the brewery.

16) Folkestone, Folkestone Waterworks, Upper Cherry Garden Pumping Station SER 1202

These two Worthington type horizontal twin tandem triple expansion, non-rotative pumps, claimed to be the first of the type in England, have been preserved off-site. The illustrated engine, No. 2379, has been re-erected at Brede Waterworks near Hastings. It can now be run on compressed air but it is intended to operate it on steam in due course. Engine No. 2380 is currently stored, in a dismantled state, at Kew Bridge Steam Museum, London (see Nos. 91-95). This engine is seized due to rust in the cylinders.

17) Folkestone, Folkestone Waterworks, Upper Cherry Garden Pumping Station SER 1202a

This rare steeple engine is believed to be by Tuxford and is now at Preston Oast Steam Museum, Preston, near Canterbury. It is essentially un-restored but can be run on steam on their occasional open days.

26) Lydd, Folkestone Waterworks, Denge Pumping Station SER 1203

This side-by-side compound pumping engine was removed for off-site preservation in 2001. It is now in the care of a private collector and is in store in Derbyshire. Although this engine is plated as a Worthington-Simpson, it is actually an example of 'badge engineering'; being a product of Robey & Co Ltd, Lincoln. It is their No. 47803 of 1936. In the centre background of the picture there is an inverted vertical compound (enclosed) engine by E. Reader & Sons Ltd, Nottingham. This is now on display at Brede Waterworks near Hastings.

31) Margate, Cobb's Brewery, King Street SER 224a

Contrary to George's statement, this engine did survive the plant's replacement in 1951. For many years it was on display at the Royal Museum of Scotland in Edinburgh. It is now in store, but complete and capable of being viewed, in the collections centre of the Museum of Scotland at Granton. There are weekly public tours but the impressive collection can be viewed at other times by arrangement.

40) Romney Marsh, The Farm, Checkfield Hill SER 484

According to *The Traction Engine Register*, this McLaren traction engine is preserved in the Science Museum's Wroughton store.

42) Sittingbourne, Bowater's Paper Mills SER 765a

This W. G. Bagnall articulated locomotive is preserved on the Welshpool and Llanfair Light Railway, Llanfair Caereinion, Powys. It is not in an operational state.

45) St. Michaels, nr Tenterden, Mr. Jarvis, Farmer SER 766

According to *The Traction Engine Register*, this Aveling & Porter traction engine survives in the Hastings area.

50) Bermondsey, Tower Bridge, A and B engines SER 1420a

These two twin tandem compound hydraulic pumping engines and accompanying boiler plant are preserved in situ. They are now accessible to the public as part of 'The Tower Bridge Experience' and one engine can be turned, very slowly, on compressed air.

51) Bermondsey, Tower Bridge, C engine SER 1420b

This cross compound hydraulic pumping engine is now preserved at Forncett Industrial Steam Museum, Forncett St Mary, near Norwich. It is demonstrated in steam on a monthly basis during the summer season.

52) Bethnal Green, Mann, Crossman Paulin Brewery, Whitechapel Road SER 530a

This single cylinder beam engine was removed in 1978 and eventually found itself at Coldharbour Mill Working Wool Museum in Uffculme, Devon. It has now had a major refurbishment and been re-erected to run on steam. It is in a former beam engine house and nicely complements the mill's horizontal cross compound engine (see Volume 7, No. 3). Photograph No. 53 (actually transposed with No. 54) depicts the horizontal single cylinder engine that was on the opposite end of the crankshaft. This engine was largely scrapped although Kew Bridge Steam Museum does have the governor in store. It is possible that a private collector also has the cylinder.

55) Finsbury, Nicholson's Gin Distillery SER 395a

This single cylinder A-frame beam engine was preserved initially in the electrical engineering department at Loughborough University. It is now hidden inside a modern industrial building at Nottingham Transport Heritage Centre, Ruddington. It has been re-erected but is not readily visible unless the door is open or you know whom to ask.

56) Finsbury, Nicholson's Gin Distillery SER 395b

This pretty little table pump by Carrett, Marshall of Leeds, or its identical twin, is on display at Armley Mill – Leeds Industrial Museum, Leeds.

60) Hammersmith, Metropolitan Water Board, Hammersmith Pumping Station SER 17a

Amazingly, this latticework beam survived the scrapping of the rest of the plant at this comprehensively equipped pumping station. It has been displayed on at least two sites prior to coming to its current resting place at Kew Bridge Steam Museum, Kew Bridge Pumping Station (see Nos. 91-95 below). It is on display in the open air in an elevated position.

63) Hammersmith, Metropolitan Water Board, Hammersmith Pumping Station — SER 17d

As stated by Watkins, this single cylinder oscillating engine is preserved by the Science Museum and is on display at South Kensington.

75) Poplar, North Thames Gas Board, Poplar Works — SER 1391

Both of the Hunter & English engines survive in preservation and are in sites open to the public. Unfortunately, as the two engines are identical, it is not possible to say where the illustrated engine is (but it is in one of two places). One engine is preserved at Forncett Industrial Steam Museum, Forncett St Mary, near Norwich. It is demonstrated in steam on a monthly basis during the summer season. The other engine is at The Village at Fleggburgh near Great Yarmouth. When last seen it was looking unloved and is probably not capable of being steamed. This latter site was due to close in September 2004 and the contents were to be auctioned.

77) Southwark, South Metropolitan Gas Co., Old Kent Road — SER 532a

As Watkins surmised, the cylinder block of this unique annular compound beam engine was indeed preserved for posterity. It is currently in the Science Museum's store at Wroughton in Wiltshire. It is understood that George's representations on the engine's behalf were instrumental in this component being saved.

78) Southwark, South Metropolitan Gas Co., Old Kent Road — SER 532b

As stated by Watkins, this Easton & Amos six-column, Woolf compound beam engine was preserved at the Birmingham Museum of Science and Industry. I am pleased to report that it is now on display at Thinktank, that museum's successor. It remains in a workable condition and is demonstrated regularly running on steam.

82) Tottenham, Markfield Road Sewage Pumping Station — SER 1178a

This Woolf compound beam engine is preserved in situ. It has been operated on steam in the past but it has been suffering boiler problems and is not operable currently.

86) Wandsworth, Springfield Mental Hospital — SER 220b

As stated by Watkins, this Maudslay table engine is preserved by the Science Museum and is on display at South Kensington.

87) Wandsworth, Young & Co. — SER 331

These two A-frame, Woolf compound beam engines are preserved in situ by Young & Co. at their Ram Brewery. They have not been run commercially for many years but are thought to be still operable for interested parties. They may be seen on application to the brewery.

91) Brentford, Metropolitan Water Board, Kew Bridge Pumping Station — SER 16a

This site is now the Kew Bridge Steam Museum and is home to four Cornish beam engines, a Bull engine and several engines that have been moved from other sites. The engine illustrated is known as the '100-inch engine' and is preserved in situ. Unfortunately, it is not

workable and its restoration to steam is regarded as a low priority.

92) Brentford, Metropolitan Water Board, Kew Bridge Pumping Station SER 16b

This is the same engine as illustrated in No. 91 above.

93) Brentford, Metropolitan Water Board, Kew Bridge Pumping Station SER 16c

The right hand engine, known as the 'East Cornish Engine', was scrapped in 1946. The left hand engine, known as the 'West Cornish Engine', has been preserved in situ as part of the Kew Bridge Steam Museum. It is demonstrated running on a regular basis.

94) Brentford, Metropolitan Water Board, Kew Bridge Pumping Station SER 16d

The Maudslay engine was built in 1838 by Maudslay, Sons & Field and was restored to working order in 1985. It is also demonstrated running on steam and tends to alternate with the 'West Cornish engine' (see No. 93 above).

95) Brentford, Metropolitan Water Board, Kew Bridge Pumping Station SER 16e

Harvey & Co of Hayle built the Bull engine in 1856-7. It is the only surviving in situ example and Kew Bridge Engines Trust is planning to return it to steam operation in 2005.

100) Hanworth, Metropolitan Water Board, Kempton Park Pumping Station SER 1434

This site operated these mighty inverted vertical triple expansion engines until 1980. Following a period of uncertainty and relative neglect, the Kempton Great Engines Trust was formed with the aim of bringing at least one engine back to life. This was achieved during 2002 but teething problems have meant that the official public opening, in steam, was held during 2004. The operable engine is No. 6, as illustrated by George.

105) Staines, Metropolitan Water Board, Littleton Pumping Station SER 1014

Of these four horizontal single cylinder uniflow pumping engines, the one furthest from the camera (No. 5020) is preserved in situ. The rest have all been scrapped and the surviving engine cannot be turned, as there is no longer any steam on site. There is also a preserved Ashworth & Parker inverted vertical compound (enclosed) generating engine in the same room.

109) Banstead, Banstead Mental Hospital SER 1472

This single cylinder A-frame beam engine, by Easton & Anderson, was removed in 1979. It is now displayed and run on steam at Bressingham Steam Museum, near Diss, Norfolk.

110) Betchworth, The Dorking Greystone Lime Co. SER 479

This is one of three surviving Head Wrightson locomotives and is preserved at The North of England Open Air Museum at Beamish. It is stated to be currently undergoing an overhaul.

111) Betchworth, The Dorking Greystone Lime Co. SER 479a

As for No. 110 above.

112) Betchworth, The Dorking Greystone Lime Co. SER 396

Baker Perkins Holdings Plc of Peterborough had both of the Perkins high pressure engines from Betchworth and preserved them until they moved from their old works in the 1990s. The smaller engine (not illustrated) is now at the Cadbury Collection in Bournville, Birmingham. This is behind Cadbury's World and may not be readily accessible. Members wishing to see this would be well advised to make enquiries beforehand. The larger, illustrated, engine is now owned by W. H. Shoebridge & Sons Ltd and is stored in a depot at Piddington in Northamptonshire. Mr Shoebridge will show the engine to persons making an appointment.

113) Betchworth, The Dorking Greystone Lime Co. SER 396a

As for No. 112 above.

114) Betchworth, The Dorking Greystone Lime Co. SER 396b

In SERG Bulletin 6,1 (spring 1984) we published a letter from the late Jim Chase stating that he had just visited this derelict site and found what he believed may be a Perkins high pressure boiler. This sounded to be larger than that illustrated and may have been the boiler for the larger engine, especially as Jim found a space that he believed may have contained a further boiler. Unfortunately we have not received any more recent reports. A *Guide to the Industrial Archaeology of Surrey,* published in 1990, states that the remains on this site are grade II listed and that the site is undergoing a programme of conservation of industrial features. I would welcome any more information on this.

118) Croydon, Croydon Waterworks, Addington Pumping Station SER 392a

Although Watkins implies that Easton and Anderson built the two engines in 1888, Glenfield Co Ltd of Kilmarnock built one of the pair in 1893. Both engines have been removed for preservation. The earlier, London-built engine, is in store at Crossness Pumping Station (see No. 14), whilst the Glenfield engine has been re-erected at Strumpshaw Hall Steam Museum near Norwich and can be turned on compressed air.

120) Croydon, Croydon Waterworks, Waddon Pumping Station SER 1205

Both of the horizontal cross compound pumping engines were preserved off-site following the official cessation of pumping in June 1983. The 1910 engine is preserved at Kew Bridge Steam Museum and is demonstrated running on steam on a weekly basis. The 1915 engine is at Strumpshaw Hall Steam Museum near Norwich and can be turned on compressed air.

125) Walton, Metropolitan Water Board, Walton Pumping Station SER 1435

One of the four Thames Ironworks Co inverted vertical triple expansion engines has been preserved in situ. This is, correctly, No. 800-4. It is no longer operable, following the scrapping of the boiler plant, but is maintained in a reasonable condition. Viewing is possible on application to Thames Water.

135) Horsham, King & Barnes, Brewery SER 1422a

This brewery closed in about 2000 and the Hindley horizontal single cylinder engine is now preserved in the visitor centre at Hall & Woodhouse's brewery at Blandford St Mary, Dorset (see Volume 7, No. 6, SER 1425).

136) Horsham, King & Barnes, Brewery SER 1422b

This Hayward Tyler horizontal single cylinder engine is also preserved by Hall & Woodhouse in Dorset. It has been integrated into their brewery tour and is turned by a discreet motor.

137) Hove, Brighton Waterworks,
Goldstone Pumping Station SER 229

Goldstone Pumping Station is now the home of the British Engineerium. The illustrated engine is the one built in 1866 by Easton, Amos & Sons of London. It stopped work in the late 1940s and although preserved in situ is now incomplete and not capable of being worked. The 1875 Woolf compound beam engine, by Easton and Anderson stopped work in 1952 and has now been restored fully. It can be seen running on steam on a monthly basis.

138) Lewes, Harvey's Brewery SER 1423

This pretty little horizontal single cylinder engine, by Pontifex & Wood of London, is preserved in situ by the brewery. It can be seen on request and is capable of being run on steam. The same room is also home to an inverted vertical single cylinder engine, by Alfred Shaw of Lewes, that was relocated from the nearby Star Lane Brewery.

VOLUME 9

Volume 9 was released in 2004, covering East Anglia & Adjacent Counties (Bedfordshire, Cambridgeshire, Essex, Norfolk, Northamptonshire & Suffolk) and has 124 illustrations of steam engines, buildings, steam vehicles, locomotives and windmills. As before, several of the illustrated examples survive and these are listed below.

THE FACTS AND FIGURES

The subject matter of 39 of the 124 photographs published still survives (31.5%) in a variable condition. These consist of:-

23 photographs of 23 stationary steam engines. These include three semi-portable engines; one undertype and two overtypes.
Photographs of "road" engines; two of road rollers, two of traction engines and one showing a pair of ploughing engines.
3 photographs of portable engines.
3 photographs of windmills; one for corn grinding and two for pumping. One of the latter is in a ruinous state
1 photograph of a boiler associated with one of the stationary engines (No. 35).
1 photograph of mill gearing associated with the above boiler and its engine.
1 photograph of a model stationary steam engine, current location not known.
1 photograph of a locomotive.
1 photograph of waterwheels.

The current disposition of the 23 different stationary steam engines is as follows: -

Six engines remain in situ as Watkins photographed them. These include one engine in a museum (No. 79), one engine "preserved" in a derelict condition (No. 35) and one site that is disused (No. 54). There is regular public access to only three sites (Nos. 5, 17 and 79). Nine have been moved from the location where Watkins photographed them to a location where they are available for viewing. These include one in a car park and three that can be run on steam.

Five engines have been moved off-site and are currently in store.

Two engines (Nos. 80 and 81) are part of a museum collection but not currently on display. One engine's current location is unknown.

THE SURVIVORS

1) Bedford, Bedford Waterworks, Clapham Road Pumping Station SER 1034

This four-column beam pumping engine is preserved off-site, al fresco in a car park at Bedford College, formerly known as Mander College. A telephone enquiry in March 2004 confirmed that it remained as an unusual car park ornament.

3) Biggleswade, Greene, King & Co, brewery SER 1240

This small horizontal single cylinder engine, by G. Adlam of Bristol, did indeed go for preservation in the Midlands. It was acquired by a private individual in Oldbury who restored it and passed it on to the Black Country Living Museum in Dudley. It is residing currently in open-air storage at the museum and is now in need of further restoration. It is not on public display but arrangements can be made to see it.

5) Cambridge, Cheddar's Lane Pumping Station SER 738

The two Hathorn, Davey differential pumping engines at this site have both been preserved in situ and can be demonstrated running on steam. The site is now the Cambridge Museum of Technology and is home to a variety of stationary steam engines and other artefacts.

17) Stretham, Waterbeach Level, Stretham Pumping Station SER 130

This Butterley beam engine, scoop wheel, boilers and a later diesel engine are now all preserved and publicly accessible. The engine can be turned by an electric motor drive.

27) Yaxley, Orton Brickworks SER 1485a

According to *The Traction Engine Register,* Barrows & Stewart engine No. 2450 survives in the Harrogate area. The picture appears to be printed back-to-front.

31) High Ongar, J. Brace & Sons SER 1471

This impressive Garrett locomobile is preserved off site at the Long Shop Museum in Leiston. This is in part of the maker's former works. The engine is displayed in a static state.

32) Hornchurch, South Essex Waterworks, Dagenham Pumping Station SER 1241a

This station contained two inverted vertical triple expansion engines and Watkins's photograph shows parts of both. Both were by James Simpson & Co. Ltd, London & Newark, one dating from 1909 and the other from 1913. Both engines were removed for preservation in 1986 and are stored in a dismantled state at the Museum of Power at

Langford Pumping Station. The pumps were scrapped and the engine beds were cut, so extensive repairs would be needed before they could run again.

35) *Maldon, Beeleigh Mill* SER 390a

This A-frame Woolf compound beam engine, built in 1845 by Wentworth and Son of Wandsworth, is preserved as Watkins saw it: that is, to say, in a derelict condition. Visits can be arranged via the Museum of Power (see No. 32 above) when the indigenous bats are not breeding!

36) *Maldon, Beeleigh Mill* SER 390b

This 'elephant' boiler is believed to be unique in Britain and is also preserved in an unrestored condition. The front of the boiler may be seen from outside the mill at any time.

37) *Maldon, Beeleigh Mill* SER 390c

This unusual and elegant mill gearing remains in situ as photographed by Watkins. It is to be noted that the photograph has been printed upside down!

41) *Stratford, Nicholson's Distillery, Clock Mill,* *Three Mills* SER 77a

The four wheels of the adjoining House Mill, also a tide mill, have been restored and may be seen on the first Sunday of each month from March to December. *Mills Open* also states - 'access to wheels of adjacent Clock Mill whenever possible'.

46) *Stratford, Nicholson's Distillery, Three Mills* SER 77f

This single cylinder bell crank engine is now on display in the Science Museum, South Kensington, London. It was restored by Historic Steam at Kew Bridge and can be turned by discreet motor.

54) *West Ham, Abbey Mills Sewage Pumping Station* SER 141

These two Woolf compound beam pumping engines, built by Lilleshall Co. Ltd between 1895 and 1900, remain in situ. They were last used in 1972 and are now disused although some painting has occurred in the intervening years. They can be seen on application to Thames Water.

55) *Wimbish, Messrs Taylor Bros, Farmers* SER 736

According to *The Traction Engine Register* this Aveling and Porter road roller, works No. 7385, survives in the St Albans area.

56) *Wimbish, Wiseman Bros* SER 686a

According to *The Traction Engine Register* these two Fowler ploughing engines (Nos. 15226-7) survive in the Folkestone area.

57) *Essex, Unidentified farm* SER 737

This Mann & Co. compound traction engine (No. 1260) is preserved and operated at Hollycombe Steam Collection and Gardens, Liphook.

59) *Bacton, John Collings, Engineer, Bacton Hall* SER 456b

According to Richard Adamek this tandem compound single crank traction engine is at Fengate Farm, Weeting. Presumably, it can be seen at the annual rally.

65) *Flitcham, Sandringham Estate Water Supply* SER 1481

This pretty horizontal single cylinder engine and geared three-throw pumps are preserved offsite at Enginuity, Coalbrookdale. This is an interactive engineering design exhibition that is part of the Ironbridge Gorge Museum Trust's complex of ten sites in the vicinity. The engine has been restored on an RSJ framework with the pumps in a cage below. It can be turned by an electric motor.

67) *Haddiscoe, Haddiscoe Pumping Station* SER 71

This twin cylinder vertical engine that drove a centrifugal pump is now preserved indoors at The Village, Fleggburgh. Its Easton, Amos & Goolden Cornish/multitubular boiler is also preserved in the same building. Unfortunately, the engine is a static exhibit and was due to be auctioned along with the rest of the collection in October 2004.

70) *King's Lynn, Bristow & Copley, Bentinck Dock* SER 1239

This Marshall Sons & Co horizontal duplex undertype is now preserved at Fengate Farm, Weeting, Suffolk. It is demonstrated in steam at the annual rally.

79) *Norwich Bridewell Museum* SER 75a

This pretty little anonymous beam engine remains on display at Bridewell Museum, Norwich. This Museum re-opened in 2004 and is open daily.

80) *Norwich Bridewell Museum* SER 75b

This small horizontal single cylinder oscillating engine still belongs to the Museum but is not on display currently.

81) *Norwich Bridewell Museum* SER 75c

This small vertical (crank overhead) oscillating engine still belongs to the Museum but is not on display currently.

86) *Shotesham All Saints, Ronald Clark, Diamond Cottage* SER 455a

The Tuxford engine (No. 1283) is preserved at Fengate Farm, Weeting and can, presumably, be seen at the annual steam rally there. The fate of the other engine is not known, but it cannot be a Ruston & Hornsby as the company was only formed in 1918, from R. Hornsby and Ruston, Proctor.

87) *Shotesham All Saints, Ronald Clark, Diamond Cottage* SER 455b

This model hypocycloidal engine is owned privately and is residing in Germany.

88) *Stokesby, Stokesby Old Hall Mill* SER 201a

According to Peter Filby, who has spent many years researching this fen mills, the derelict tower of this pumping windmill still stands (at TG437094). It is in a ruinous condition and overgrown by trees.

94) *Thursford, T. Cushing, Contractor* SER 519

According to *The Traction Engine Register* this Marshall tandem road roller (No. 87125) survives in the Shepton Mallet area, Somerset.

102) Little Houghton, Rousselot Gelatine Co. SER 1397

This French-built horizontal single cylinder engine remained workable until the closure of the works in 1980. It was removed for preservation by a Mr Heygate in 1983 and is stored under tarpaulins at Bugbrooke Flour Mill, Northamptonshire. There are no plans for its immediate re-erection.

103) Northampton, Northampton Water Works, Cliftonville Pumping Station SER 127

This Woolf compound beam pumping engine, built in 1863 by Easton and Amos, is now on display at Kew Bridge Steam Museum in London. It was received as a kit of parts, having been dismantled in store for some years, and was restored during 1977-8. George Watkins was present at its first public steaming and it has remained a regular performer ever since. It is in steam every weekend.

105) Raunds, Manor Brickworks SER 1485

This Foster overtype (No. 14736) was preserved in situ by Mr Smith, the site's owner. Mr Smith is deceased and the site has been cleared. The current location of the engine is unknown but is almost certain that it survives somewhere. We would welcome any information about the engine's location.

110) Combs, Webb & Son, The Tannery SER 204

This grasshopper beam engine was moved to the Museum of East Anglian Life at Stowmarket. It is undergoing restoration but is not yet on public display. According to Colin Bowden, the likely manufacturer is W. P. Wilkins of Ipswich and the likely date is 1851. These are the same as for the boiler on which it stood.

112) Drinkstone, Drinkstone Windmill SER 206

This is an ancient post mill that is dated 1689 but is probably much older. There is also a more recent smock mill that lost its sails on conversion to engine power. Both mills survive and are open occasionally. Further information is available in *Mills Open*.

113) Farnham, Mr Heffer SER 527

The only surviving engine by E. Youngs is a single cylinder portable engine at Bressingham Steam Museum near Diss, Norfolk. As this was preserved when seen by Watkins, it is more than likely this is the engine at Bressingham.

115) Fritton, St. Olave's Priory Mill SER 202a

This windmill and scoop wheel survives and was subjected to extensive repairs in 1999. It is always visible from the riverbank.

116) Glemsford, The Silk Mill SER 207

This single cylinder, A-frame beam engine is owned by Newcastle Discovery Museum and is in secure covered storage at the new regional store at Beamish – The North of England Open Air Museum, where it was seen on the ISSES AGM in 2002. Unfortunately, the flywheel is incomplete. There are occasional open days at the store and it can be accessed

with permission from the museum. This is the second engine in the series to be featured twice and can be seen at Newcastle upon Tyne Museum of Science and Engineering in Volume 2, plate No. 101.

118) Leiston, Richard Garrett & Sons, Engineers SER 459

The rare Aveling & Porter locomotive, *Sirapite*, was returned to the former works of Richard Garrett & Sons on March 10th, 2004. The site is now home to the Long Shop Museum, housed in one of the buildings of the former works (see No. 31 above). The museum trustees have acquired it from Preston Services near Canterbury and it is in need of a full restoration.

119) Lound, Lowestoft Waterworks Co,
Lound Pumping Station SER 72

These two grasshopper beam engines, built by Easton and Amos in c 1854, remain preserved in situ by the water company. One can be turned by an electric motor.

122) Wickham Market, Rackhams Flour Mill SER 1015

This horizontal single cylinder engine, by Whitmore and Binyon of Wickham Market, is now preserved at the Museum of East Anglian Life at Stowmarket and is on public display. This is contrary to Watkins's statement that it had been scrapped in 1959.

124) Woolpit, Windmill SER 205

This vertical single cylinder engine by Gardner of Sittingbourne is now preserved in the boiler house at Crofton Pumping Station, Wiltshire (see Volume 7, No. 113). The engine can be demonstrated on steam but has lost the heavy diagonal bracing seen in Watkins's photograph.

We would welcome any further information regarding any of the sites illustrated by Watkins. It is possible that sites or engines survive that we do not know of and we would like to be corrected in these instances.

VOLUME 10

In IB 25.3 we published the ninth in a series of articles listing surviving engines illustrated in Landmark Publishing's series of *Stationary Steam Engines of Great Britain*.
Volume 10 was released in 2005, covering marine steam engines and has 98 illustrations of steam engines, boilers and vessels. As before, several of the illustrated examples survive and these are listed below.

THE FACTS AND FIGURES
The subject matter of 39 of the 98 photographs published still survives 39.8(%) in a variable condition. These consist of:-

34 photographs of 31 steam engines. Three engines are shown twice (Nos. 21 + 37, 73 + 76 and 97 + 98). These are nearly all marine engines used for vessel propulsion but three were used for auxiliary purposes (Nos. 38, 64 and 65).
4 photographs of surviving vessels. Two of these have accompanying photographs of the engines (Nos. 24 and 90), one is preserved in a museum (No. 75) and one is without its steam engine (No. 87).
1 photograph of a boiler (No. 11). This is accompanied by a picture of the accompanying engine (No. 10).

The current disposition of the 31 different engines is as follows: -
Eleven engines remain in steam vessels that are either privately owned or owned by museums, trusts or other commercial organisations. Four engines are in privately owned vessels and two are in vessels different to that listed by Watkins. Of the six owned by organisations, one is in America, one is operated as a public house and one remains in commercial operation.
Three have been removed from their vessels and are on display in publicly accessible museums.
Five are believed to be no longer in vessels and are privately owned.
Three have been removed from their vessels and are definitely in museum stores.
One has been removed from its vessel and is in a scrap yard.
One has been removed from its vessel and is for sale.
Two are still preserved in the open air, although one has moved its site.
Three remain preserved in a museum as seen by George.
Two were seen by George in a museum but their current location is unknown.

THE SURVIVORS

8) Port of Bristol Authority, 'Dredger B D 6' SER 340

The single cylinder diagonal engine from this scraper dredger was preserved and has been re-erected in a mock-up of part of the hull in the Maritime Heritage Centre in Bristol docks. It can be turned over by an electric motor.

10) Cambridge, S. S. 'Artemis' SER 1438a

This vessel is in the ownership of a private individual and is based on the River Cam. The current owner acquired the vessel in 1996 and it was hoped to back in steam in 2000. The vessel retains its original Simpson, Strickland two crank quadruple expansion engine as photographed by Watkins.

11) Cambridge, S. S. 'Artemis' SER 1438b

The original Simpson, Strickland water tube boiler survives and has now been restored and re-united with the vessel. The Merryweather B boiler was in the vessel between 1952 and 1996.

21) Weymouth, Cosens & Co., P. S. 'Empress' SER 397

As stated in the text, this very nice oscillating engine is preserved and on display in South-ampton Maritime Museum (see No. 37 below).

24) Loch Lomond, P. S. 'Maid of the Loch' SER 1260a

This paddle steamer ceased to operate in 1981 and its future was uncertain for some time. In 1996 The Loch Lomond Steamship Company was formed with the intention of preserving the vessel and restoring it to steam. Much work has been completed but the vessel still requires much hull work and a new boiler before it can steam. In the meantime, the compound diagonal engine is being refurbished by volunteer labour.

25) Loch Lomond, P. S. 'Maid of the Loch' SER 1260b

As for No. 24 above.

29) Gloucester Docks, British Waterways, S. S. 'Mayflower' SER 1224b

Following a period of dereliction and deterioration, *Mayflower* was obtained by the Bristol Industrial Museum and has been restored fully. She is now in steam several times a year and offers trips around the Floating Harbour.

30) Gloucester Docks, British Waterways, 'Dredger No 4' SER 1224c

This dredger retired from active service in the early 1980s and is now preserved at the National Waterways Museum, Gloucester. It is maintained in an operable condition and is occasionally demonstrated to the public. It has reverted to its original name of *SND No. 4*.

31) Tewkesbury, British Waterways, 'Dredger No 3' SER 1478

This dredger was in commercial operation until 1999 and was subsequently for disposal. The engine has since been removed from the vessel and is now privately owned by a Steam Boat Association member in Cornwall.

36) Southampton, The Maritime Museum, P. S. 'Empress' SER 1424a

This is the engine described in No. 21 above and is on public display.

37) Southampton, The Maritime Museum, P. S. 'Empress' SER 1424b

This steam steering engine is also on public display. Despite the implication in the text, neither this nor the oscillating engine is in working condition.

38) Southampton, The Maritime Museum, S. S. 'Thornycroft Bee' SER 1424c

The engine is on public display.

39) Woolston, River Itchen Floating Bridge, 'Vessel No 8' SER 84a

This compound grasshopper beam engine was preserved in the open air at Wendron Forge for many years. It was sold on when that site changed ownership and is currently in a Hampshire County Council museum store in Winchester. The compound beam engine from *Vessel No. 10*, which is similar to that seen in No. 41 (SER 84b), has followed a similar path to the same store.

42) Dover Harbour Board, S. S. 'Snapper' SER 413b

This vessel has had many names, having been variously called HMS *Handy*, HMS *Excellent*, HMS *Calcutta*, HMS *Snapper* and, latterly, *Demon*. The vessel was acquired by Pound's ship breaking yard at Tipnor, Portsmouth in c1971. The crane was demolished but the hull and machinery were left to deteriorate in a partly beached condition. More recently, the owner has removed the engine and boiler. The engine is in a largely dismantled condition, with the larger castings outdoors and is waiting for possible restoration. It is now known that Ross and Duncan of Glasgow built the engine.

45) Dumbarton Pier, Clydeside, P. S. 'Leven' SER 557

This early side lever marine engine is now preserved in the open air outside the Denny Ship Model Experiment Tank in Dumbarton and can be seen at any time.

46) Renfrew Ferry, Glasgow, Ex P. S. 'Clyde' SER 556

This pair of grasshopper side lever marine engines remains in the open air at Renfrew, as photographed by Watkins. They are accessible at all times.

53) Manchester, Salford Docks, floating Heavy Lift Crane SER 1340b

This was known as the *60 Ton Crane*. Both of the inverted vertical compound engines were acquired by a Mr Gregory of Tansley and subsequently moved to the ownership of Mr M List-Brain. For some time they were in the open at the Maritime Museum Complex, Ramsgate but they are now at Preston Court near Canterbury. They may be seen on the occasional open days of the Preston Oast Steam Museum but are both for sale.

57) Mersey Docks and Harbour Board, Floating Crane 'Birket' SER 1409

This vessel later moved to the Hull dock system and was renamed *Beverley*. She apparently remained in service until 1984 and was subsequently broken up. Mr Gregory of Tansley saved one of the two inverted vertical compound engines by Fleming and Ferguson. It subsequently passed along a chain to Tommy Nuttall and is now preserved in a steamable condition at Markham Grange Nursery, Brodsworth.

62) Port of London Authority, S. S. 'Leviathan' SER 577b

Watkins states that this engine was preserved at the Birmingham Museum of science and Industry. This museum closed in the late 1990s and the engine is now in a new secure store in Birmingham. It is not usually accessible to the public but a special request to the Museums and Galleries section of Birmingham City Council would probably result in access.

63) Port of London Authority, S. S. 'Leviathan' SER 577c

This three cylinder Willans engine is in the ownership of the Science Museum and is believed to be in their store at Wroughton, Wiltshire. The store is accessible on application.

68) Staines, Taylor's Yard SER 746c

This inverted vertical twin tandem compound engine is owned privately by a member of the Steam Boat Association in Surrey. (The engine listed as SER 746a is privately owned by a Steam Boat Association member in Middlesex and is being restored for static display).

70) Aynho, Steam Launch 'Emma' SER 1475

This vessel and its Savery compound engine survive in private ownership and it is active on the River Teign in Devon.

71) Newcastle Museum Science and Engineering SER 1035a

The current location of this Sisson inverted vertical triple expansion engine is not known but it is considered to be a certain survivor. It is not on public display at Newcastle Discovery Museum. This is the same engine as No. 76 below (SER 1460c).

72) Newcastle Museum of Science and Engineering SER 1035b

Again, the current location of this is uncertain but it is not on display at Newcastle Discovery Museum. This engine was built by G F G DesVignes.

73) Newcastle Museum of Science and Engineering SER 1460a

Parsons' experimental yacht *Turbinia* is now on display at Newcastle Discovery Museum after several years when it was not on display. The small viewing windows have been re-

instated, after a period of absence and the public can again appreciate the incredibly cramped working conditions.

74) Newcastle Museum of Science and Engineering SER 1460c

This is the same engine as in No. 73 above (SER 1035a).

76) Newcastle-upon-Tyne, Messrs France, Fenwick, P. S. 'Eppleton Hall' SER 1297

As stated by Watkins this paddle tug was sailed to San Francisco in 1969-70 and has remained there ever since. She is part of the San Francisco Maritime National Historical Park and has in recent years had some restoration work undertaken. She is not currently in a steamable condition.

81) Oxford, Salter's steamboats, S. S. 'Grand Duchess' SER 658d1

This inverted vertical compound engine by J Samuel White of Cowes is the property of the National Maritime Museum. It is currently on loan to Markham Grange Steam Museum, Brodsworth and has been restored to a steamable condition.

83) Oxford, Salter's Steamboats SER 797

The triple expansion Sisson engine from *Henley* is now privately owned in Surrey.

85) Oxford, Salter's Steamboats, S. S. 'Cliveden' SER 797e

Cliveden is still owned by Salter Brothers and is in a laid-up state. As stated by Watkins', she is no longer steam powered.

87) Loch Katrine, S. S. 'Sir Walter Scott' SER 1261

This inverted vertical triple expansion engine remains in regular use during the summer months, much as when Watkins photographed it. However, the vessel has had another set of new boilers since then.

88) Loch Katrine, S. S. 'Sir Walter Scott' SER 1261a

This is the same vessel as above (No. 90) and remains in regular commercial service.

90) Bristol, Steam Launch, 'Eythorne' SER 1326

This Simpson, Strickland two crank quadruple expansion engine survives in steam launch *Vixen* as stated by Watkins. This is privately owned and based in Scotland.

91) Bridgwater, Bridgwater Dock, The Scraper Dredger SER 1116

This vessel, now known as *Bertha*, was a fixture in the Maritime Museum at Exeter for many years. It was even maintained in operable condition and steamed occasionally. Following the closure of the museum it has led a peripatetic existence and is currently as Eyemouth in Scotland where a new museum is being established.

93) Birmingham, W. Melville SER 1474

To the best of our knowledge, Mr Melville and his Simpson, Strickland quadruple expansion engine both survive.

94) *Solihull, L. V. Nelson, Steamboat 'Brindley'* SER 1470a

This twin cylinder engine by Gabriel Davies of Abingdon remained in *Brindley* until 1976. It is now in the steam launch *Duchess of Argyll* on the Thames. This is privately owned. The Merryweather boiler was sold separately and its current location is unknown.

95) *Solihull, L. V. Nelson, Steamboat, 'Catherine de Barnes'* SER 1470b

The vessel was renamed as *Unity* and was based at Wigan Pier. It appears that the plant is no longer in the vessel and is owned privately by a Steam Boat Association member.

96) *Solihull, L. V. Nelson, Steamboat, 'Catherine de Barnes'* SER 1470c

This is the same vessel and plant as above (No. 97) and the same comments apply.

98) *Hull, Paddle Ferry, 'Lincoln Castle'* SER 889

This vessel and its diagonal triple expansion engine are preserved as a floating public house at Grimsby. The engines can be viewed from main deck level through some large windows. Permission for a closer inspection would have to be sought from the management.

Addendum

The book also contains a section showing 21 stationary engines that had been missed from the earlier volumes. Of these, four survive. One is on display in a public museum, one is displayed in a glass case in the town centre, one is in store and possibly for disposal, and the last is in store in the open air. These are as follows: -

1) *The Gillingham Pottery, Brick & Tile Co,*
Gillingham, Dorset SER 1380

This quite large horizontal single cylinder engine by Hindley is believed to be privately owned and is stored in the open in the former gas works yard at Sherborne Dorset. It has been there for many years but it is possible that it may be relocated in the future.

2) *Hampshire, Portsmouth Waterworks, Havant.* SER 10a

This little grasshopper beam engine is preserved in the former boilerhouse of Eastney Pumping Station, Portsmouth. This is a public museum and the engine can be demonstrated running on steam.

10) *Green Bros, Abbey Mill, Billington, Lancashire* SER 1097

This engine stopped work in 1979 and was removed in 1987/8. It is the property of a Mr Jack Taylor of Planned Maintenance (Pennine) Ltd in Haslingden. The engine is in store and is possibly for disposal at a price.

17) *Ford ,Ayrton & Co, Low Bentham, Yorkshire* SER 1099

This inverted vertical single cylinder engine is preserved in a large glass-sided building in Bolton town centre. It is turned over by an electric drive and is an excellent testimony to the town's engineering industry.

STATIONARY STEAM ENGINES OF GREAT BRITAIN
VOLUMES 1 - 9
COMMENTS AND CORRECTIONS

By Colin Bowden

VOLUME 1 – YORKSHIRE

See revised contents list in this volume for corrections to company names, locations and geography. It should be noted that there are also a large number of errors involving confusion between worsted and woollen mills. These are not corrected here.

7) Darton, North Gawber Colliery
The illustration is reversed.

8) Tankersley, Wharncliffe Silkstone Colliery
The engine maker is J. & G. Davies.

30) Castleford, Glass Houghton Colliery
Cylinders are probably 25in and 40in dia.

44) Thorne, Thorne Colliery, No. 1 Shaft
Cylinders are 36ins and 60ins dia. Compounding by the addition of the LP cylinders took place in 1929, not 1937 as stated.

46) Askern, Askern Colliery, No. 2 Shaft
The drum was probably 16ft - 24ft in dia.

52) Elland, John Maude & Sons, Stainland
Cylinders were 18ins and 35ins x 4ft. The engine was installed here in 1950 probably, not 1956. "in 1954" is thus probably wrong.

69) Elland, J. Speak & Co., Ing Wood Mills, West Vale
SER108b should be SER1088 (see Vol 1 No 57).

72) (printed as 73) Halifax, I. & I. Calvert, Illingworth
The LP cylinder has a piston not slide valve.

91/92) Kingston-upon-Hull, Chambers & Fargus Ltd., High Flaggs Oil Mill
The illustrations are of the same engine, photographed at different times.

99) Bradley, Peter Green & Co.
The cylinder diameters are probably 13in and 25in. The engine was named *Progress*.

105) Brighouse, W.T. Knowles & Co., Pipe Works
The cylinder diameters were 13in and 26in. The six engines referred to were originally 26in x 4ft stroke. Tandem compounding took place in 1911 by Hick, Hargreaves adding 13in cylinders.

113) Leeds, United Hospitals Central Laundry, Whitehall Road
HP cylinder diameter was 13in.

122) Huddersfield, Job Beaumont & Co., Longwood
Cylinders were $16^1/_2$in and 29in x 4ft (from J. & E. Wood records).

129) Middlesbrough, Gjers, Mills & Co., Ayresome Ironworks
Blowing "tube" must be blowing tub.

134/5) Mirfield, George Lyles & Co., Ledgard Bridge Mills
The illustrations have been switched.

136/7) Mirfield, James Walker & Co.
The horizontal tandem was not scrapped until 1976/7.

138) Ossett, J. M. Briggs & Co., Runtlings Mill
LP cylinder was 23ins dia (not 22in).

148) Pudsey, John G. Mohun & Co., Alma Tannery
The cylinder was 14in dia. The engine was standby until 1978 and removed for preservation in 1979.

155) Rotherham, The Park Gate Iron & Steel Co.
The Belliss & Morcom details can be filled in. Cylinders were $16^1/_2$ and 23in x 10in. Design figures: 365 bhp, 428 rpm and 150 psi.

165) Sheffield, The English Steel Corporation, River Don Works
The engine stroke is 4ft 0in (not 4ft 6in).

168) Sheffield, Thomas Wragg & Co., Refractory Clay Products, Loxley
The cylinder was 21in x 3ft (not 20in x 3ft 6in).

170/1) Sheffield, Tyzack Sons & Turner, Little London Works
The illustrations have been switched.

189) Shipley, Stuart Bros.
Presumably the last line of the text should refer to "a throttle governor".

190) Silsden, Taylor Bros., Waterloo Mills
Presumably "tangenical" should read "tangential".

197) Swinton, Holdsworth & Gibb, Moorside Mills
This site should be in the Lancashire volume.

198) Chapeltown, Newton Chambers & Co., Tankersley Park Shaft
"It differed from the previous engine". This must be a reference to 32 (SER 66b) – which should have been the previous engine. [See corrected contents list.]

212) Walton, Walton Colliery
The engine stroke was 6ft 6in, not 7ft.

218) Wilsden, Denison's Ltd., Ling Bob Mills
The psi is given as 14ft 0ins, which is certainly incorrect!

VOLUME 2
ABERDEENSHIRE

1) Inverurie, Thos. Tait & Sons
The glazing calender was by Masson, Scott & Bertram, London, 1885, and it seems quite likely that this maker and date also apply to the engine.

2) Inverurie, Thos. Tait & Sons
The engine cylinders were 20in & 30in x 12in.

AYRSHIRE

5) Auchinleck, Highhouse Colliery, No. 2 Shaft
I have a date of 1896 for this engine. It was not stopped until 1983. The drums are 10ft.

EAST LOTHIAN

14) Prestongrange Colliery
This colliery is at Prestonpans. The maker was J. E. Mare & Co., Plymouth Foundry, 1853. It was erected 4th-hand in 1874, when Harvey provided a new beam. Working conditions in 1893 were 162 hp, $3^{1}/_{2}$ spm, and 35 psi.

LANARKSHIRE

24) Stepps, Cardowan Colliery
The pit may have been due to close in 1972 as stated, but in fact production continued until 26 August 1983. The engines remained in situ until 1984/5. The drums are 14ft.

MIDLOTHIAN

30) Newtongrange, Lady Victoria Colliery
The engine dates from 1891.

PERTHSHIRE

35) Blairgowrie, Thompson & Co.
Keithbank Works should be Keathbank Works.

37) Blairgowrie, Thompson & Co., Ashgrove Works
The maker is Pearce Bros., and not Pierce as stated. Cylinder dia 24in, not ft!

38) Dunblane, Wilson & Sons
This was a worsted spinning not a woollen mill. The engine cylinders were 13in & 17in x 2ft 6in.

STIRLINGSHIRE (AS GIVEN)

44) Alva, Glentana Mills
Alva is in Clackmannan not Stirlingshire. The cylinder of this engine was 11in x 30in.

CUMBERLAND

50) Workington, Workington Iron & Steel Co.
The rebuild date was probably 1944 not 1954. [This has still to be confirmed from Walker Bros records.]

DURHAM

60) Burnhope, Burnhope Colliery, Fortune Pit
The illustration is upside down.

67) Darlington, Darlington Waterworks
HP stroke is 5ft 3in not 5ft 6in.

78) Hetton, South Hetton Colliery
Maker is Worth Mackenzie, not Worth McKenzie.

93) Washington, Washington Colliery, F Pit
The cylinder stroke is 5ft, drum 11ft 6in.

95) Wheatley Hill, Wheatley Hill Colliery
The Robey numbers are 43979 and 43980. Number 43970 must be a mistake.

96) Whitburn, Whitburn Colliery
For 'Corliss drop valves', read 'Drop steam and Corliss exhaust valves'.

NORTHUMBERLAND

100) *Mitford, Brown & Co*
The illustration is reversed.

VOL 3:1 LANCASHIRE A-L

29) *Bolton, Crosses & Winkworth, Gilnow Mill*
Read J. Musgrave, not Musgrove. Presumably the new cylinders were added 18.

47) *Bolton, Thos. Walmsley & Sons*
The engine is now thought to be possibly by John & Edward Wood, Bolton (on perhaps rather flimsy evidence) and the date possibly c. 1830-1840. It is believed that it was installed (second-hand) c. 1866. It was rebuilt with new cylinder and crank in 1933-5, stopped work in 1976 and was removed for preservation in 1978.

48) *Bolton, Thos. Walmsley & Sons*
The two Hick, Hargreaves engines were built 1919-21, with cylinders 28in x 3 ft. They stopped work in 1976 (No.E.8/19) and 1983 (No.E.7/19), and were scrapped in 1983 – a sad loss.

52/3) *Briercliffe, Hill End Mill Co.*
'Robert's' is William Roberts.

74) *Burnley, Sutcliffe, Clarkson & Co., Wiseman Street*
The engine is now thought to be probably W. & J. Yates, Blackburn, 1887. It was rebuilt by Burnley Iron Works Co. Ltd (Order No. 99) in 1912. It then had a new HP cylinder by Cole, Marchent & Morley Ltd., Bradford in 1947. The cylinders were 17^5/$_8$in and 30in x 3ft 6in. It continued working until 1979 and is now preserved in situ. (Most of this information from Geoff Shackleton.)

83) *Bury, The Lancashire Cotton Corporation*
This is Pilot Mill as stated in the contents.

90) *Chadderton, Junction Mill, Middleton Junction*
It was a horizontal twin tandem compound built by George Saxon Ltd., Manchester in 1875. It had Corliss valve HP and slide valve LP cylinders and developed 1,600 hp. There is a note on George's contact print that the HP cylinders were replacements. The photo was taken in 1956.

97) *Chorley, W. & C. Widdows, Canal Mill*
The illustration is not one of the Canal Mills engine. It is that of Victoria Mill, Nelson, which is repeated in Volume 3.2 (See No.35.)

99) *Clitheroe, James Thornber, Holmes Mill*
The cylinders stroke is 3ft 0in, and not as stated.

115) *Finsthwaite, Cowards Bobbin* Mill
The cylinder is 15^1/$_4$in x 1ft 11in. The engine was probably second-hand when it was installed c.1880.

116) *Facit, Thos. Hoghton, Whitfield Mill*
This should have been included under Whitworth in Volume 3.2, with the other Facit mill (actually called Facit Mill).

119) *Haslingden, The Grane Manufacturing Co.*
The engine did not stop until 1978.

148) *Leigh, The Butts Mill Co.*
This is not a photograph of the Butts Mill Co. engine. It is actually that of the Hall Lane Spinning Co, Leigh (see *Textile Mill Engine* Vol 2 No. 65).

VOLUME 3:2 LANCASHIRE L-W

3/4) Leigh, Parsonage Colliery
Watkins's notes suggest that the original (16ft - 22ft) drum was replaced by the parallel drum (in fact 17ft dia) some time in the period 1965-1968.

37) New Hey, Ellenroad Ring Mill
The usual speed quoted for this engine is $58^{1}/_{2}$ rpm. rather than the figure of 65 rpm given here.

41) Norden, R. Cudworth
The cylinder stroke is 3ft 0in. The figure of 100 rpm must be incorrect. The correct figure is 65-67 rpm.

56/57) Chadderton, The United Mill Co.
This should have been in Volume 3.1 with the other Chadderton engines.

117) Shaw, Hardman, Ingham & Co., Diamond Rope Works
The cylinders are 16in and 32in dia.

121) Southport Water Board, Bickerstaffe Pumping Station
This pumping station is at Bickerstaffe, near Ormskirk, not at Southport. 660psi is obviously incorrect. An article in *The Flywheel* (April 2003) gives (probably more likely) alternative figures: Cylinder: 28in x 6ft. Psi: 40.

122) Sutton Manor Colliery
Cylinder diameters were probably 33in & 55in.

140) Wardle, Leach's Crossfield Woollen Mills
The illustration is reversed.

VOLUME 4

Caernarvonshire

4) Llanberis,
Dinorwic is 1848 (J.W. Lowe, *British Steam Locomotive Builders*)

6) Llanberis, Snowdon Mountain Railway
Cylinders: $11^{3}/_{4}$in x $23^{3}/_{4}$in. 200 psi.

7) Llanberis, Snowdon Mountain Railway
Cylinders: $11^{3}/_{4}$in x $23^{3}/_{4}$in. 200 psi.

Carmarthenshire

21) Llangennech, Morlais Colliery
Cylinders are 20in x 3ft 6in (not 2ft).

Denbighshire

27) Ruabon, Ruabon Brick & Terra Cotta Co.
Cylinder stroke is 4ft 0in, not 4ft 6in.

<div align="center">GLAMORGANSHIRE</div>

35) Cardiff, Melingriffith Tinplate Works, Whitchurch
This engine may have piston valves (as stated in *The Steam Engine in Industry)*, not slide valves.

39) Crynant, Cefn Coed Colliery
In *The Steam Engine in Industry* this photograph is described as at an unknown colliery, and there seems to be some doubt as to whether this illustration is of Cefn Coed. There was an identical (or very similar) engine at Britannia Colliery, Bedwellty, Monmouthshire; this was built by The Uskside Engineering Co., Newport in 1907. Possibly it is this engine which is illustrated.

41) Crynant, Cefn Coed Colliery
The stroke of this engine is 6ft, not 5ft. There is uncertainty about the cylinder dimensions, some sources agree with Watkins (32in), others say 36in.

42) Crynant, Cefn Coed Colliery
Cylinders are 9in x 1ft 8in, not 1ft 0in.

55) Mountain Ash, Navigation Colliery (North Pit)
This engine had piston valves. The diameter of the cylinders was 22in, not 20in. I have a date of c.1880, and sources disagree on the diameter of the fan, claiming both 42 and 43ft.

61) Pontypridd, Tymawr Colliery, Hopkinstown
Cylinders are 34in. The new cylinders and valve gear were added by Worsley Mesnes Ironworks Ltd. in 1910 (Order/No. R5), not in the 1930s.

64) Swansea, Yorkshire Imperial Metals Ltd., Hafod Works
The cylinder was 29in x 3ft 3in. 2,000 hp seems impossibly high even as a peak load hp Musgrave records quote a design figure of 600 ihp. "Some dozen or more" suggests rather fewer Musgrave uniflows than were actually built. Hills, *Power of Steam,* gives the number as 54 or more.

70) Treherbert, Fernhill Colliery (No. 3 Shaft)
The cylinder diameter was possibly 25in. The probable approximate date of manufacture is c. 1865, and the second-hand installation date at Fernhill Colliery was given by the NCB as 1869.

<div align="center">MONMOUTHSHIRE</div>

74) Abercarn, South Celynen Colliery
I have cylinders as 24in. I think this was No. 3 Shaft.

75) Abercarn, South Celynen Colliery
Cylinders were 25in. 1 think this was No. 1 Shaft.These shaft numbers for South Celynen accord with those given by John Cornwell, *Collieries of South Wales,* vol :1

78) Crumlin, Navigation Colliery (South Shaft)
Markham records show original cylinders as 32in. If Bryan Davis is correct and cylinders were 28in, this supports George Watkins's suggestion that these were smaller replacements.

88) Newport, Stewarts & Lloyds Ltd., Mannesmann Tube works
The stroke was 4ft, not 5ft

89) Pontypool, Glyn Pit

This is apparently not a Neath Abbey Engineering Works engine, the date of installation being 1856/1865. (See Palmer & Neaverson, *Industrial Archaeology Review* XIII, 1, 1990)

<div align="center">CHESHIRE</div>

103) Birkenhead, West Cheshire Water Board, Prenton Pumping Station
The LP cylinder was probably 52in, not 54in.

106) Brereton, Flour Mill
The stroke is 2ft 6in, not 2ft 0 in

111) Ellesmere Port, Manchester Ship Canal Docks, Hydraulic Power Houses
The illustration is of the engines in the Lower Engine House, Sir W. G. Armstrong & Co., Newcastle upon Tyne, built in 1866, installed here 1895. Both No. 227 and No. 228 are shown, No. 228 in the foreground. Cylinders were $16^1/_4$in x 1 ft 8in. All were probably scrapped 1978/1980.

114) Kettleshulme, Sheldon Bros., Lumb Hole Mill
The engine was probably built by John & Thomas Sherratt, Salford Iron Works, 1832.

<div align="center">SHROPSHIRE</div>

141/2) Ironbridge Gorge Museum Trust, Blists Hill site
These are of course the same engine, shown preserved off-site.

147) Shrewsbury, Coleham Head Sewage Pumping Station
The figures I have are 13in x 3ft $1^7/_8$in and 20in x 4ft 6in. [Not 100% certain of these.] The flywheel was 16ft 0in

VOLUME 5
<div align="center">DERBYSHIRE</div>

1) Bamford, Robert Marsland & Co., Bamford Mill
Cylinders are 16in & 32in x 3ft.

2) Bamford, Robert Marsland & Co., Bamford Mill
The turbines were dated 1934 and were transferred from a cotton mill at Edale in 1954 (J. D.Gilbertson, *A Short History of Bamford Mill*, 1980). They were scrapped after Carbolite Ltd. left the mill in 1994/6.

7) Church Gresley, Cadley Hill Colliery, No. 1 Shaft
There seems no reason to doubt that the engine was built by Thornewill & Warham, and 1868 is the generally accepted date. It is believed to have been installed in 1947 and continued in use until 1988.

14) Cromford, Leawood Pumping Station, Cromford Canal
The cylinder was 50in x 10ft (designed stroke) and not as stated. The pump stroke was similarly 10ft.

17) Hartington, DSF Refractories, Friden
The Robey engine was numbered 22110-22111 and built in 1902.

28) Pleasley, Pleasley Colliery, North Pit
The cylinder was $40^1/_2$in (not 28in) in diameter and it had a 19ft 6in drum (not 18ft). It is now confirmed to have been a Lilleshall Co. engine of 1904, replacing a Worsley Mesnes engine of 1874. The 1924 Markham on the South shaft also replaced a Worsley Mesnes engine. Both shafts apparently had Reader sinking engines which did not survive for long.

30) Stanton-by-Dale, Stanton & Staveley Ironworks
It is the 1897 engine which is illustrated. The cylinders were 14in, 23in and 38in x 2ft.

34) Wirksworth, Middleton Incline, Cromford & High Peak Railway
The date of this engine is 1829, and the cylinder I think 23in x 5ft 1in. It was in use
until 1962. [1952 looks like a misprint.]

LEICESTERSHIRE

39/40) Bagworth, Desford Colliery
39 is an illustration of the No. 2 Shaft winder, 40 is No. 1 as stated. The two engines
are virtually identical, No. 1 being Wood & Gee No. 975-6 of 1901, No. 2 Wood &
Gee No. 1000-1001 of 1902.

42) Donisthorpe, Donisthorpe Colliery, No. 1 Shaft
The drum was 13ft, not 12ft. It was No. 1 with Gooch, No. 2 with Stephenson's link
motion. The No.2 Shaft winder had a plate: *J. Jessop, London Steam Crane & Engine
Works, Leicester,* and there seems no reason to suppose that it was not originally built
by Jessop around 1872, when the two shafts were sunk. It was probably this engine
which is described in an Appleby Bros., London catalogue, 1877, the Jessop company
being an offshoot of Appleby established in 1866.

45) Ibstock, Ellistown Colliery
The Belliss & Morcom engine was No. 5384 of 1913, twin cylinder not compound.
Cylinders were 17in & 17in x 11in and design working conditions 260 bhp, 370 rpm
and 55-60 psi.

55) Moira, Rawdon Colliery
I believe this is No. 1 Shaft. The original builder was Andrew Handyside & Co.,
Britannia Works, Derby, date 1868. But successive rebuilds meant that little was left of
the original.

57) Snarestone, Hinckley Waterworks, Snarestone Pumping Station
The cylinder stroke was 4ft 0in, not 3ft 6in.

LINCOLNSHIRE

64) Crowle, Belton Brick Co.
The high-speed engines were Belliss & Morcom No. 3072 and Browett, Lindley No.
2411, and not as stated.

73) Owston Ferry, South Axholme Drainage Board, Owston Ferry Pumping Station
Two oil engines were installed – one in 1952 and another in 1964. Only one tandem
compound was left by 1977 when this photograph was taken.

74) Pinchbeck, Pinchbeck Marsh Pumping Station
The date is 1833, which accords with that given for 75, the same installation. The
flywheel diameter is 18ft 6in.

81) Sleaford, Bass & Co., Maltings
Cylinders were 14in and $22^{1}/_{2}$in (from Robey records).

87) Stamford, Melbourn Bros, All Saints Brewery
The date of the Marshall engine is believed to be 1910. It was installed here in 1946/7,

88) Tattersall, Dogdyke Pumping Station
There is an 1856 date on the Bradley & Craven plate, and there seems no reason to
doubt that this is of the original maker.

94) Wilsthorp, Peterborough, Wilsthorp Pumping Station
There were two pumps per engine, bucket & plunger $17^1/_2$in and 12in x 3ft

NOTTINGHAMSHIRE

95) Bestwood, Bestwood Colliery
The maker is R. J. & E. Coupe, Worsley Mesnes Ironworks (the company did not become Worsley Mesnes Ironworks until later). The drum is probably 18ft in diameter.

99) Bilsthorpe, Bilsthorpe Colliery, No. 1 Shaft
The drum was 20ft in diameter (not 14ft as given in the text).

107) Hucknall, Linby Colliery
The engine illustrated is the No. 2 Shaft winder, Robey No. 40542-3. Cylinders were $24^1/_4$in x 3ft 4in. The drum was 9ft 6in. This was the coal winder. (No. 1, not illustrated, Robey No. 40516-7, a larger engine, was used for men and materials.)

109) Kirkby-in-Ashfield, Bentinck Colliery, No. 2 Shaft
Cylinders were 32in, drum 16ft.

110) Kirkby-in-Ashfield, Bentinck Colliery, No. 3 Shaft
Cylinders were 36in, drum 16ft.

113) Kirkby-in-Ashfield, Langton Colliery
I have the Robey on No. 8 Shaft as installed 1935, not 1956 [but not 100% certain of this!]

124) Nottingham, Nottingham Water Works, Basford Pumping Station
The force pump I believe is 17in x 3ft 0in.

129) Sutton Bonington, Hathernware Ceramics
The Belliss & Morcom details can be filled in: No. 8267 of 1930, cylinders 13 in & 21 in x 9in.

STAFFORDSHIRE

138) Brownhills, Potters Clay & Coal Co.
This is Tangye No. 10453, the date believed to be 1896.

141) Burslem, Dunn, Bennett & Co., Dalehall Pottery
I have a stroke of 2ft 0in, flywheel 5ft 6in, installation date 1948.

146) Draycott in the Moors, Cresswell Pumping Station
This has drop valves (as actually stated in the text) – not Corliss valves.

148) Eccleshall, Millmeece Pumping Station
This illustration also is of the Ashton, Frost engine (same as 147).

152) Hanley, Jesse Shirley & Son
I believe J. & T. Sherratt ceased to operate in 1838, so if the engine is by this maker, it must date from the 1830s. I have a cylinder diameter of $31^5/_8$in

155) Hopwas, Tamworth Waterworks, Hopwas Pumping Station
I have a cylinder of 25in

156) Lichfield, South Staffs Waterworks, Sandfields Pumping Station
The maker is J. & G. Davies, date 1873. Working conditions: 150 whp, 7spm and 40psi.

160) *Rugeley, South Staffs Waterworks, Brindley Bank Pumping Station*
The date of this engine is 1907, the HP cylinder 28in, and the stopping date was 1968.
Both HP and LP cylinders have Meyer expansion valves and not as stated.

161) *Rugeley, South Staffs Waterworks, Brindley Bank Pumping Station*
The capstan shown in the illustration was by John H. Wilson & Co. Ltd., Liverpool.

170) *Stretton, Burton-on-Trent Sewage Works, Clay Mills Pumping Station*
The LP cylinder figures 38in x 8ft 0in have been omitted in error.

171) *Stretton, Burton-on-Trent Sewage Works, Clay Mills Pumping Station*
The accepted date for this engine seems to be 1889.

186) *Wombourn, Bilston Waterworks, Bratch Pumping Station*
The cylinders are 16in, 26in & 40in x 3ft 0in, working conditions 139 1hp, c. 24rpm
and 150psi.

VOLUME 6

(On p. 12 there is a reference to the *Bids Journal*, which should be *BIAS Journal*.)

BERKSHIRE

2) *Speen, Sir Richard Sutton's Benham Park Estate*
Cylinders are 11in & 11in x 1ft 4in (from Robey records). The date is 1913.

BRISTOL

5) *Bristol City Docks, Princes Wharf*
Cylinders are 10in x 1ft 4in and 5$^1/_2$ in x 9in. Date 1875.

14 & 16) *Bristol Waterworks, Victoria Pumping Station*
This is the same engine.

15 & 17) *Bristol Waterworks, Victoria Pumping Station*
These refer to the same two engines.

BUCKINGHAMSHIRE

36) *Buckland, Chiltern Hills Water Co., Dancers End*
I have cylinders 14in diameter (compared with 18in), and flywheel 11ft 0in.

39) *High Wycombe, Thomas Glenister Co.*
The date of the Davey, Paxman is 1914, not 1912. The Marshall is believed to date
from 1883 rather than the early 1900s as stated. The cylinders of the tandem
compound are 10$^1/_2$in & 17in x 1ft 6in

43) *Princes Risborough, The Risborough Furniture Ltd.*
I have cylinders 14$^1/_2$in & 25in x 2ft 8in (from Marshall records).

GLOUCESTERSHIRE

52) *Frampton Cotterell, West Gloucestershire Water Co.*
The cylinder dimension figures as stated look suspect. *The Steam Engine in Industry*,
Vol 1. gives 16in, 27in and 44in x 3ft, with working conditions of 150 hp, 25 rpm and
150psi.

68) *St Mary's Mill, Minchinhampton*
The engine is thought possibly to date from c.1890, and to have been installed here
c.1904.

<center>HEREFORDSHIRE</center>

95) Hereford, Hereford Waterworks, Broomy Hill Pumping Station
There were two flywheels. The steam pressure given (100psi) looks like a misprint.
Generally accepted details are 120 hp, c. 26rpm. and 160psi. For the high lift there
were originally two double acting bucket pumps (5¹/₄in dia), but these were superseded
by the smaller twin cylinder engine installed in 1906.

<center>HERTFORDSHIRE</center>

96) Cheshunt, Metropolitan Water Board, Turnford Pumping Station
The engine was built in 1845, installed at Hampstead in 1847 and erected at Turnford
1869-1870.

105) Potters Bar, Wrotham Park Estate
The date is 1856 (from Easton & Amos invoice).

106) Ware, Metropolitan Water Board, Broadmead Well
The cylinder was 24in in diameter, not 28in. [24in is given in *The Stationary Steam
Engine* and accords with James Simpson records.]

<center>OXFORDSHIRE</center>

113) Burford, Garne & Sons, The Brewery
I have an engine stroke of 1ft 2in, flywheel 5ft (not 4ft).

117) Combe, Combe Sawmill
The maker is possibly Thomas Piggott & Co., Birmingham, the date c.1852.

120) Hook Norton, The Hook Norton Brewery Co.
I have cylinder dimensions c. 10in x 1ft 10in. The probable date of installation is 1899,
the date of a major rebuilding of the brewery.

<center>WARWICKSHIRE</center>

135) Leamington Spa, Leamington Spa Sewage Works, Princes Drive
All the details can be filled in: Cylinders 12in, 18in and 29in x 1ft 6in. 102ihp, 28-
32spm and 120psi.

137) Napton on the Hill, Napton Brickworks. Cylinder stroke is 3ft 0in

VOLUME 7
<center>CORNWALL</center>

1) Pool, South Crofty Tin Mine, Robinson's Engine
Before reaching South Crofty, this engine worked initially at Alfred Consols, Gwinear;
then Crenver and Wheal Abraham, Pelly's Shaft; then Tregurtha Downs Mine.

<center>DEVONSHIRE</center>

3) Uffculme, Fox Bros., Coldharbour Mill
The engine cylinders are 14¹/₂in & 27in x 3ft 6in. This was a worsted spinning mill,
and not as stated.

<center>DORSET</center>

8) Bridport, J.C. & R.H. Palmer, The Old Brewery
This is Brown & May No. 6429 built in 1900.

<div align="center">HAMPSHIRE</div>

19) Basingstoke, Sewage Pumping Station
This is Tangyes of course, not Tanges!

20) Havant, Portsmouth Waterworks, Havant Pumping Station
The cylinders dimensions were: 18in, 31in and 50in x 3ft 0in.

21) Horndean, George Gale & Co., Brewery
This engine may have been built by Plenty & Son Ltd., Newbury, c. 1870.

22) Horndean, George Gale & Co., Brewery
The Belliss & Morcom engine was No. 8858 of 1935.

23) Otterbourne, Southampton Waterworks, Otterbourne Pumping Station
The correct cylinder dimensions are 18in, 31in and 54in x 4ft 0in.

25/26) Otterbourne, Southampton Waterworks, Otterbourne Pumping Station
Both these illustrations are of the 1895 engines (25 must be of the C engine, 26 of the D). The 1886 pair (A and B) had been removed by the time of illustration 25, their space being by then occupied by the turbines referred to.

32) Twyford, Southampton Waterworks, Twyford Pumping Station
The date of this engine is 1913. The cylinders are 16in, 28in & 46in x 3ft 0in. Working conditions: c.150hp, 25rpm and 150psi. It did remain.

34) Winchester, Winchester Sewage Works, Garnier Road Pumping Station
Cylinder dimensions and design working conditions can be filled in: 12in, 19in & 30in x 2ft. 150ihp, 30spm, and 150psi.

35) Winchester, Winchester Waterworks, Romsey Road Pumping Station
The cylinder sizes were: 17in x 4ft 1$^{1}/_{2}$in; 25$^{1}/_{2}$in x 5ft 6in.

<div align="center">SOMERSET</div>

40) Bath, Bath Gas Works, North Engine House
This was Belliss & Morcom No. 8288, and not as stated. Cylinders were 14in & 19in x 10in.

51) Bathford, Bathford Paper mills
It is stated that it 'may be preserved'. In fact, although preservation had been intended, it disappeared!

60) Chelvey, Bristol Waterworks, Chelvey Pumping Station
The date was probably 1879, and cylinder 45in x 5ft 6in (Jas Simpson records), and not as stated.

61) Chelvey, Bristol Waterworks, Chelvey Pumping Station
These were not by any means the last Watt beam engines!

67 Clutton, Osmond & Co., Sawmills
Judging from the No. and date, this was presumably a Ruston, Proctor engine.

68) Creech St Michael, Bridgwater & Taunton Canal, Pumping Station
The Boulton & Watt engine list gives a cylinder diameter of 33$^{1}/_{2}$in, and not 30in as stated.

85) Othery, Somerset Rivers Board, Southlake Pumping Station
I have a stroke of 1ft 0in for this engine.

107) *Westonzoyland, Somerset Rivers Board, Westonzoyland Pumping Station*
The diameter of the cylinders may have been 18in. [This figure needs confirming!]

<div align="center">WILTSHIRE</div>

111) *Devizes, Wadworth & Co., Brewery*
The generally accepted date for this engine is I think c.1885, the new brewery
construction date. The existing brewery, bought by Wadworth in 1875, was started
much before 1860 I believe. The cylinder was c. 10in x 1ft 8in.

113) *Great Bedwyn, Kennet & Avon Canal, Crofton Pumping Station*
The maker and date details as given appear to be confused. The No. 1 Engine, Boulton,
Watt & Co., 1812, was rebuilt as a Cornish engine by Harvey, 1845. The No. 2 Engine
(a replacement of the first engine of 1802) was a Sims type compound built by Harvey
in 1844, which was then altered to a single cylinder engine in 1905.

117) *Trowbridge, McCall Bros.*
The cylinder details were: 16in & $26^{1}/_{2}$in x 2ft $3^{1}/_{2}$in. The 750hp quoted may be the
result of a misreading of the alternator plate, which I think was 500KVA (and 300KW)
and not 500KW as given in Watkins's original notes.

VOLUME 8
<div align="center">KENT</div>

3) *Ashford, Henwood Pumping Station*
Both engines have been preserved off-site.

7) *Chatham, Chatham and Gillingham Waterworks, Luton Pumping Station*
James Simpson records give cylinder dimensions: 35in x 5ft 2in and 56in x 8ft.

16) *Folkestone, Folkestone Waterworks, Upper Cherry Garden Pumping Station*
Cylinder dimension figures can be corrected: 7in, 11in & $17^{1}/_{2}$in x 1ft 3in. The engines
were designed to work with a steam pressure of 80psi at 36-52spm. The other
remaining waterworks Worthingtons were at Marham in Norfolk, and were scrapped in
1977.

25) *Ightham, The Kentish White Brick Co.*
The Ensor Mill engine referred to (see Vol 3.2 No. 88) was scrapped in 1975.

26) *Lydd, Folkestone Waterworks, Denge Pumping Station*
These are Robey built engines of 1916 and 1936. Cylinders are $8^{1}/_{4}$in & 13in x 1ft 0in;
and 14in & $19^{1}/_{2}$in x 1ft 8in respectively. The larger of the two engines is the one
illustrated.

33) *Meopham, Gravesend Waterworks, Meopham Pumping Station*
It is the 1930 engine which is illustrated.

<div align="center">LONDON</div>

50) *Bermondsey, Tower Bridge, A and B engines*
The cylinders are $19^{3}/_{4}$in & 37in x 3ft 2in, and not as stated.

53) *Bethnal Green, Mann, Crossman & Paulin Brewery. Whitechapel Road* and 54)
Bethnal Green, Metropolitan Water Board, Old Ford Pumping Station
These two illustrations have been switched

73) *Lambeth, Metropolitan Water Board, Brixton Hill Pumping Station*
The LP cylinder diameter is 21in, not 2in.

79) *Southwark, South Metropolitan Gas Co., Old Kent Road*
There is at least one Donkin - Farey type preserved – privately, at High Easter, Essex.

82) *Tottenham, Markfield Road Sewage Pumping Station*
Cylinders are 20in x 4ft 3in; 35in x 6ft 0in. The engine is still *in situ*.

83) *Tottenham, Markfield Road Sewage Pumping Station*
The cylinders were as suggested: 8in, 12in & 20in x 1ft 3in. Design working
conditions: 40ihp; 38spm; and 100psi. The two sites retaining Worthingtons referred
to are presumably Marham, Norfolk (see above); and Leamington Spa Sewage Works
(see Volume 6, No. 135) – engine later removed for preservation. However, a number
of oil fuel depots also had Worthington engines when Watkins was writing this note,
and those at Lyness, Orkney remain today, preserved in situ.

87) *Wandsworth, Young & Co.*
The cylinder details I have (possibly not 100% confirmed) are 12in x c.2ft 4$\frac{1}{4}$in; 18in
x 3ft 4in. Flywheels are 12ft (1835 engine) and 14ft 6in (1867 engine). Working
conditions: 16hp and 20hp; 32rpm; 60psi. They stopped working probably c.1980.

89) *Westminster, John Oakey & Sons, Wellington Mill*
Easton & Anderson records suggest that there were two compound beam engines: one
with cylinders 18in x 3ft 1in and 36in x 5ft; the other (with a slightly larger hp
cylinder) 24in x 2ft 11in and 36in x 5ft. Both had 18ft flywheels. The third engine had
a single cylinder 16in x 3ft 0in.

MIDDLESEX

93) *Brentford, Metropolitan Water Board, Kew Bridge Pumping Station*
Both West and East Cornish Engines are shown in the illustration (left and right
respectively).

94) *Brentford, Metropolitan Water Board, Kew Bridge Pumping Station, No.6 engine
house* The cylinder diameter is 64in, not 65in, the date 1838.

96) *Enfield, Metropolitan Water Board, Alma Road Pumping Station, Ponders End*
The date of the engine is 1896, not 1888.

SURREY

109) *Banstead, Banstead Mental Hospital*
The date of this engine is 1875, the cylinder 16in x 3ft 0in.

118) *Croydon, Croydon Waterworks, Addington Pumping Station*
One engine is Glenfield Co., Kilmarnock, 1893. The engines continued in use until
1975.

120) *Croydon, Croydon Waterworks, Waddon Pumping Station*
The HP cylinder diameter was 21 in, not 24in. There were Meyer expansion valves on
both HP and lp cylinders. They continued in use until 1982.

122) *Croydon, Woodside Brickworks*
This was Ruston, Proctor No. 39445 of 1910. Cylinders were 16in & 26$\frac{1}{2}$in x 2ft 8in.
Working conditions: 450hp?; 120rpm; and 160psi.

Sussex

135) *Horsham, King & Barnes, Brewery*
The cylinder was probably 8in x 1ft 0in

VOLUME 9
CAMBRIDGESHIRE

16) St Neots, Paine & Co.
'haft' presumably should read 'shaft'.

ESSEX

31) High Ongar, J. Brace & Sons
The date of installation is c.1936.

32) Hornchurch, South Essex Waterworks, Dagenham Pumping Station
The engines were built by James Simpson & Co. Ltd. in 1909 and 1913. The cylinders were 15in, 25in & 40in x 3ft and 15in, 26in & 42in x 3ft respectively. The illustration shows No. 2 on the right and in the foreground the pump quadrants of No. 1. (The No.2 quadrants had evidently been removed by 1966.)

35-37) Maldon, Beeleigh Mill
The water mill was not exactly abandoned – it burnt down – in 1875. After this, the steam mill was apparently never used again. The 37 illustration is upside down.

54) West Ham, Abbey Mills Sewage Pumping Station
The LP stroke is 7ft 6in, not 8ft.

NORFOLK

67) Haddiscoe, Haddiscoe Pumping Station
The engine was removed for preservation 1971/3.

82) Norwich, Norwich Model Engineers Society
The photograph date of 1939 given in the text is presumably incorrect.

86) Shotesham All Saints, Ronald Clark, Diamond Cottage
This cannot be Ruston & Hornsby – this company did not exist as such until 1918. Presumably it is Richard Hornsby, but 1844 seems early.

NORTHAMPTONSHIRE

102) Little Houghton, Rousselot Gelatine Co.
The generally accepted date for this engine is 1928, but it was not installed here until 1938, when the works was established. It had certainly not been there for nearly 70 years as suggested. As a French-built engine, its cylinder dimensions should be given in metric terms (i.e. 450mm x 700mm), and the other statistics should be 175hp; 120rpm; and 150 psi.

103) Northampton, Northampton Water Works, Cliftonville Pumping Station
This engine went to Kew for preservation.

104 Northampton, Northampton Gas Works
This locomotive was built in 1888 according to J. W. Lowe.

105 Raunds, Manor Brickworks
This engine was built in 1942, apparently for the Ministry of Supply as a standby at Lincoln Sewage Works, before installation at Raunds in 1945. The cylinder was $10^{1}/_{2}$in x 1ft 3in. It developed 50bhp using steam at c.140psi and running at 150rpm. It was in use at the brickworks until c.1948 and standby until perhaps c.1970. Production stopped in 1974.

<div align="center">SUFFOLK</div>

110) Combs, Webb & Son, Tannery
The engine was probably built by W.P. Wilkins (the same maker as that of the original Cornish boiler), and installed in 1851, perhaps not second-hand as suggested. The cylinder replacement date may be 1904. The stroke was 2ft 4$\frac{1}{2}$in. The beam was 5ft 6in between centres, and the flywheel 11ft. A steam pressure of 60psi and working speed of c.50-60 rpm have been quoted.

118) Leiston, Richard Garrett & Sons, Engineers
The locomotive was built in 1906 (J.W. Lowe).

119) Lound, Lowestoft Waterworks Co., Lound Pumping Station
The date was c.1854, the flywheel 8ft, not 7ft 6in.

120) Newmarket, Newmarket Waterworks, Southfields Pumping Station
The Hathorn, Davey engine dated from 1910, not 1920 as suggested.

VOLUME 2. NEW NOTES ON THE ENGINES AT DARLINGTON WATERWORKS.

by J. F. Prentice who has been involved with their preservation since 1978.

67) Darlington, Darlington Waterworks, Coniscliffe Road Pumping Station SER 513

Maker:-	Designer was Glenfield and Kennedy; manufactured by Goodfellow of Manchester and erected by Teesdale Brothers. (Note – engines at Blagdon, Somerset, are almost the same)
Cylinder Dimensions:	HP 18in x 5ft 3in; LP 29in x 7ft 0in – Cornish Valves
*Hp:*140	*Rpm:* 12 - 16 *Psi*: 100
Service:	Town Water Supply by abstracting 2.6 million gallons per day from the River Tees and 2.5 million gallons per day into Darlington.

The first supply was in 1849 with a single beam engine, which, in parallel with an 1853 beam engine served until 1907 and 1912 respectively. The 1904 beam engine operated initially with the previous beam engines. A 1907 Fielding and Platt gas engine replaced the 1849 engine and the 1853 engine was replaced in 1914 by the Richard Hornsby gas engine (No 68), the three engines operating as necessary until 1926. In that year electric motor driven pumps were installed to supply the full pumping duties and replaced the 1907 gas engine. The 1904 beam engine and 1914 gas engine were retained as standby engines and operated for one week each year until 1955, without the electric pumps, to prove their standby capability. The 1904 and 1914 engines are operated under pumping load on open days; the electric pumps are retained.

68) Darlington, Darlington Waterworks, Coniscliffe Road Pumping Station SER 1496

Type:	Twin cylinder suction gas engine and two sets of triple ram pumps
Maker and Date:	Richard Hornsby, 1914
Cylinder dimensions:	Two cylinder each 19in bore, 24in stroke
Hp: 220	*Rpm:* 200
Service:	Town Water Supply by abstracting 2.7 million gallons per day from the River Tees and 2.5 million gallons per day into Darlington at 200rpm

The twin gas engine drove by a wide stitched leather belt to a countershaft and through separate clutches and gearing to either the 'river' pumps or the 'town' pumps, allowing both or either sets to operate. The engine is preserved and operates under water pumping load on open days but uses mains North Sea gas instead of the preserved producer gas plant.

69) Darlington, Tees Valley Water Board, Broken Scar Pumping Station SER 1017

Cylinder Dimensions:	HP 22½ in x 5ft 1in and LP 35in x 7ft 0in
Ihp 150	*Rpm:* 14 *Psi:* 80
Service:	One engine abstracting River Tees water for treatment, the other for Town supply from water treatment works.

These engines were installed to augment flows to Stockton and Middlesbrough and operated in parallel with the two earlier pairs of beam engines of 1857 (abandoned in the 1930s) and of 1868 (which operated in parallel with the 1886 engines until 1955). Their cranks were connected part way along the beam with their single pumps driven from the outer end, each 7ft 0in stroke and 28in bore, double acting. The engines were fitted with expansion valves on McNaught and Varley's principle driven by a cam which could slide along the revolving shaft on a spiral feather to vary the expansion. The engines operated until 1955 to meet increasing water demand and in their last year of operation pumped into supply their largest volume of water before electric pumps were commissioned.

COMMENTS ON DRAINAGE ENGINES BY K. S. G. HINDE

VOLUME 5

73) Owston Ferry Pumping Station SER 1501

One Marshall tandem engine was taken out in 1952, and replaced by a twin tandem Ruston 9HXR diesel engine. (Hayes, G., *Guide to Stationary Steam Engines,* (1981 and 2nd ed. 1990), p. 137.

74) Pinchbeck Marsh Pumping Station SER 194a

Maker possibly Butterley, but this is unsubstantiated. Date 1833. Hp more probably 20.

114) Misterton, Soss Drainage Station SER 46a

Clark, R. H., *English Mechanics*, 24 December 1937, states the stroke as 90 ins. and the length of the beam as 21 ft. The Engine was called *Ada*

116) Misterton, Soss Drainage Station SER 46c

Installed 1895. Cylinder: 12 in. and 22 in. by 18 in.

117) Misterton , Soss Drainage Station SER 46d

Dates: *Kate* on left of photo 1828; *Ada* on right 1839

82) Pode Hole Pumping Station SER 196

Correct date of photo to 1937. (presumably *Holland* Engine)

88) Tattershall, Dogdyke Pumping Station SER 146

Erected 1855. Maker: Bradley & Craven.

VOLUME 9

4) Benwick, White Fen Pumping Station SER 128

This was almost certainly scrapped in 1937 when a diesel engine and pump was installed. (District Order Book, Middle Level Office).

6) Cottenham, Chear Fen Pumping Station SER 208

This was erected in 1842. The plant was last used in 1937 and dismantled in 1948. (Commissioners' Minutes, Cambridge Record Office)

14) Over Fen Pumping Station SER 209

This plant was scrapped in 1942, when a diesel engine and pump was erected on a different site.

17) Stretham Pumping Station SER 130

This was rated at 60 hp.

19) Upware Pumping Station SER 131a

This was rated at 70 hp.

22) *Blackbush Pumping Station No 2* SER 198

Maker: Foster. Date: c. 1870
Cylinder: 10 x 20 ins.
Replaced 1939, but not removed until after 1957.

23) *Whittlesey, Kingsland Fen Pumping Station* SER 129

This plant was scrapped in 1949. (District Minutes).

74) *Middleton Towers Estate Pumping Station* SER 135a

Ronald Clark states that this was built in 1877.

76) *Northwold Fen Pumping Station* SER 136a

The engine house plaque, now stored at the disused Wretton pumping station, states 1849.

89) *Stow Bardolph Fen Pumping Station* SER 73

This was rated at 50 hp.

TRACTION ENGINES AND OTHER PORTABLE ENGINES
ERRATA

Reproduced by kind permission of the Road Locomotive Society

This is a work in progress and all comments and additions are welcome to Tony Brown, R.L.S. Records Officer, 23 Hall Street, Soham, Ely, Cambs, C137 5BN.

Pages 185 & 186 typify the problems with the information given in this book and in what we see of George Watkins notes. For instance, we know that the number for Savage 464 is wrong since the whereabouts of that engine is fully documented. In fact it is Savage 474 which is at Loveday's but it is not mentioned in the notes. So while we can rule our Savage 364 from other photographs we may never be sure if the picture is of 474 or 491.

There is a further problem with the date given for the picture. It is well attested in contemporary letters and notes that by September 1951 there was only one engine remaining with Loveday and that was Savage 364. In which case it is not possible that George Watkins can have made these notes and taken this picture in 1952 as stated.

Cover Wallis Simplicity 8022
1 McLaren 112
3 Armstrong Whitworh, 8 Ton QR in Salford Area reg BA 9263
7 Royal Show at Cardiff in 1901
11 Engine is OSPC 59 or 60. Also only Fowler compounds have valves on top
15 Aveling 2375, 1888 is date not engine number
16/17 Robinson & Auden Portable 1328
18 Aveling 8145
19 Aveling 2375
23/24 Babcock & Wilcox 95/4014
26 Clayton & Shuttleworth 48837
27 Wimbish is in Essex, not Cambs. Pictures are of Aveling & Porter 7385.
 Also the dimensions givenare inaccurate.
44 Picture printed back to front and owner is previous one, not current.
45 Tasker 1670 of 1915. Burrell Wagon is 6 Ton 3953
63 Collings no 2
64 Collings no 1
65 Collings no 2 – taken on an earlier occasion than 63
67 Top is McLaren 1163, bottom is Dodman 2275 but printed back to front.
73 Foden wagon is a Speed model so either 13890 or 13902
74 Description relates to Savage 614, reg EB 2751
75 From notes top picture should be Clayton 38902, Savage EB 2945 with the
 Allchin 1263 on the right.
76 Savage 'Teutonic' EB 2945, engine number unknown
77 Allchin 1263
79 Sun Tractor is 13730 and owner is Crawford
88 Fowell 106, owned by Epton's not Rundells
93 Salford Priors is Warwickshire and not Worcs. Although Bomford & Evershed
 thought of themselves as Worcs.
97 Fowler / Goode's 3938 and 3958
100 Bottom picture printed wrong way round
102 Fowler 8231, B4 Side Drum engine
103 Top 2 Fowler 8231, bottom 8232
104 Fowler 8231

106 Fowler 15227
107 Fowler 14892
110 McLaren 112 with Fowler Roundabout tackle
111 Green tandem compound, address is West Dereham
112 Top Green tandem compound, bottom Wallis 7757 (?)
113 T G Potts is Great Harwood, Lancs, Armstrong Whitworth 8R21
114 Green 2080
116 Burrell 2863 with Green 1438 behind it.
122 Fowell 88, Burrell CE 7945 engine number unknown
123 Burrell CE 7945 with Fowell 88 behind
129 Hornsby
130 Brown & May picture back to front, Hornsby
131/133 Hornsby
135/136 Hornsby
140 Lampitt No 6, BW 4433 with Aveling 2603 behind
141 Two Wallis & Steevens engines foreground with Lampitt & Aveling behind
142 Lampitt Portable
148 Mann 1260, probably owned by A Fuller, Boyton End, Thaxstead, Essex
150 & McLaren 1553
152 Fowler 13878
154 Fowler 13879
155 McLaren 1552
162 Allen 74 reg BW 4609
166 Same picture as page 42
167 Ransomes 39088, Wilder reg as BL 4150
168 Picture back to front
173 Ruston SCD Tractor 52370 owned by A E Bridgeman, Haydon Wick, Wilts
175 Picture back to front
180 No reference can be found to Chris Lambett owning Garrett 24063
182 Tasker A1 number 1318
185 Savage number is 474 not 464
186 Savage 491
187 Tasker 1914 of 1924
196 Fowler 5190, Garrett 33442
199 Marshall 15391
200 Fowler 5190
201 Marshall 15391, Bottom Garrett 33442, Wallis ?, Aveling 3437
203/204 Fyson T3
205 Garrett 33202
206 Wallis 8022 owned by Frederick Godden, Cheam, Surrey
207 Bottom picture includes Robey 42561
208 Wallis 2448
213 Tasker 1914
212 Paxman 19412 behind Garrett Suffolk Punch
219 Same picture as on page 208

Acknowledgement and thanks are owed to various members of the RLS for helping to identify some of these engines. This listing is kept updated on the website of the Road Locomotive Society – www.roadloco.og

MAKER	SER	Vol-Plate	MAKER	SER	Vol-Plate
Daglish & Co.	1338	3.1-1	Duncan Stewart	1047a	2-15
	1332a	3.1-125		1416a	3.1-50
	647	3.2-15	Dunlop, Meredith	1299a	2-94
	801	3.2-64	Dunston Engineering Co.	613	2-65
	607	3.2-142	Easton & Amos	116	5-92
	794	3.2-214		534	6-105
	685	4-92		776	6-103
	1368b	5-109		92a	7-83
	1369	5-113		89	7-97
	1372b	5-119		94a	7-98
	32a	7-59		236	7-102
	131a	9-19		94	7-106
	131b	9-20		93	7-107
Dalling, J.	75d	9-82		532b	8-78
Davey, Paxman & Co.	1208	6-26		229	8-137
	1281	6-39		127	9-103
	1223	6-85		72	9-119
	1067	7-117	Easton, Amos & Anderson		
	622	8-68		88	7-81
	581	8-134		92a	7-82
Davies, J. & G.	626	1-8		92a	7-83
	253	5-156		91	7-85
Davies, J.	248b	5-181		71	9-67
Davis, Gabriel	1470a	10-94	Easton & Anderson	1077	1-143
Davy Bros.	989d	1-133		148a	5-68
	1040	1-165		8b	7-30
	1169	1-169		231	7-36
	1410	1-213		10a	7/10-2
	1247	2-50		222b	8-19
	372	2-66		226	8-39
	565b	2-74		18a	8-71
	988	3.1-13		328	8-89
	1118	4-22		1472	8-109
	21a	5-89		392a	8-118
Day, Summers & Co.	84a	10-39		228a	8-139
De Klop	1224c	10-30		228b	8-140
De Winton	653a	4-9		129	9-23
Denny, Wm	1261a	10-88		200	9-26
Donkin, Bryan	1214	6-8		1241c	9-28
	1286e	6-10	Easton, Anderson & Goolden		
	1037	6-21		118	5-128
	8a	7-29		288a	6-52
	1322	7-39	Ebor Engineering Co.	623	1-208
	1322i	7-41		267	3.2-5
	1373a	7-54		174	3.2-7
	1373b	7-55		1287b	3.2-40
	1325	7-104	Elliott & Garrood	523	10-92
	1325b	7-105	Evans, W., & Co.	31	7-86
	1324b	7-115		1211	7-87
	576	8-74		1225	7-89
	532c	8-79	Fairbairn	176a	3.2-108
	582	8-124	Fairbairn, Lawson, Combe, Barbour		
Douglas & Grant	1049	2-8		891b	5-102
	1268	2-39	Fairfield Shipbuilding & Engineering Co.		
	1048	2-41		816	10-2
	1258	2-44		559	10-27

MAKER	SER	Vol-Plate	MAKER	SER	Vol-Plate
Farland & Brearley	63	1-26		852	4-91
Fawcett, Preston & Co.	185	4-129		853	4-93
Fenton, Murray &				1072	5-32
Wood (model)	455b	9-87		145	5-94
Fenton, Murray & Wood	196a	5-83		347	5-149
	1465	6-131		800	5-182
Ferranti Ltd	610	3.1-93		39c	5-185
Fielding & Co.	332	6-49		37b	7-120
Filer & Stowell	461	9-38		227b	8-37
Finch & Co.	406a	10-6		138	8-102
Fleming & Ferguson	822	6-132		203b	9-93
	670	8-128		1033c	9-101
	669	8-129	Gardner	205	9-124
	579	8-143	Garrett & Sons, R.	1023	1-96
	433	10-54		1471	9-31
	1409	10-57		458	9-117
	1274	10-89	Gibb, Hogg & Barclay	1254a	2-25
Fletcher of Derby (?)	214	9-68	Gilkes (?)	1295	2-102
Foden	943	4-15	Gimson & Co.	120	5-50
Foden, E.	1167	4-106		1482a	5-51
Forrester, G.	99b	3.2-11		121	5-155
	101	4-99		68	5-170
Foster & Co., J.	77c	9-43		288	6-51
Foster & Co., W.	1485	9-105		1425	7-6
Fowler, J.	1345	1-212		233a	7-33
	682	4-29	Glasgow, D.	76	9-91
	959a	4-65	Gledhill, R. & J.	273	1-86
Fraser & Chalmers	1429	1-44	Glenfield & Kennedy	1343	1-107
	1430	1-45		1426	5-29
	1334	3.2-131		774a	6-107
	679	4-50		87	7-53
	1484a	5-44		286	8-27
Fullerton, Hodgart			Glenfield Co.	1427	5-30
& Barclay	991a	5-80	Goddard & Massey	1034	9-1
	1257	2-21	Goddard, Massey		
	1321a	4-74	& Warner	957	7-14
Furnevall, J.	103b	3.2-78	Goodfellow, B., & Co.	985b	3.1-19
	1098	3.2-143		638	4-109
Galloways Ltd.	694	1-33		606b	4-112
	1045	1-130		877	4-122
	989a	1-131		86	7-71
	989c	1-132	Goscote Foundry	191a	6-139
	993a	1-156	Graham & Co.	56	5-14
	922	1-184	Grange Iron Co.	1300	2-93
	1331	3.2-3		1368c	5-110
	1180	3.2-4	Grant, Ritchie	1252	2-5
	495	3.2-17		1271a	2-9
	850	4-16		1293	2-29
	934	4-18		1290	2-30
	944	4-45		1448	2-98
	94b	4-47	Great Western		
	1301a	4-48	Railway Co.	1140b	6-7
	400	4-58	Greenhalgh & Co.	1192a	3/10-7
	402b	4-84	Greenwood & Batley	588	6-22
	402c	4-85	Griffin, C., & Co.	1323	7-45
	815c	4-87	Gwynne, J. & H. & Co.	469	4-128

MAKER	SER	Vol-Plate	MAKER	SER	Vol-Plate
	46c	5-116		25a	5-18
	1216	6-54		24a	5-124
Hall & Co., A.	1454	10-17		39a	5-183
Hall & Co., J. & E.	344	6-101	Hayward-Tyler	1422b	8-136
	77b	9-42	Headley, J. & E.	73	9-89
Hamilton	1068	6-81	Hepple & Co.	1083	10-75
Handyside A.	1197a	5-20		1297	10-76
Harvey & Co.	99a	3.2-10		514b	10-78
	847a	4-94		97	10-51
	847b	4-95	Hick, B. & Son	42	5-126
	847c	4-96		399	7-58
	258	4-102	Hick, Hargreaves & Co.	1155	1-1
	9	6-74		1428c	1-43
	12b	8-5		1129	1-105
	82	8-9		1500	1-113
	81	8-10		1039a	1-152
	13a	8-34		1099	1/10-17
	13b	8-35		856a	3.1-25
	83	8-49		855	3.1-26
	17a	8-60		1021a	3.1-30
	17d	8-63		751(2)	3.1-31
	19	8-70		834	3.1-43
	14a	8-66		1120b	3.1-48
	16a	8-91		1012	3.1-117
	16b	8-92		1094	3.1-114
	16e	8-95		968a	3.2-55
	50	8-107		726	3.2-124
	47	9-34		756	3/10-9
	583	9-52		941	4-17
Harvey, W., & Co.	436a	5-130		963	4-37
Harveys & Co.	380a	1-215		850c	4-57
	380b	1-216		850d	4-72
	561	2-14		961	4-90
Hathorn, Davey & Co.	1078	1-144		1282	6-42
	158a	3.1-56		678	6-53
	170b	3.1-63		1421b	8-99
	759	3.2-8	Hindley, E. S.	1453	3.2-120
	1497	4-76		1380	7/10-1
	39d	4/10-14		1422a	8-135
	891a	5-101	Holborow	316	6-48
	491	5-144	Holcroft T.	248a	5-180
	1467	5-146		144	9-16
	1466(1)	5-147	Holman Brothers	653	4-8
	1488	5-160	Horn, J. & Co.	395c	8-57
	1488b	5-161	Horn, Thomas	483	8-3
	39b	5-184	Horsfield, J. & J.	111	1-10
	1285a	6-14	Howard & Co.	364a	3.2-46
	1285c	6-16	Hoyle & Son	151	1-114
	774a	6-107	Hughes & Lancaster	1204a	8-131
	1377	7-32	Humphrys & Tennant	764a	10-34
	289	7-103	Hunt & Co., R.	211	9-29
	1435	8-126	Hunter & English	283b	6-100
	738	9-5		1391	8-75
	739	9-9		77d	9-44
Hawthorn, R. & W.	371a	2-80		77g	9-47
	371b	2-81		577	10-60

MAKER	SER	Vol-Plate	MAKER	SER	Vol-Plate
	1398	5-87	Murray & Paterson	1445	2-24
	1283	6-38	Murray & Co., T.	375b	2-61
	1281	6-39		378	2-63
	1242	6-43		377a	2-82
	1217	7-108	Musgrave & Sons	1428a	1-41
	893b	8-8		385a	1-219
	199a	9-24		385b	1-220
	1239	9-70		1264	2-3
	406b	10-9		1192b	3/10-8
Maschineatabrik Augsburg Nürnberg				932	3/10-6
	992b	5-77		756(3)	3.1-4
	992c	5-78		1007	3.1-7
Mather & Platt	1416b	3.1-49		178	3.1-29
	1141	3.2-107		751(1)	3.1-32
Mather Dixon	9c	3.2-12		1183	3.1-34
	99c	3.2-12		833	3.1-37
	1413	4-11		725a	3.1-38
Maudslay, Sons & Field	220b	8-86		725b	3.1-39
	16d	8-94		1028	3.1-46
Maw, J.	11	8-141		869	3.1-76
McNaught, J. & W.	1348	1-188		632(1)	3.1-84
	1030	3.2-25		632(2)	3.1-85
	599	3.2-37		780	3.1-92
	899a	3.2-87		900	3.1-129
	591	3.2-100		1092	3.2-14
	590	3.2-101		713	3.2-24
	760	3.2-103		169a	3.2-31
	898	3.2-145		169b	3.2-32
McTaggart & Co.	1292b	2-33		906	3.2-65
Metcalfe, T.,	1206	6-1		1230	3.2-69
Middleton, T.	532a	8-77		1157	3.2-72
Millburn Engineering	1248	2-51		933	3.2-132
Mills, Heywood (?)	1148	3.1-128		983a	3.2-147
Mills, E.	1491b	1-111		609b	3.2-149
Mordey, Carney & Co.	84b	10-40		942	4-59
Moreland, R. & Co.	79a	6-97		962	4-64
	771	6-98		815a	4-86
	770	8-97		994a	5-1
	768	8-101		1279	5-15
	668	8-133		122	5-53
Morton, R.	530b	8-53		35	7-118
Morton, S. & H.	413c	8-11	Napier, Robert	557	10-45
Moule, J. & Co.	338	6-31	Nasmyth, Wilson & Co.	684	4-81
Murdoch, Aitken & Co.	1440a1	4-139		388b	5-96
	1440a2	4-140	Neath Abbey Ironworks	812	4-89
Murray & Co., T.	566	2-52	Neilson & Co.	119	5-41
	375a	2-60	Newbridge Foundry	1314	4-60
	376a	2-70	Newton, Bean & Mitchell	931	1-49
	376c	2-72		1088	1-57
	564	2-79		926	1-75
	369a	2-86		1235	1-106
	369b	2-87		1351	1-148
	373	2-92	Newton, Chambers	66a	1-31
	566	2-103		66b	1-32
	377b	2-107		67b	1-47
Murray, Mathew	95	6-158		67a	1-198

MAKER	SER	Vol-Plate	MAKER	SER	Vol-Plate
North Moor Foundry	342	6-122		57a	1-126
Oliver & Co.	1170	5-16		569	1-195
Owen, S.	333	7-47		1236	1-221
Parsons & Co.	968b	3.2-54		1165	3.1-54
	1460a	10-73		1161	3.1-55
Paul, Matthew	1261	10-87		705	3.1-61
Pearce Bros.	1263b	2-37		1125	3.1-68
Pearn, F, & Co.	1027b	4-131		1101	3.1-71
Peel, Williams & Peel	849a	5-162		361	3.2-19
Penn, J., & Sons	665	8-48		709	3.2-56
	140	8-90		709a	3.2-57
	487	10-19		1071	6-115
	397	10-21		1114	7-3
	398a	10-22		1473	7-38
	1424a	10-36	Pollit & Wigzell (Reblt)	1188	1-100
Perkins, A. M.	396	8-112	Pollock & Macnab	216	8-96
	396a	8-113	Pontifex & Wood	1423	8-138
Perran Foundry	560	2-13	Pratchitt Brothers	1481	9-65
	554a	2-47	Priestley, W.	339	6-34
Perry, T., & Son	465b	6-157	Qualter Hall & Co.	1316c	4-42
Petrie & Co., J.	1046	2-40	Radhead, J.	514a	10-77
	1019	2-43	Rankin & Blackmore	817	10-3
	154	3.1-10		1260b	10-25
	631	3.2-27	Renshaw, W. R.	249	4-147
	973	3.2-38	Richardson, T.	370a	2-76
	1057	3.2-75		370b	2-77
	899b	3.2-85		663	9-51
	594	3.2-86	Richardsons, Westgarth	955	4-32
	597	3.2-90		992a	5-76
	1103	3.2-91	Riches & Watts	454	9-78
	938	3.2-92	Roberts & Sons, W.	1186a	1-4
	596	3.2-94		979	3.1-14
	970	3.2-96		167b	3.1-53
	593	3.2-97		803	3.1-67
	1184	3.2-98		918	3.1-77
	175	3.2-99		506b	3.1-100
	157a	3.1-120		1100	3.1-101
	874	3.2-146		1126	3.1-102
	698	3.2-210		1025	3.2-126
	259a	5-47		977	3.2-29
	763	5-48		976	3.2-30
	147	5-71		704a	3.2-33
Pickup & Knowles	1287	3.2-39		704b	3.2-34
Piguet, Établissements	1397	9-102	Roberts, Wm	622	1/10-20
Plenty & Co.	1478	10-31	Robey & Co.	1259	2-38
	1406	10-55		1299b	2-95
Pollit & Wigzell	1087	1-18		1321b	4-75
	805	1-27		1480	5-17
	1086	1-34		1399	5-81
	1059	1-52		1364	5-107
	1060	1-56		1280	6-2
	1089	1-58		1284	6-37
	552	1-66		288c	6-70
	1091	1-78	Robinson & Cook	937	3.2-214
	1066a	1-97		740a	8-20
	697	1-120	Robinson, J.	895	3.2-59

MAKER	SER	Vol-Plate	MAKER	SER	Vol-Plate
Rose, T.	341	6-113	Shenton, J. & Son	349a	5-165
Rothwell & Co.	100a	3.2-9	Sherratt & Co.	430a	5-152
Rushton's Foundry (?)	1404	3.1-107	Shorrock & Co., J. & R.	829	3.1-106
Ruston & Hornsby	1496	2-68	Simpson & Co., James	607	3.2-142
	1498	7-110		33a	6-13
	1384b	8-2		772	6-106
Ruston, Proctor	1381b	8-122		1219	6-135
Ryde & Co.	123	5-46		1376c	7-25
Sandys, Vivian	351	5-143		230	7-26
	814	7-1		32b	7-60
Savages	516c	5-59		893a	8-7
Savery, T. A.	1475	10-70		414	8-12
Saxon G., Ltd.	1135	3/10-4		1202	8-16
	838	3/10-5		1203	8-26
	1064	3.1-2		227a	8-36
	633b	3.1-44		17b	8-61
	633a	3.1-45		421	8-64
	648	3.1-132		743	8-65
	1093	3.1-134		14b	8-67
	496	3.2-16		18b	8-72
	1164	3.2-23		18c	8-73
	1005	3.2-26		219	8-81
	717	3.2-45		137	8-104
	643	3.2-80		773	8-106
	860a	3.2-111		1205	8-120
	1133	3.2-114	Simpson & Denison	746c	10-68
	601	3.2-115	Simpson Strickland & Co.	1438a	10-10
	1134	3.2-210		1438b	10-11
	494	4-105		1326	10-90
	886	4-126		1474	10-93
	1228	5-5	Simons & Co., W.	894	10-1
Schofield & Taylor	1237	1-186		432b	10-14
Scott, T.R.M. & S.	70	10-69		1224a	10-28
Scott & Hodgson	619a	1-70		1224b	10-29
	1065	1-197		1035a	10-71
	672	7-17		1460c	10-74
	807	3.1-3		658b	10-79
	755	3.1-91		658c	10-80
	644	3.2-81		797	10-83
	645	3.2-82		894a	10-97
	860b	3.2-112	Skedd, James	1294	2-12
	1352	3.2-117	Slaughter & Co.	80	8-59
	688	4-28	Smith Bros & Eastwood	1105	1-99
	949	4-62	Smith, J & Co.	221	8-115
	1142	4-108	Soudley Foundry	683	4-36
	714	4-110		242c	6-77
	1226	4-123	Spencer, R.	90	7-99
	1150	1-190	Stephenson & Co., R.	429	5-58
Sharples & Co., W.	1147	3.1-12	Stevenson & Co.	1332	3.1-126
	884	3.1-104	Stothert & Pitt	1503	6-5
	876a	3.2-88		244	7-46
	1382	8-25	Stothert, G. K.	478	7-109
Shaw, Mark	1138	1-16		405	10-7
	1074	1-192	Stott & Co., S. S.	1123	3.1-82
Shearer & Pettigrew	1255	2-22		1336	3.1-118
Sheepbridge Co.	1400	5-4		789	3.1-119

MAKER	SER	Vol-Plate	MAKER	SER	Vol-Plate
	468	4-101	Wood, J., & Co.	367	1-63
Whitaker & Low	1320	4-77		1251	2-7
White, J. S., & Co.	419	10-66		1330	3.1-146
	419a	10-67	Wood, J., & E.	619b	1-71
	658d1	10-81		1490	1-122
	658d2	10-82		508	1-201
Whitham, J. & Co.	24b	5-97		510	1-202
	327	9-95		715	3.1-6
Whitham, S. & J.	183	1-116		1158	3.1-35
Whitmore & Binyon	213	9-7		1009	3.1-83
	524	9-114		1008	3.1-105
	1015	9-122		649	3.1-139
Whittaker & Co., C.	883	3.1-15		649a	3.1-140
	982	3.1-121		1050	3.1-145
Whitworth & Co.	57	1-125		1052	3.1-147
Wilkes, J.	1486	6-137		637	3.2-1
Wilkinson & Co.	708	3.1-142		470	3.2-18
Willans & Robinson	379b	1-93		719	3.2-102
	612	2-46		608a	3.2-141
	1174	5-61		983c	3.2-148
	734	5-123		1122	4-124
	589	6-3	Wood, R. & Co.	1492	1-112
	585	6-4		284	8-58
	488a	7-10	Wood, S. & E.	795	3.1-40
	488b	7-11		802	3.1-96
	531	8-80		1405	3.1-108
	580	8-130	Woodhouse & Mitchell	1234	1-48
Williamson & Co.	1384a	8-1		1112a	1-103
Wolstenhulme, J.	1204b	8-132		1112b	1-104
Wood Bros.	105	1-51		1130	1-149
	381	1-64		928	1-210
	551	1-65		720	3.2-93
	59	1-67	Worsley Mesnes Co.	641 (3)	3.2-136
	929	1-72		1316	4-40
	1232	1-74		959c	4-66
	880	1-83		1363b	5-9
	997	1-150		1362	5-55
	1154	1-185		1419	5-56
	65	1-196		388a	5-95
	621	1-207		1356	5-174
	69	1-209		1354	5-157
	153	3.1-11		1355a	5-158
	824	3.1-97	Worth Mackenzie	370c	2-78
	851	4-63		747	6-95
	544	4-132	Worthington-Simpson	733f	1-160
	1143a	7-51		774b	6-108
	1178a	8-82		10b	7-20
Wood Bros? / Ebor Eng?	1144	1-200		1376a	7-23
Wood Bros. Marsden's	1289	2-20		233b	7-34
	1361a	5-42		1383	8-13
Wood & Gee	1437a	5-39		1178b	8-83
	1437b	5-40		1434	8-100
Wood J., & Co.	1370	5-26		1014	8-105
	1371a	5-111		1241a	9-32
Wood, Baldwin	1349	1-84	Wren & Hopkinson	1374	7-13
	1346	1-108	Yarrow & Co.	660	9-53

MAKER	SER	Vol-Plate	MAKER	SER	Vol-Plate
Yates & Thom	1431	1-46	Maker unknown	359	1-7
	1039b	1-153		152a	1-11
	857	3.1-33		152b	1-12
	1337b	3.1-58		1166b	1-15
	1229	3.1-116		270b	1-25
	1162	3.1-149		1069a	1-28
	1063	3.1-133		109b	1-37
	1051	3.2-2		275	1-50
	1031	3.2-67		106a	1-53
	876b	3.2-89		108	1-55
	1004	3.2-121		60	1-68
	1329	3.2-122		617	1-69
	749	3.2-123		276	1-80
	642	3.2-128		278	1-81
	1353	3.2-129		1402	1-85
	742	8-103		277	1-87
Yates, W. & J.	1108	1-19		1491a	1-110
	990	1-95		182	1-115
	162	1/10-16		840	1-121
	1017	2-69		1090	1-127
	981	3/10-3		1044b	1-129
	1097	3/10-10		692	1-134
	985a	3.1-18		692	1-135
	1022	3.1-20		356b	1-177
	904	3.1-86		383b	1-182
	507	3.1-103		1152	1-187
	917	3.2-36		1238	1-193
	785	3.2-60		550	1-204
Young, H., & Co.	821	6-134		920	1/10-15
Yule, John	1273	2-17		1270a	2-1
				1047b	2-16

Note:
Where an entry was missed from Volume 1-9,
but now appears in this volume, the index
entry will appear like this: example 3/10-3

			MAKER	SER	Vol-Plate
				1256	2-23
				562a	2-27
				378	2-63
				565a	2-73
				1460b	2-101
				155	3.1-8
				1102	3.1-9
				1120a	3.1-47
				167a	3.1-52
				158b	3.1-57
				170a	3.1-62
				170c	3.1-64
				171	3.1-65
				984	3.1-95
				503	3.1-111
				263	3.1-113
				159	3.1-122
				545	3.1-124
				1231	3.1-141
				104	3.2-6
				804	3.2-35
				364b	3.2-47
				1156b	3.2-71
				1414	3.2-73
				831	3.2-95

MAKER	SER	Vol-Plate	MAKER	SER	Vol-Plate
	176b	3.2-109		27b	6-66
	860c	3.2-113		2b	6-72
	360	3.2-135		2c	6-73
	365	3.2-140		242a	6-75
	1442	4-26		242e	6-80
	1441	4-27		28	6-86
	1309	4-31		53	6-87
	1302	4-39		1a	6-89
	1310a	4-43		1200	6-102
	1318	4-46		324	6-117
	1306	4-71		343b	6-125
	85a	4-73		542	6-129
	1189a	4-114		1465e	6-130
	1333	4-127		191a	6-139
	467	4-136		191b	6-140
	393	5-3		38	6-143
	1221a	5-6		543	6-155
	1221b	5-7		346	6-160
	190	5-27		1245	6-161
	1436	5-36		234a	7-4
	125a	5-37		234b	7-5
	1361a	5-42		1451	7-21
	320	5-43		1378	7-28
	1362	5-55		30a	7-43
	194a	5-74		1115b	7-57
	146	5-88		6	7-72
	117	5-91		1212	7-100
	386	5-118		37a	7-119
	387a	5-120		1201	8-15
	436b	5-131		1202a	8-17
	437	5-132		222a	8-18
	476	5-133		224a	8-31
	438	5-134		239	8-38
	1412	5-141		395a	8-55
	475	5-150		217	8-69
	431	5-151		329	8-76
	23	5-154		215	9-2
	492	5-159		78	9-8
	345	5-164		282	9-15
	350	5-168		198	9-22
	1357	5-169		210	9-30
	473	5-175		143	9-50
	439a	5-176		134	9-69
	439b	5-177		133	9-71
	762	5-178		136a	9-76
	435	5-179		75a	9-79
	1013	6-19		75b	9-80
	442	6-20		75c	9-81
	241A	6-23		204	9-110
	241B	6-24		1407	10-15
	287	6-25		553c	10-49
	7a	6-27		1433	10-50
	7d	6-30		1035b	10-72
	51	6-40		1470b	10-95
	26	6-63		1470c	10-96
	26a	6-64			

SERIES EDITOR, TONY WOOLRICH

Tony was born in Bristol in 1938. He became interested in technical history in his school days.

He trained as a craftsman in the engineering industry, and from 1970 has combined his craft and historical skills in modelmaking for museums and heritage projects.

He has also published books and articles on aspects of technical history and biography. A particular interest is industrial espionage of the 18th century. Another interest is 18th century and early 19th century technical books and encyclopaedias, in particular Rees's *Cyclopædia*, (1802-1819). He has been working on a biography of the engineer John Farey, jr (1791-1851) for the past 20 years.

Since 1989 he has been heavily involved cataloguing for the National Monuments Record, Swindon, the Watkins Collection on the Stationary Steam Engine. He is also a constant consultee to the Monuments Protection Programme of English Heritage.

Since 1994 he has been acting as a contributor to the New *Dictionary of National Biography* working on biographies of engineers and industrialists. He is a contributor to the *Biographical Dictionary of Civil Engineers*, published by the Institution of Civil Engineers, 2002.

He has recently completed for Wessex Water plc a study of the water supplies of Bridgwater, Wellington (Somerset) and Taunton, and was part of the team setting up the company's education centres at Ashford (near Bridgwater) and Sutton Poyntz (near Weymouth).

He is now working on the Portsmouth Block Mills Project for English Heritage, investingating the engineering history of the machinery.

ACKNOWLEDGEMENTS

Thanks are due to Keith Falconer who had the foresight to acquire the collection for the RCHME, and to Helga Lane, (late of the RCHME Salisbury office) who made the original computer database of the Steam Engine Record.

Much help in the production of these volumes has been given by David Birks, National Monuments Record Archives Administration Officer; Anna Eavis, Head of Enquiry and Research Services, and the members of the public search room staff at Swindon.

Colin Bowden and Jane Woolrich did the often-difficult proof checking.

Many thanks to John Cornwell for providing the photographs of the author.

The series publishes George Watkins's texts as he wrote them and it is acknowledged that he did make mistakes. While obvious spelling and typing errors have been changed, to begin to rewrite his work in the light of present-day knowledge is an impossible task.